STORYBOARDS: MOTION IN ART

SECOND EDITION

STORYBOARDS: MOTION IN ART

SECOND EDITION

MARK SIMON

Focal Press

Boston Oxford Auckland Johannesburg Melbourne New Delhi

Focal Press is an imprint of Butterworth–Heinemann.

 A member of the Reed Elsevier group

 Recognizing the importance of preserving what has been written, Butterworth–Heinemann prints its books on acid-free paper whenever possible.

 Butterworth–Heinemann supports the efforts of American Forests and the Global ReLeaf program in its campaign for the betterment of trees, forests, and our environment.

Library of Congress Cataloging-in-Publication Data
Simon, Mark, 1964–
 Storyboards : motion in art / Mark Simon. — 2nd ed.
 p. cm.
 Includes index.
 ISBN 0-240-80374-4 (pbk. : alk. paper)
 1. Storyboards. 2. Commercial art—Vocational guidance—United States. I. Title.
 NC1002.S85 S56 2000
 791.43'0233—dc21 99-043777

British Library Cataloguing-in-Publication Data
A catalogue record for this book is available from the British Library.

The publisher offers special discounts on bulk orders of this book.
For information, please contact:
Manager of Special Sales
Butterworth–Heinemann
225 Wildwood Avenue
Woburn, MA 01801-2041
Tel: 781-904-2500
Fax: 781-904-2620

For information on all Focal Press publications available, contact our World Wide Web home page at: http://www.focalpress.com

10 9 8 7 6 5 4 3

Printed in the United States of America

CONTENTS

ACKNOWLEDGMENTS

I would like to thank my editors Marie Lee, Terri Jadick, and Maura Kelly. They have been not only incredibly responsive, but also a collaborative joy.

I would also like to thank all the people who have submitted samples of their work for inclusion in my book. In a book about graphics, it would be boring without any samples. A number of software companies were also incredibly helpful in sending me samples of their software for inclusion in this book. Every person and company is listed at the end of my acknowledgments with information on how to contact them. Each of them, by going the extra yard and pulling together not only their work but also getting the all-too-hard-to-get release forms, have proven their value in our industry and deserve patronage (hint, hint).

The producers and directors I interviewed are not only great people with whom to work, but they are also close friends. I thank you all: Nina Elias Bamberger, David Nixon, and Jesus Trevino.

And to the artists whom I interviewed and who participated in the coolest storyboard experiment ever done, you've helped future generations of artists more than you can imagine. Thank you for your help Joseph Scott, Mark Moore, Chris Allard, Keith Sintay, Willie Castro, and Steve Shortridge, and Dan Antkowiak, my long-time assistant.

The writers who lent their work to these exercises prove that every great work starts with the written word. Thank you Jenni Gold, Wayne Carter, Troy Schmidt, and my lovely wife, Jeanne Pappas Simon.

Over the last couple of years, my assistants have been extremely helpful in tracking down all the information and people in this book. Your help allowed me a few hours of sleep each night: Dan Antkowiak, Bill George, and Jason Teate.

To my parents who taught me I could do anything, I love you both.

And of course my wife, Jeanne. You allowed me to spend far too many nights finishing this book late at night, and you continue to support me through all of my crazy ideas. You are my life. You are also the miracle-maker in creating our children, Reece and Luke. I love you.

Patronize these people and companies. (I love being subtle.)

Macromedia
Flash
Internet animation software
800-457-1774

Human Software
Squizz!
Image-manipulation software
408-399-0057
www.humansoftware.com

Keith Sintay
Artist/Animator
818-834-7325

Jeanne Pappas Simon
Writer
407-370-2673

Jenni Gold
Gold Productions
Writer/Director
407-380-3456

Troy Schmidt
Writer
iamtodd@aol.com

Chris Allard
Storyboard Artist
617-964-9062

Wayne Carter
Writer
awc54@aol.com

Willie Castro
Laser Storyboard Artist/Animator
407-859-8166
www.av-imagineering.com

Steve Shortridge
Storyboard Artist
423-232-5191

EPL Productions, Inc.
Film, video, special effects, computer animation,
 game development
1100 Hali Ridge Ct.
Kissimmee, FL 34747
407-397-1770

Dan Antkowiak
818-679-8236
storyboards@aol.com

Thomas Miller
Liquid Digital Illustrations
423-928-8090
digisaur@preferred.com

Jesus Trevino
Director
323-258-0802

Klasky Csupo
Animation Production
Storyboard Artists:
Steve Ressel
Cathy Malkasian
Jeff McGrath
Paul Demeyer
323-463-0145

Black Belt Systems
WinImage
Image manipulation and morphing software
13 Turning Wheel
Glasgow, MT 59230
800-888-3979
www.blackbelt.com

Stage Tools
Bill Ferster
OnStage!
Previsualization software
540-592-7001
www.stagetools.com

David Nixon
David Nixon Productions
Commercials, industrials
407-352-5259

Kai
SuperGoo
Image manipulation software
805-566-6200

PowerProduction Software
StoryBoard QUICK ARTIST
StoryBoard Artist
Preproduction and animatic software
800-457-0383

Sunbow Entertainment
Animation Production
100 Fifth Avenue
New York, NY 10011
212-886-4900

And, of course, if you need to get a hold of yours truly to offer me the next Spielberg picture, I can be reached at:

Mark Simon
Animatics & Storyboards, Inc.
Storyboards, animatics, character design, After Effects, animation production
407-370-2673
www.storyboards-east.com

CHAPTER 1

INTRODUCTION

The storyboard is an illustrated view, like a comic book, of how the producer or director envisions the final edited version of a production to look. This view of the production is the most effective form of communication between the producer or director and the rest of the crew. Just as building plans direct construction crews to build a house the way an architect designed it, storyboards direct film and TV crews to produce a project the way the director designed it. Each drawing instantly relates all of the most important information of each shot and defines a singular look for the entire crew to achieve.

Storyboards actually started in the animation industry. In the early 1900s, the great animator Winsor McCay was creating comic strips for his amazing animations. These were certainly some of the earliest storyboards. Later, in the late 1920s and early 1930s, scripts for the emerging animation field were typed out in the format of live-action scripts. This very quickly caused complications. A written description of an animated action does not necessarily get the right idea across. If the script said a character had a funny expression on its face, what does that mean? It's easy to write the words "funny expression" or "funny action," but animating a character to achieve it is much more difficult. The animators were finding out that a written gag was often not funny when translated into animation.

To remedy this, the "storymen" (there were no women in the story departments back then) began to draw sketches of the salient scenes and gags. Very quickly they started adding more and more drawings to their scripts until it became customary to sketch the entire story. In order for the entire story-writing team to see the sketches, they were tacked up on the wall. Someone had the bright idea of putting these sketches onto large pieces of beaverboard (thus the term "storyboard"). Beaverboard was used extensively for partitions and ceilings, and it is a lightweight, fibrous board that is easy to push tacks into. This was advantageous for the storymen, who were tacking up hundreds of drawings. With the drawings on such boards, the entire story could also be moved and viewed in another room.

Animations at the time started holding written descriptions down to a minimum. Writing was limited mostly to dialogue and simple camera instructions. If an idea did not hold up graphically, it was rejected.

Storyboards are now used to help develop a script, flesh out an idea, enhance a script, and/or visualize a finished script. Development of animations often use storyboards throughout the entire production process. The *Star Wars* epics used storyboards to work out ideas and scenes before the script was complete. They are a

great device to help develop a project in all phases of production.

Over the years, the practice of storyboarding has become more prevalent in live-action shooting. Although animations have every scene storyboarded without exception, live action storyboard use is mostly limited to commercials, as well as action, stunts, and special effects scenes in movies and TV shows.

A well-done set of boards is beautifully representative of any visual motion, like a comic book; the images flow together to tell a story. The line work may be somewhat rough, or it may be very tight and detailed, but what is important is properly visualizing the flow of the story.

You've heard that "A picture is worth a thousand words." In the entertainment industry, a picture is worth much more than a thousand dollars. When people read a script, everybody gets a different image of what it should look like. The producer and the director, however, are the ones who make the final decision. Without a set of boards to represent exactly how they want a scene to look, any number of things can go wrong. Statements might be heard on the set like, "Oh, that's what you meant," or "What are you doing?!!! That is NOT what I asked for!!" If everyone is working towards the same vision, miscommunications such as these will not happen.

In the golden years of animation, in the days of Chuck Jones, Tex Avery, Bob Clampett, Friz Freleng, and Walter Lantz, the directors drew most of their own storyboards. As animation studios grew, tasks were delegated to others. Only recently has the trend of directors doing their own storyboarding begun to grow again. Some of the newer animators, such as John Kricfalusi of *Ren and Stimpy* fame, feel that it's important for cartoon writer/directors to draw their own boards.

He feels that it's important for stories to be written by cartoonists who not only can write; they can draw. Cartoons are not just funny writing, they are funny images and sight gags. Cartoonists know the capabilities and limitations of the medium and can best take advantage of it. Writing alone can't do this. Cartoons are best when they do the physically impossible and deal with exaggeration.

Live-action storyboards are generally done in pre-production, as soon as a script is in its final stages. Storyboard artists will work mostly with a director to illustrate the images in his or her mind for the entire crew to see. At times they may work with a producer, if the producer's vision is the guiding force in a project, or prior to a director signing onto a project.

The other person a storyboard artist is likely to work with is the production designer. The production designer holds the creative vision of a project regarding everything behind the actors, including not only sets and locations, but also props and, at times, costuming. The look of the sets and locations will be extremely important to the character's action. A storyboard artist may help out with the look of a project in a number of different ways. The production designer will supply the artist with all the visual information needed. Storyboard artists may also be asked to draw conceptual illustrations of what the sets or locations should look like before detailed designs and construction starts.

The people running a low-budget production may think they are saving money by not using boards, but quite the opposite is true. The lower the budget, the more organized the production has to be in order to accomplish the difficult task at hand. Any misunderstandings or bad communications can throw the already too-tight schedule out the window. The more a project is boarded, the better the preproduction will

FIGURE 1.1 *Winslow* boards by Keith Sintay.

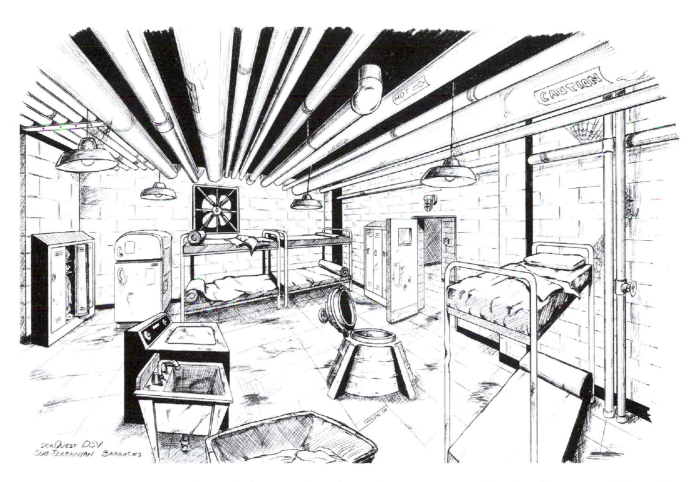

FIGURE 1.2 *seaQuest DSV*. Rendering of subterranean barracks. Production Designer: Vaughan Edwards. Artist: Mark Simon. (© by Universal City Studios, Inc. Courtesy of MCA Publishing Rights, a Division of MCA, Inc.)

be, the less overbuilding of sets and props will happen, and the faster the crew will move in unison to get all the coverage in shots. Instead of shooting every angle for possible edits, every edit is shown on the boards, cutting the extra cost of film and processing, as well as the labor expense of shooting excess footage and wading through miles of useless film in the editing suite.

For example, I storyboarded a number of scenes on a shoot for Chuck E. Cheese pizzerias. This shoot used a walk-about, a character suit of Chuck E. that someone walks around in, instead of animation. After looking at the boards, production decided that they wanted the walk-about to have a different hairstyle for one segment. Deciding this with the storyboards was much cheaper than having realized it while an entire crew stood around waiting for a puppet's hair to be changed.

Drawing storyboards is a wonderfully exciting and creative outlet. A storyboard artist is crucial in both the flow of a story and in the organization of a shoot. Good storyboarding requires knowledge of directing, editing, storytelling, and camera techniques. Add artistic talent and the ability to work with others to tell a visual story, and you too may enjoy illustrating in the exciting world of entertainment.

For producers, directors, and other crew people who don't draw, knowledge of storyboarding is just as important, for it will enhance your ability to communicate with your crew and in the end help you tell a better story and run a better production.

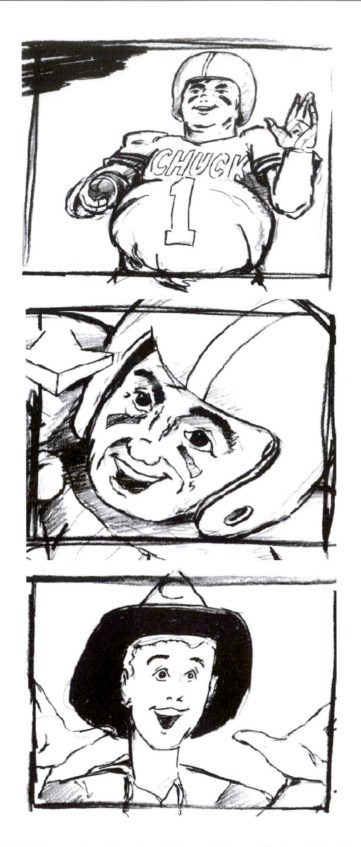

FIGURE 1.3 *Jonathan's Town* boards by Mark Simon. (© 4friends Prod., Inc.)

PART ONE

THE BUSINESS OF STORYBOARDING

CHAPTER 2

GETTING STARTED

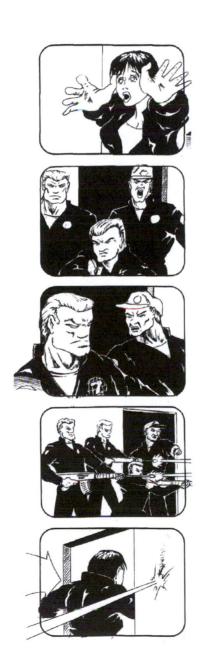

FIGURE 2.1 *seaQuest DSV* boards by Mark Simon. (© by Universal City Studios, Inc. Courtesy of MCA Publishing Rights, a Division of MCA, Inc.)

The knowledge of storyboarding is important for everyone who has to communicate and understand visuals in production. You do not have to be able to draw well to produce functional storyboards, although lacking such ability may limit your chances of making a career out of it. A director sketching quick boards for the DP (director of photography) does not need quality art to get the point across. Production people simply need to be able to read storyboards to understand and make use of this great production resource.

If you are interested in pursuing storyboarding as a career, the first step in becoming a storyboard artist is understanding what storyboards are and how a storyboard artist works. Since you are reading this book, you're taking the right first step. As important as the ability to draw is, it's not the most important aspect of storyboarding. Storyboards with bad art can still be good storyboards, but storyboards without the story are just art, not storyboards. Even great artists tend to produce poor art at times when the production deadlines are too short. As David Lux, the storyboard artist on *Beethoven II*, says,

> There are guys who have ten times the drawing ability I have, amazing artists. But I will run rings around them when it comes to finding the shots. I feel that I have the directorial sense to find out where the drama is and where the camera wants to be. (*Orlando Sentinel*, September 17, 1993, by Laurie Halpern Benenson)

You also need to learn about directing and editing, and you need to learn to sketch the human form quickly. Many directors got their start as storyboard artists, such as Alfred Hitchcock, Joe Johnston (who directed *The Rocketeer*, *Jumanji*, *Honey I Shrunk The Kids*), and others. You will be called on to help solve content problems, flesh out action sequences, and direct scenes on your boards as well as fill out the director's vision.

Next, you will need to be able to draw. There are many great books and classes that can teach you how to draw. I'll show you some helpful hints for the drawing process, but I'll leave basic instruction to others. This book, however, will teach you how to be a better, and more successful, storyboard artist.

During your search for that elusive first job, you will need to send out résumés and prepare a portfolio for any meetings. Of course to send out résumés, you need to know who to contact for work. Once you find out who to contact, you need to know what those prospective employers will want to see. One source of the answers to these questions is this book.

Another source of information about storyboards is your local professional storyboard artist. Most artists are more than willing to talk with other artists, so it never hurts to ask. The easiest way to find storyboard artists is to ask around in your local film community, or you can look in the local production directory, which can be found at the chamber of commerce or film commission for your area.

For those of you who are experienced storyboard artists, it's never too late to get started on improving both your boards and your professionalism. If you get just one good idea from this book, it will have been worth it.

FIGURE 2.2 Redrawn boards from *The Disciples*, by Mark Simon.

CHAPTER 3

RÉSUMÉS

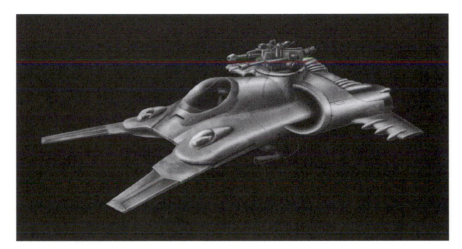

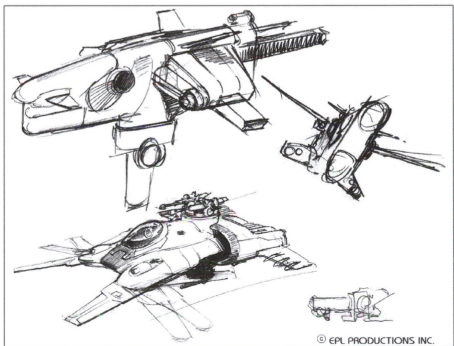

FIGURE 3.1 STRATOS-FEAR
fighter craft concepts. (© EPL
Productions, Inc.)

Your résumé is likely to be the first impression prospective clients will get about you and your work. You never get a second chance to make a first impression. The contents and organization I suggest you use on your résumé for the entertainment industry are likely to be quite different from the way you learned to create a résumé in school. What you don't say about yourself is as important as what you do say and how you say it. The likelihood of your getting a call for work from your résumé is highly dependent on a number of things.

First of all, you need to make sure your résumé contains nothing that doesn't relate to the job for which you're applying. Items such as age, height, hobbies, and marital status should never be on a résumé. You don't want to look like an amateur. For better or worse, impressions have a lot to do with whether or not you get hired. Why take a chance that something on your résumé might leave a negative impression?

Age is an issue best not brought up. If you're young, an employer might think you don't have enough experience. If you are older, they might feel a job is not challenging enough for you. Don't let this become an issue. Other pieces of information may indicate your age, and you need to be aware of them. If you list education at all (not a necessity in this industry), any graduation date is nearly as telling as your birth date.

Your purpose is to get a job with your résumé, not in spite of it. Below are do's and don'ts for résumés and short explanations of each.

Eighteen Common Résumé Mistakes

1. *Listing unrelated job positions.* You may have been a headwaiter, but that has no relevance to your ability to be a storyboard artist. If you were a set PA (production assistant), and feel you need to show knowledge of the industry, you can include some backup information in a secondary section of your résumé, such as Related Information or Related Experience.

2. *Including age or reference dates.* Dates are never helpful. Employers will immediately figure your age and that may work for or against you. Job dates are also problematic. Generally they are misleading, and someone may look at scattered dates and wonder why you didn't work very long at any one job or why you had so long off between projects. Without reference dates, these issues never come up.

 The length of time on a job can also work against you. For instance, I did the storyboards and some character design on the movie, *The Waterboy. The Waterboy* was the number one movie of the 1998 fall season. Most people probably assume I worked on it for three to five months. Their minds fill in the perfect amount of time. I only worked on it for three days. If I put that amount of time down on my résumé, it would only work against me.

3. *Including unrelated personal information.* Height or race has nothing to do with your abilities. Your professional qualifications should be the only criteria for whether or not you get an interview.

4. *Using the term "Objective."* Professionals don't have an objective, they offer a service now. Use of that term shows you are fresh out of school and have no experience to offer them. Place your job title boldly at the top so there is no question as to what you are looking to do for an employer.

5. *Explaining a position instead of using the job title.* Anyone in a position of hiring you knows what the job is. Explaining it gives the impression you have no idea what you are doing.

6. *Putting your name and title in lowercase or a small font.* Résumés have to stand out and demand the attention of an employer. If your title is hard to see immediately, it could easily be looked over and discarded. Lowercase fonts have the tendency to give the impression of being meek.

7. *Listing unrelated hobbies.* No one cares what your hobbies are unless they relate directly to your job function. If you spend weekends drawing caricatures at the local fair, that's relevant. If you like to play racquetball, that's not relevant.

8. *Having too many pages.* The only people who should have more than one page are those with a tremendous background. You will have no reason to use more than one page for your résumé during your first few years in the business. If you're just trying to fill up space, it will look like it. Employers are not easily fooled. You also don't need to list every job you've done, list only those that are the most impressive.

9. *Not listing relevant information.* Give yourself every chance you can. If you have relevant skills that others don't, employers need to know about it. If you are bilingual, list it. If you've won relevant awards, list them.

10. *Listing reasons for leaving jobs.* Any reason just sounds like you're making up excuses. Every job ends in this industry; it's expected and never questioned unless you bring it up. Having an excuse makes it look like you were fired.

11. *Putting education at the top.* Whatever is at the top of your résumé is most important. Experience should be most important. Putting education first says you have no experience.

12. *List only education from a highly regarded source.* Education is never as important as experience. (I can say this because I have both.) Education rarely means anything in this field. Certain producers do tend to hire from their alma maters, so education may be helpful, but it is best kept to a minimum, or at least to the end of your résumé.

13. *Making updates or corrections by hand is incredibly amateurish.* This tells an employer he is not worth your time to print a new résumé. With computers, this should never be an issue.

14. *Using overly detailed descriptions.* A résumé should be short and to the point. A glance should tell an employer everything she needs to know. A glance is often all your résumé will get.

15. *Supplying reference letters before being asked for them.* Cold-call résumés with reference letters are too bulky to look at and make the applicant look desperate. Since this industry does thrive on contacts, you can list the important contacts from each project on your résumé. If the employer recognizes some names, it may help, but keep contacts to names and positions, not comments.

16. *Misspelling the names of the recipient or company.* This shows a lack of regard and professionalism. Call ahead if you're not sure of a spelling.

17. *Taking credit for more than you should.* If you were just assisting a storyboard artist, don't say you were the storyboard artist. This will always come back to bite you.

18. *Having an unreadable résumé.* Many résumés are almost unreadable because the copies are so bad or the print is too small. Some may be off-center or have information marked off. This looks amateurish.

Eight Ways to Enhance Your Résumé

1. Use humor (if you're comfortable with it).
2. Use a single-page presentation.
3. Put your name, phone number, and position in bold at the top.
4. Show experience to back up the position for which you're applying.
5. Include related affiliations (unions, guilds, associations).
6. Include related awards.
7. Have clean and easy to read copies.
8. List pertinent education only if from a highly respected university in the field.

FIGURE 3.2 Easy chair commercial storyboards by Mark Simon.

CHAPTER 4

PORTFOLIOS

Storyboard employers will want to see samples of your storyboarding work before you get hired. Everyone knows that production storyboards are not always the nicest looking artwork and that the quality of the drawings is only a small portion of the importance of good storyboards, but employers will still want to see quality art. Good art is what sells in an interview. You need to present your best stuff.

Experienced storyboard artists need to customize their portfolio for each new client to match her needs. Make sure you keep copies of every project you do so you have samples to show.

FIGURE 4.1 STORYBOARD BY DAN ANTKOWIAK.

But what if you don't have any examples to show prospective employers? "How do I get experience without having examples to show that I can storyboard?" you may ask. Here's an easy solution. Don't wait until you are offered a storyboarding job (it may be a looooong wait) to draw storyboards; start drawing them now.

There are four quick and easy ways to build an initial storyboard portfolio before you get hired onto professional projects. These tips were given to me by a storyboarding agent in Los Angeles to help me get started.

1. Write a short action sequence of your own and "board it out" (industry talk meaning to do the storyboards).
2. Take an action sequence from someone else's writing and board it out.
3. Look at an existing project, like your favorite action movie, and draw out a scene.
4. Volunteer to draw the storyboards on a low-budget or student project.

Once you put some samples together you need to get feedback on your portfolio before you start interviewing. When you start showing your boards to people resist the urge to explain each shot. Your boards should be self-explanatory. If questions arise about what is happening, you should try to figure out how to enhance your boards to make them more understandable. Remember, it's your job to make the viewer understand your drawings; it's not anyone else's job to read your mind or solve the problems in your art.

If you are showing your portfolio around and you notice you have to explain why some boards are not as good as others, get rid of them. You should only show your best, and you don't need that many to prove your worth. You can get by with as few as three sample sequences, and each sequence can be as short as eight to ten frames. Don't make them too long; clients and employers want to get through samples quickly.

I emphasize drawing a sample "action sequence" over static sequences because visually it is the most interesting and will grab people's attention. Try to keep most of your sequences down to eight to twenty panels. This will make it easy to scan a complete scene quickly. Individual drawings out of context, on the other hand, don't get across your ability to tell a story visually.

Any storyboards you draw can be shown as examples of your own work. Be careful presenting any

FIGURE 4.2 STORYBOARDS by Alex Saviuk.

sequences you board out based on projects you didn't work on; you don't want it to look like you're stealing someone else's professional credit. If it wasn't a commissioned job, it shouldn't go on a résumé. If you work on a job for free, it is considered a commissioned job. Work you aren't paid for shows your skills just as well as compensated work.

Student films are a great training ground. You will get experience drawing boards and working with directors as well. If you're lucky, you may also run into a promising young director who will go on to work on bigger projects and bring you with him. This is how many people's careers develop, by moving up the ladder with friends. Even professionals will often lend a hand to student films during slow times in hopes of making more connections with other professionals and up-and-comers. You never know who you'll meet on a student film, especially in Los Angeles or New York.

Make sure you include sketches and less finished work in your portfolio. Clients want to see that you can work quickly. Anyone can labor over a piece and make it look good, but in storyboards, time is of the essence.

You should also customize your portfolio, if possible, for each interview. If you're interviewing with a client who does commercials, try to have commercial samples in the front of your portfolio. If you're going to an animation studio, show animation boards. Producers and directors want to see samples of your work that are as close as possible to their current project. It's often a crapshoot, but the more you know going into an interview, the less of a gamble it is.

While knowing what the client is looking for helps, it may not always be enough. I had a potential client once who called and asked for samples of superhero-style storyboards. I sent over sample action sequences from *McHale's Navy*, *seaQuest DSV*, and others. They called back and asked for other samples that showed more extreme angles with live-action superheros. I tried to explain to them that none of my clients had asked for the exact style they were looking for, but that my other boards showed a keen grasp of action and storytelling. This client could not understand that and hired someone else. That's like not being hired because I had never used a certain color in my art. It may not seem fair, but it is how the industry functions sometimes.

Every new project you work on, whether for yourself or a client, can be a newer, better portfolio piece.

FIGURE 4.3 Conceptual storyboards for arcade game *Behind Enemy Lines*. (© EPL Productions, Inc.)

CHAPTER 5

EDUCATION AND SKILLS

There is no training ground better than experience. One pitfall to watch for is jumping into a project that's over your head and losing potential future business because you didn't know what you were doing. There are very few places that teach live-action storyboarding, and those that do often only offer it sporadically. Most animation schools teach storyboarding. Whether you prefer animation or live action, you can benefit from learning animation storyboards. There are other ways to learn storyboarding from different sources, however.

In recent years more live-action production schools have been offering classes on storyboards, though they are still few and far between. Students are partly to blame. Most live-action film students want to be directors and only want to go out there and direct; they don't want to take the time to properly plan a scene. They often don't want to learn about or pay attention to the benefits of preproduction. Schools are also to blame because they far too often don't explain how important preproduction is to their students. We're missing the chicken and the egg in this equation. Knowledge of storyboarding isn't just important for artists—it's important for all filmmakers.

To save yourself a lot of frustration, you should know how to draw the human form very well. Drawing well is not a necessity for drawing functional boards, but is important if you want to get paid well for them. The first thing anyone sees of your storyboarding work is the quality of your drawing.

Life drawing classes are extremely helpful. Drawing live models is better than drawing from photos. You get a better feel for the roundness of the human body. It is also important to learn the skeletal and muscular systems of the body. By knowing the skeleton, you will know how a body can bend and how to move it. Knowing the muscles allows you to pose your figure and add dimension to it. When you draw a person wearing clothes, the body under the clothes determines how the clothes should fold and drape to look realistic. If you are not in school, you may be able to find an extension course at a local school or life drawing classes offered by community art stores and associations. Disney offers, and insists upon, continuing classes for all of their artists. That is one of the many reasons that Disney artists are regarded as the best.

You can also study life drawing in other ways. You can sketch your family, and you can go to the mall or the zoo and sketch people there. Since storyboards generally portray the human form in motion, you should practice drawing people in action when possible. Drawing people while they're moving helps you sketch

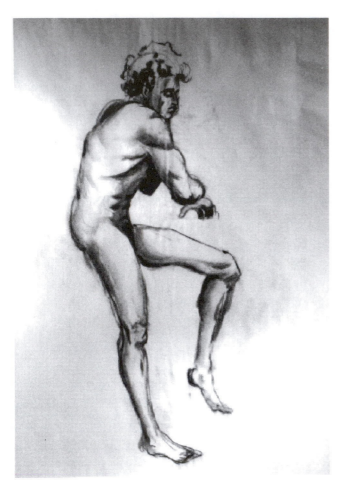

FIGURE 5.1 Life drawing in charcoal by Mark Simon.

quickly and capture motion in your art. You can ask your significant other to pose for you. If need be, you can also practice by working from photos in books or magazines. Videos can also work as a reference.

You will also need to have schooling in perspective rendering. Storyboard artists should be able to quickly sketch backgrounds and objects in perspective. As Mark Moore, an Industrial Light & Magic (ILM) illustrator, says, "Try drawing the [*Star Trek*] U.S.S. Enterprise from every conceivable angle."

Nina Elias Bamberger, executive producer of CTW's (Children's Television Network) *Dragon Tales, Big Bag,* and other animations, suggests that watching television and studying animations, both new and old, are some of the best training animation storyboard artists can get. She also suggests that artists produce animatics, edited video of storyboards, of their storyboards to see how they work in sequence and if the

visual story is well told. Software and computers are inexpensive enough these days that producing animatics is fairly easy and economical. Programs such as *Adobe After Effects, Storyboard Artist,* Macromedia's *Director,* or *OnStage!* are all easy to learn and can be used to produce quality animatics that can play back on a computer.

Besides an education in drawing, I also recommend a few courses in filmmaking, even for animators. Try to get into at least one course that has as much hands-on filmmaking as possible. Not only is it more fun, but you will get a better feel for how to properly build the action in a scene if you are shooting and editing your own shorts. It will also help to have a background, formal or informal, in the history of film. Classic storytelling techniques still work. Steven Spielberg is a master at using classic film techniques in his movies. You will also find that when directors describe a scene, they often refer to another movie or TV show.

A great way to study filmmaking, special effects design, and the industry as a whole is by viewing special edition DVDs and "The Making of . . . " videos with audio tracks by the filmmakers. Instead of listening to others describe why they *think* someone designed a shot or a scene a certain way, you can listen to the directors, producers, and designers tell you themselves. Many DVDs offer one or more additional audio tracks that allow the viewers to watch a movie and listen to the filmmakers talk about their films shot by shot. This could very well be the best way to study film and directing.

You should also try to work on a set. Get a job as a set PA (production assistant) on as many shoots as you can. Pay attention to how the director works and how she describes each scene and each shot. Nothing can beat being able to draw upon hands-on experience. Besides understanding action, understanding the terminology is also important. While you will learn a lot of terms in this book, nothing beats working with all the terms in context. If possible, follow a project through the editing stage. (Sit quietly in the back.) Editing is where all the shots start to make sense and where some poorly planned scenes can be salvaged.

When you're ready to start getting your first storyboarding jobs, look to film schools. You can offer your services to student filmmakers at no cost, to give yourself some experience working with directors and gain some credits. You do not need to be enrolled in a school to help on student films. Many professionals in Los Angeles help out on USC and UCLA student films when work is slow. You never know who you'll meet or what contacts you'll generate.

A useful education in storyboarding doesn't have to take place at a school, but you can take advantage of a number of opportunities in school. Most of what you learn is up to you to learn on your own, regardless of any formal education. Chapter 52, "Schools Offering Storyboarding," lists a number of schools that teach storyboarding as classes or as part of their film and animation curriculums.

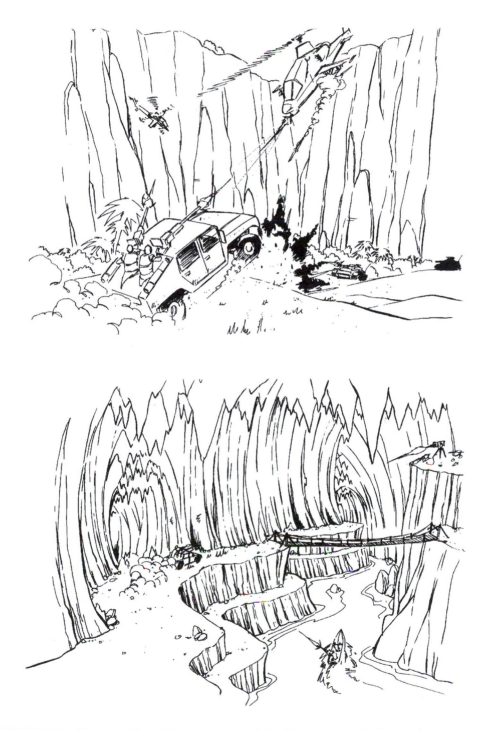

FIGURE 5.2 Conceptual boards for arcade game *Behind Enemy Lines*. (© EPL Productions, Inc.)

CHAPTER 6

MATERIALS

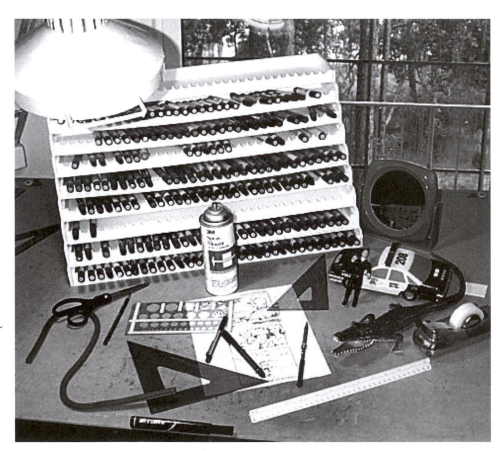

FIGURE 6.1 Miscellaneous supplies on author Mark Simon's desk at Animatics & Storyboards, Inc. Notice the toys and small mirror used for reference. The marker stand was handmade with foam core to accommodate all the markers.

The essential materials needed for a storyboard artist are few, but the list gets longer as you enhance the quality and detail of your work. A number of these materials are simply a matter of personal preference.

The materials a storyboard artist is likely to use are:

Pencils (mechanical, non-repro, Ebony, etc.)	Computer, graphics programs, and printer
Pens	Scale ruler
Markers	Straight edges
Charcoal	French curves
Colored pencils	Eraser shield
Pastels	Mirror
White Conte or China marker	Reference books and objects
Plain or Bristol paper	Templates
Preprinted storyboard templates	Erasers (kneaded, pink, gum, electric)
Light table	Compass
Brushes	Contracts
Ink	Copier
Cameras (Polaroid, film, digital, video)	Frisket (repositionable masking film)
White-out or white ink	Airbrush
Toothbrush	Glue stick or spray mount
	X-acto knife or scissors

There is no one correct way to draw storyboards as long as the client is happy with the end result. Different artists use different types of paper, pencils, pens, and so on. There are a number of things to keep in mind when using different materials.

Some artists use regular pencils, and others use mechanical pencils; some use nonreproducible blue pencils and ink over them, and others draw in charcoal. Each method gives different results. I use a mechanical pencil with 2B leads. This is because you never have to sharpen a mechanical pencil and the 2B leads are extremely dark. I don't ink my boards (except when coloring in a large black area) because it takes too long. The 2B lead is picked up very well by a copying machine. I let the machine do my inking for me. There are some cautions to using a soft 2B lead. Some copying machines drag the lead across the page when you use the automatic document feeder. Always test it first. The same will happen with charcoal.

Many Disney layout and storyboard artists use blue or black charcoal for their drawings. Mark Moore of ILM uses blue pencil first, then markers; he then copies the art and finishes with other markers, white pencil, and white out. Others use different mediums depending on what type of project they're working on. Chris Allard uses pencil if he's doing humorous work, "to keep the energy alive," as he puts it, or he uses ink for dramatic boards to get the shadows.

Kneaded erasers are great on light-stock papers and tend not to mar them. They also erase pastels. Electric erasers and shields allow you to erase around objects and to erase pinstripe lines.

Colored markers are used for some presentational boards along with pastels and colored pencils. Airbrush and markers are a favorite in the advertising world. The airbrush markers have become a quick way to simulate a real airbrush, but the markers dry out much faster.

White ink, Conte, and China markers are used for highlighting. The toothbrush can be used to spatter a field of stars onto your work with the white ink. Many artists now use paint programs on their computers for all their coloring.

Every artist has a favorite type of paper to work on. I use regular typing paper. I like the texture it has, and it runs easily through copiers. I use my computer and *CorelDraw* to design and print my own custom forms

FIGURE 6.2 An eraser shield.

for each job. Bristol board, a very heavy art paper, holds up better, but you can't run it through copier feeders. It also gets expensive and takes up a lot of space when the average twenty-one-minute animation is 200 to 300 pages long. The preprinted forms you can buy at art stores can be nice looking, but the large black areas often designed as the negative space on the forms don't reproduce well.

You will need a scale ruler and French curves when you are drawing backgrounds and sets for a project. You may also need a computer to help.

A mirror allows you to use your own hands and face for reference. I use multiple mirrors to see myself from different angles. You can also use books and magazines for reference.

I use the light table when I need to trace over my own boards or a background I want to use and don't have the time to draw freehand.

The knife and scissors are for replacement panels. There will be times when you have to add, change, or delete frames from your boards.

I like to give clients the copies of my boards. This prevents them from accidentally smearing the originals in copiers. I also like to hold onto the originals in case there are some last-minute changes; then I don't have to redraw an entire frame, I can just erase what I need to fix. I have my own copier to save the time of running back and forth to the copier place. Time is money. I have the Xerox 5320 with a top feeder and 8 1/2 × 11 paper up to 11 × 17 paper. It reduces and enlarges to 50 percent and 200 percent, respectively. This is handy when converting scaled images. I have found that my images have the best copied quality when the machine is set on Standard contrast, not auto, and is one setting darker than the midpoint. The standard contrast copies the pencil lines much darker and less detail is lost.

You may find that you work best with a totally different set of tools. That's great. The most necessary tool is storytelling talent.

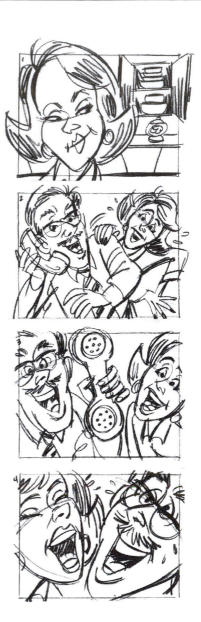

FIGURE 6.3 Storyboards by Chris Allard. Rough pencil boards for Ocean Spray's Craisins commercial.

CHAPTER 7

HOW I GOT STARTED

I had been art directing for a couple of years and I wanted to start storyboarding as well. I had played around with it but I didn't know the specifics. I went to see a storyboard agent in Los Angeles to get some pointers. He was incredibly helpful. He explained to me how to charge for boards. He looked at some of my work and gave me some suggestions on my live-action boards, such as "Make it look less cartoony." He suggested that for practice I look at a commercial or take a scene from a feature film and storyboard it. He told me to make sure that the scene had action in it. He then said he would be happy to look at my work again. I took him up on his promise. I boarded out several scenes from movies and commercials. I also made up my own short action sequences to draw. I spent months doing this.

Once I felt strongly about my boards, I approached the executive producer on an HBO series, *1st & 10,* that I was working on as construction coordinator. I showed him my work, the practice boards I had done for the agent, and told him I would love to do any boards that the show might need. He asked to keep a few samples (always be ready to leave samples) and whether I had done any of these for pay. He was smart; most people never ask that question. I was truthful, and said with a cracking voice, "No."

About three weeks later, he asked me if I was interested in boarding some scenes for an upcoming episode. I was at his office in a flash. He showed me the script and said that it lacked the scariness that it needed and asked if I could make it more frightening and still have some humor in it. Without really knowing how I said, "Sure," and thought I would figure it out later. He told me that the director didn't know about the boards I was about to draw and he wanted to keep it that way. He asked me what I would charge. I told him a certain dollar amount per panel, a rate much cheaper than the norm. He responded, "Since this is your first job storyboarding, I'll make you a deal. I'll give you half of that. If the director likes them and decides to use them, I'll give you twice what you asked for." Even though that may have sounded like a scam, I trusted him and agreed to the deal.

That night I asked my fiancée, now my wife Jeanne, to help me figure out how to make those scenes scary. We watched a couple of scary programs on TV to see what made them that way. We then rewrote the scenes. From our rewrites I sat down and started boarding them out. I tried to take into account all of the cinematic tricks of the trade: extreme close-ups, figures hidden in the dark, shock, and surprise.

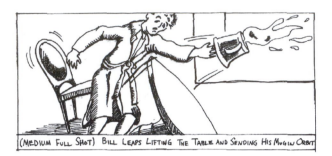 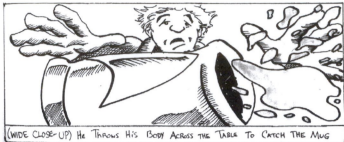

(MEDIUM FULL SHOT) BILL LEAPS LIFTING THE TABLE AND SENDING HIS MUG IN ORBIT

(WIDE CLOSE-UP) HE THROWS HIS BODY ACROSS THE TABLE TO CATCH THE MUG

FIGURE 7.1 STORYBOARDS BY STEVE SHORTRIDGE.

I met with the executive producer twice during my drawing of the boards and he gave me a number of great suggestions based on what I presented him. The whole project ended up being over seventy panels. The following week he gave a copy of the boards to the director. The director loved them and used a lot of our ideas in the shooting a few weeks later. The executive producer was good on his word and paid me double what I had originally asked. The best part of all was that I now had at least one professional job behind me on a popular show as a storyboard artist.

The best way for you to get started is the same way I did. Draw samples boards. They could be based on a TV show, commercial, or movie, or from a book, play, or even your own story. Think visually about your scenes and ask for opinions from someone who would know about good storyboards. Not only is this good practice, but you are proving to potential clients that you have the drive necessary to follow through on any boarding project. You could offer free storyboards to student filmmakers. This will give you practice working with directors and start your portfolio. Telling someone you can draw storyboards isn't good enough; you have to prove it.

FIGURE 7.2 COMMERCIAL STORYBOARDS BY MARK SIMON.

CHAPTER 8

BENEFITS TO PRODUCTION

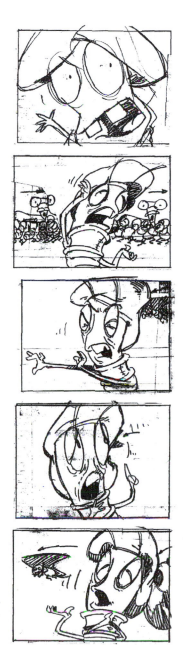

FIGURE 8.1 *SANTO BUGITO* STORY-boards by Klasky Csupo. NOTICE THE ACTING SHOWN IN THE boards.

Time. Money. Communication. These are powerful words in the entertainment industry. Far too often a production will opt not to pay for storyboards. This is being penny wise and pound foolish. Developing and using storyboards solves production problems, saves time and money, and can be used for testing an idea early on.

In animation, the benefits are not only plentiful, they're unavoidable. Nina Elias Bamberger, executive producer for CTW (Children's Television Workshop) animation, says

Storyboards are the blueprint for the series. They convey the emotions; they convey the creative direction of the series. Since often times, like in Dragon Tales, *we ship to several studios in order to get the work done on time. The storyboards are what will guarantee uniformity throughout the series and its quality control. And it also gives the producers the opportunity to fine-tune what they want the series to look like before it's out of their hands for a while.*

Storyboards also help break down the language barrier between countries.

One major benefactor of live-action storyboards is the director. Developing storyboards with an artist forces the director to fully visualize the script. When the artist is doing breakdowns, lists of needed camera shots, it also presents directors with options that they may not have considered. The storyboards become a visual shot list. Directors may actually mark off each drawing as the shooting proceeds to make sure they get every shot.

Storyboards also help with continuity. Screen direction, the direction in which a character or object is moving across the screen, is very important in all scenes, but it is the hardest to control in action and special effects scenes. Successive cuts may be shot on different days or even different weeks. It's hard to keep track of screen direction when different elements of the same scene are shot so far apart. Boards act as a blueprint for each shot and limit potential problems with screen direction.

The director may also use the storyboards to explain their direction to an actor and the cameraman. It is always easier to show someone what you want, rather than just explain it.

There is a tremendous amount of work that needs to be done on a set at any given time, and there are never enough hours in the day to accomplish it. With a full set of storyboards, the production manager will be better able to schedule the shoot. There will be less chance of cost overruns when the shoot is scheduled properly.

When a scene is boarded and the crew heads have those boards, there are fewer needless questions asked and less time wasted. When the crew can see the director's vision prior to shooting, they are better able to anticipate what is needed—and the shooting will proceed faster and more smoothly because of it. The faster the crew works, the less the production will cost. Time is money.

Film is money too. When each shot is planned in advance with boards, the director and the director of photography are able to shoot less coverage. In other words, they are able to shoot only the exact shots needed to cover the scene, and they don't necessarily have to shoot the entire scene from multiple angles. The boards will also help them plan complex camera moves.

When a designer reads a script and sees a new set, he feels the need to build the entire four walls of the set in case the director wants to shoot in different directions. When a scene is fully boarded, the designer may find out that only one section of a set is needed, thus saving time and money in construction and set dressing. Of course, the designer may also use the storyboard artist to do a conceptual rendering of a set for approval by production before construction starts.

Projects with lots of effects and stunts constantly have production problems coming up as different elements of each shot raise their heads. With storyboards,

FIGURE 8.2 Redrawn storyboard from Fox's TV movie, *Wilde Life,* by Mark Simon. This location had to be dressed, decorated with palms and branches, and have a tree removed for the jeep to fly off the road.

these problems may be fleshed out early while there is still time to deal with and design it properly. Often, different elements in a single special effects shot may be shot months apart. These shots need to be planned completely so that the shot will work correctly and will fit in with the flow of the story and the final edit. The storyboards can break down these shots into their different elements so that each crew—first unit (the director and lead actors), second unit (often a separate director shooting stunts and cut-aways without the main actors), and special effects—is working in conjunction with one another.

Every time stunt coordinators or special effects people budget for a stunt or effect, they pad their bid (make the bid more expensive) in preparation for the unexpected. Without storyboards, stunts or effects could be designed differently from what the director is looking for. With storyboards, the look can match the director's vision, each element may be designed down to its minute details, and a more exact budget can be worked out. Stunt and effects people often hire storyboard artists on their own so that they can use the boards as part of the contract specifying exactly what elements are included in their bid.

When advertising agencies are pitching an idea for a commercial to a client, they usually use storyboards to carry the visuals of the presentation. These generally are done in color and do not include every shot, just enough information to get the idea across.

Large corporations also use storyboards to present marketing ideas to the decision-makers. These may be simple sketches or vibrant color illustrations.

Storyboards may also be used to test the viability of a finished commercial product without the great expense of shooting it. These drawings are shot on video and edited together just like a live shoot. This footage is then dubbed with music and voices. This is called an animatic. The animatic may then be shown to test groups around the country.

Productions benefit from boards in many ways. They may cost money in preproduction, but that cost is much less than the hidden expenses caused by a lack of proper planning or any miscommunication.

FIGURE 8.3 COMMERCIAL PRESENTATION boards by Alex Saviuk and Mark Simon. HUMOROUS COMMERCIAL PRESENTATION boards for a MAYORAL RACE. CLIENT: CHERNOFF/ SILVER & ASSOC.

CHAPTER 9

WHO HIRES STORYBOARD ARTISTS

If you want to draw boards for a living, you need to know who to approach for work. Not every business of the types listed below will use boards, but many of them will. Some don't want to spend the money, some do roughs themselves, others have no idea how helpful boards really are, and some make great use of storyboards. You should let them all know what you offer, either for that one time or for the many times when they do need boards.

There are more storyboarding opportunities available than most people realize. The following list should provide you with enough information to find storyboard clients in most cities.

24 Types of Storyboard Clients

1.	Advertising Agencies	13.	Producers
2.	Commercial Production Houses	14.	Directors
3.	Industrial Production Houses	15.	Production Managers
4.	Documentary Filmmakers	16.	Laser Show Design Houses
5.	Live Event Designers	17.	Television Series
6.	Convention Services	18.	Music Videos
7.	Cel Animation Houses	19.	Special Effects Houses
8.	Animatics Houses	20.	Stunt Coordinators
9.	Computer Animation Houses	21.	Theme Park Designers
10.	Film Production Companies	22.	Interactive and Gaming Companies
11.	Local Affiliate Stations	23.	Web Design Companies
12.	Art Directors	24.	In-House Marketing Division of a Large Corporation

Let's look briefly at why each of these potential clients might need boards.

ADVERTISING AGENCIES

Ad agencies will need boards to show clients what proposed commercials will look like for their approval before shooting. They also will use them as guidelines for bids from production companies. Creative directors and art buyers are the people in agencies who call on storyboard artists.

FIGURE 9.1 COMMERCIAL PRESENTATION STORYBOARDS BY MARK SIMON AND DAN ANTKOWIAK. CLIENT: CHERNOFF/ SILVER & ASSOC.

COMMERCIAL PRODUCTION HOUSES

Once the production house gets the job from a client or an ad agency, the director will often want his own shooting boards, instead of using the agency boards. These will be much more detailed than the agency boards and the director will probably add his or her own visual signature. Commercials have the highest budget per second of airtime, and they probably use boards more than any other type of production, with the exception of animation. Because the images fly by so fast, they need to be very organized to make sure that the idea is properly presented. There may be thirty panels for a thirty-second spot. Some commercials have even more than one image per second.

INDUSTRIAL PRODUCTION HOUSES

The ultra-low budgets of industrial films make preproduction planning a must. Again, the boards would be used to present the idea to the client. It also helps the crew be much more efficient. These days a lot of postproduction effects and computer graphics are used to enhance the look of these productions, and storyboards will help to develop each.

DOCUMENTARY FILMMAKERS

Documentary filmmakers will use boards not only to present to a client, but to get financing. At times a documentary needs to recreate some event in great detail. Boards may be used to work out the details.

LIVE EVENT DESIGNERS

Like most of us, these designers have bosses that have to approve things. Your boards are what they would use to get that approval, whether from the city, the client, the amusement park, or whomever. Boards are also often used along with the designs to help in the bidding. The boards may also show what the people attending an event would see.

CONVENTION SERVICES

Convention services have basically the same need as event designers. Boards will be more like production drawings, showing the layouts of the facility and how the convention traffic will flow.

ANIMATION HOUSES

For cel animation—classic hand-drawn animation—houses, animation is boarded out completely for every shot. The animators use boards as a blueprint from which to animate. Each storyboard panel should represent the key frames. (A key frame is each portion of a motion of a character or object in the animation.) Animation boards show not only the action, but also the acting. Up to 600 panels for a seven-minute animation may be needed.

ANIMATICS HOUSES

An animatic is basically a video storyboard, or a freeze-frame style of animation shot to illustrate an expensive commercial or interactive show. The actual animatic is usually highly rendered in full color with some camera moves introduced. Boards will be used to determine the full color renderings and how the camera moves will work. A client may spend as much as $30,000 to $50,000 to have an animatic done to test the concept for a commercial or TV pilot. As high as this testing cost may seem, it's a bargain compared to wasting many times that or more shooting a concept that may not work. Expensive game shows may have an animatic made instead of spending over $100,000 for large sets and props for a pilot. The animatics are edited in with whatever live action was shot, and the final product is used for demographic testing. Some animatics are cheaper than others; it depends on the length and complexity of the project. Many animatics are produced using only the storyboard art.

FIGURE 9.2 FRAMES FROM A PRESENTATION ANIMATIC TO VILLAGE ROADSHOW THEATERS. THE PRESENTATION SHOWED HOW TO MAKE THE ENTIRE MOVIEGOING EXPERIENCE A PRODUCTION. PRESENTATION BY SOUNDELUX, ANIMATIC PRODUCED BY ANIMATICS & STORYBOARDS, INC.

COMPUTER ANIMATION HOUSES

Boards illustrate for the client how the project will look before expensive computer time is used. Story, continuity, and acting are also illustrated, just as in cel animation.

FILM PRODUCTION COMPANIES

Feature films use storyboards to work out production problems and detail special effects and stunt shots. There is generally no need for more detail than finished pencil. Some segments may call for more detail than others, but quite often the time available is not enough to allow for time-consuming boards to be drawn. What matters most is portraying a visually exciting series of images that will get across the story information that the director wants. Certain panels of a storyboard may be drawn out as a production rendering, a larger drawing using more detail and color for use in presentations, construction, and effects.

LOCAL AFFILIATE STATIONS

Normally local affiliate stations have an art department that handles all their needs. Special reports, news openings, and any show produced from within may need boards. They also produce low-budget commercials that may need boards for approval and shooting.

ART DIRECTORS

Many art directors can't draw or don't have time to draw storyboards on projects. When boards are needed on a project, art directors are often the ones approached to draw them or to find someone who can.

PRODUCERS

Producers will use boards to illustrate their vision of what the finished project should look like to show to a production crew or a director. The boards may also be used as part of a pitch to sell an idea. Even when a producer is not working directly with the artist, she will usually be the one to give the final OK on whom to hire.

DIRECTORS

Directors will call for boards when they see difficult shots in the schedule. On commercials, directors will often want the agency's boards redone with their exact vision. Some directors have their favorite artists travel with them.

FIGURE 9.3 LASER SHOW STORYBOARDS BY WILLIE CASTRO FOR AVI, AUDIO VISUAL IMAGINEERING. NOTICE THE SIMPLE LINE WORK NEEDED FOR LASERS TO REPRODUCE.

PRODUCTION MANAGERS

If producers or directors do not have their own storyboard artists available, they will have the production manager find them one.

LASER SHOW DESIGN HOUSES

Laser shows are composed of laser images that are often animated to move in time with music. Those images and how they are manipulated need to be planned out with a set of boards.

TELEVISION SERIES

As in films, if there is action or FX (special effects), producers and directors may want boards to work it out. Sometimes the openings are boarded. I boarded the first opening for Nickelodeon's *Clarissa Explains It All* to provide the technicians who were doing the camera moves and FX with a visual of the creator's idea. Amblin's *seaQuest DSV, The Cape,* and *Second Noah* all used storyboards for special effects and stunt scenes.

MUSIC VIDEOS

Most music videos won't have enough of a budget for boards, but some do. Those with wild FX and sets may use boards.

SPECIAL EFFECTS HOUSES

Often a production chooses an effects house before all the boards are done. During production, the effects house will generate many of the boards needed for the shots they have contracted, either as part of their bid or as a way to develop their shots. The effects house may board out their own vision of a shot and send it to the director for approval or notes.

STUNT COORDINATORS

Generally the production provides stunt coordinators with finished boards for bidding and shooting. When stunt coordinators aren't given boards and they need to develop boards themselves, you want them to know who to call.

FIGURE 9.4 PRESENTATION ART FOR CHARACTERS IN A THEME PARK RIDE. ART BY MARK SIMON.

THEME PARK DESIGNERS

Theme parks have videos to entertain patrons in their queue lines. Queue lines are the long lines patrons hate to stand in while waiting for a ride. These videos are often boarded out. Some theme parks also put on shows for certain times of the year. Universal Studios Florida uses boards for events such as Halloween Horror Nights and the making of their haunted house. The boards for a haunted house may show the perspective of a patron going through it. A new ride may also be storyboarded. The designers may board out the entire experience, from standing in line to sitting on the ride, and exiting out the retail area, to show the client what they are planning on doing.

INTERACTIVE AND GAMING COMPANIES

Interactive games and videos are becoming one of the hottest commodities around. They are extremely complex in their design. For each action a player chooses there may be any number of responses the computer will make. Every action needs to be fully planned. Storyboards are perfect for use in planning these actions and reactions.

FIGURE 9.5 STORYBOARD PANEL FOR ARCADE GAME, *Behind Enemy Lines*. (© EPL PRODUCTIONS, INC.)

IN-HOUSE MARKETING

Many major companies design and produce all their commercials and marketing videos in-house. Their marketing departments need storyboards for presentations as well as production.

WEB DESIGN

Websites are big multimedia files that need to be organized. Web animations, like *Shockwave, Flash, GIF,*

and others, need to be planned and approved just like any other type of animation. It's beneficial to know how these animation programs work in order to properly storyboard for them. *Flash,* for example, is a popular vector-based, as opposed to pixel-based, animation program that allows many more animated options than classic cel animation or *GIF* animations. Knowledge of *Flash* is the only way to know how to storyboard for it.

CHAPTER 10

HOW PRODUCTIONS WORK

FIGURE 10.1 Commercial presentation storyboard for a mayoral race. Storyboards by Alex Saviuk and Mark Simon of Animatics & Storyboards, Inc. Client: Chernoff/ Silver & Assoc.

Every production, director, and producer will work with storyboard artists differently. It will help you to understand how different situations may work. Here are the basic situations you are most likely to run into.

COMMERCIAL EXAMPLE #1

The production company, or advertising agency, is bidding on a job for a client. They have an idea but need to present it to the client. They approach you to draw the boards according to their vision. These presentation boards will be larger than most production boards and will likely be in color. This will give them a graphic pre-

sentation of their pitch. You may get the call for this late on a Tuesday, for example, and they are likely to need the art by Friday morning. You should charge by the panel.

COMMERCIAL EXAMPLE #2

An advertising agency has chosen a production company to shoot the commercial for them. They have a set of presentation or "agency" boards that were used to sell the idea to the client. The director on the project looks at them to get a general idea of what the client is looking for and starts to do her own shot

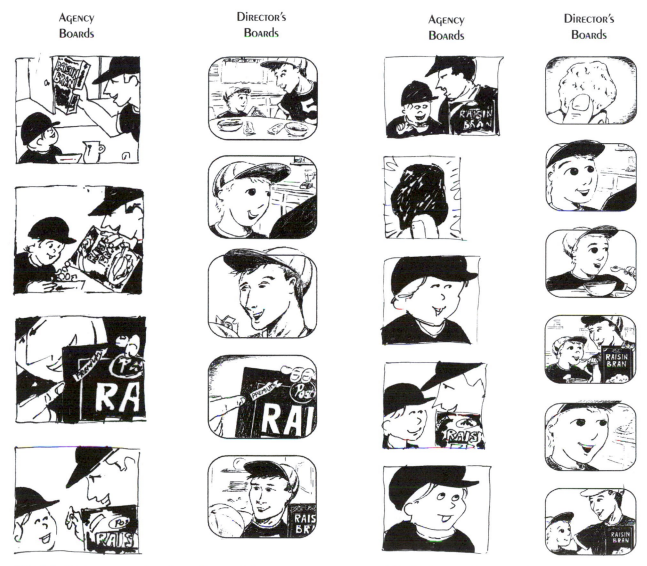

FIGURE 10.2A AGENCY BOARDS VS. DIRECTOR'S BOARDS.

FIGURE 10.2B DIRECTOR'S BOARDS VS. AGENCY BOARDS.

breakdowns. The director sits down with you, her shot list, and the agency boards and may explain how her shots differ from the agency boards and what extra shots she wants to see. These will be the director's boards, which are given to the crew and used by the production. If this production is in a different city than the one you live in, they may fly you in, put you up in a hotel, and give you a per diem (a daily rate to live on) of $30 to $50 a day. You will charge by the day or the week, and since they provide you with the place to work and your supplies, you are considered an employee and they own the art. Make sure you keep copies for your portfolio.

David Nixon, a commercial director, describes the problems with agency boards.

> *A lot of times with agencies they like to do a computer board, where they have taken a real life image and they've just adapted it some way. And it doesn't really have much excitement to it other than it's a real life image. But the problem is that it shows no flow.*

The previous sample is a comparison of actual agency presentation boards and the director's production boards that I drew. Since I don't have permission to use the actual agency boards, I have reproduced them myself. I have tried to give the exact same feel and quality of the agency boards to accurately represent the differences. Notice in the director's boards how some of the shots have changed, how some shots were added, and how subtle some of the changes are. While some presentation boards are highly rendered, some, as you see on the previous page, are poorly drawn.

ACTION EXAMPLE #1

The producer brings you in and explains the look he wants on this project. He hands you a script and details a sequence that he wants boarded out. You leave and do some thumbnails of what you think the action should look like. You and the producer get together again to go over your ideas and revise and refine them. You finish drawing the final boards on your own, and then the producer gives them to his director or uses them to budget the cost of doing that sequence. You will probably charge by the panel unless it's a long project, and then you may charge by the day or week. This is exactly how a project at HBO went for me, as I detailed earlier in Chapter 7, "How I Got Started."

ACTION EXAMPLE #2

The director of a project calls you in to help with some action sequences. She has a clear-cut idea of how she wants it to look. The two of you flesh out her idea in thumbnails; at the same time you are offering her advice on the flow of the scene. She okays your thumbnails as you discuss each shot. During your meeting the director may show you sample clips from other movies she is emulating. You go away for a few days and finish the boards. You charge by the board on a short project or charge for your time on a longer one.

GRAPHICS LOGO ANIMATION EXAMPLE

A computer graphics company has a project to produce for a client. Time on the computer system is very expensive, so to flesh out what the client wants they ask you to sit in on the meetings to board out everything first. If they want to animate a logo, your boards present not only how the shots should look but also how all of the elements work together. The computer graphics company shows these boards to the client for approval. Once everyone agrees on the look the computer artists can start laying out the needed elements. You have given the graphics company a direction to go without needlessly and expensively spending excess time on expensive CGI equipment (computer graphics). You charge them per panel.

ANIMATION EXAMPLE

You are working on a short seven-minute animation. You're hired for a flat fee for the episode that you're doing. The episode is eleven minutes long and it should take you about three weeks. The production company sends you the script, the forms to draw on, sometimes the rough audio of the actors, and any visual references you need. Props, characters, and backgrounds are generally designed before you get the board. You should get director's notes, but not always. You will send your roughs to the storyboard supervisor who will make notes and tell you what to change. You need to send in the final boards by the deadline given to you. On the Nickelodeon animation, *The Brothers Flub*, we were able to work from the audiotapes. A number of the sequences were recorded with different attitudes than we had imagined from the script, which of course made a difference in the visuals. We never received any director's notes or talked with a director. Our artist on that project was chosen because his style matched the style of the cartoon.

SC. 113 BG. 50 166

SC. 114 BG. WL 167

SC. 115 BG. 50 168

SC. 116 BG. WL 169

SC. 117 BG. 51 170

FIGURE 10.3 *BROTHERS FLUB* STORYBOARDS BY WOLVERTON of ANIMATICS & STORYBOARDS, INC. (© SUNBOW ENTERTAINMENT.)

PRODUCTION EXAMPLE #1

You are in the art department, in any position, of a project that needs boards. You are the only one in the department experienced at drawing boards. You get the job, but there is a very good chance you will not get paid extra, unless you draw the storyboards outside your time at work (they are already paying you for your time, regardless of what you do with it). In any case, your portfolio now has another new piece. You don't get paid anything extra and they own the art.

PRODUCTION EXAMPLE #2

You are a staff member on a series. You are the story-board artist. You also do the conceptuals—concept illustrations of sets and locations. The show schedule dictates a new show is to be shot every seven days. That means you have seven days of prep for the next show. It takes a day or two for the location scouts to find possible locations. You go with the director, producer, production designer, and others to see each location. You go over possible scenes with the director at each location and you take reference photos for your boards. By the fourth day of prep the director knows what he wants and you sit down and take notes. This is the same time the production designer has thumbnail sketches for the sets for that show and wants you to render them. You need to juggle both jobs and get them done quickly. The boards are rough but accurate. You need to finish the scenes that will shoot first. You finish the last scenes two days into shooting. It is now time to start going on location scouts for the next episode with the next director. This will go on for about nine months, the average run of a TV season. You are being paid by the week and the production owns the original art you draw as well as all rights to it. This is work for hire; you are an employee. Check with the production coordinator and make sure that you are on the crew list and that they have all of your correct information. The crew list is used to assemble the credits (which you want) and is the way the crew can reach you for other projects. This is how my stint as the storyboard artist on Amblin's *seaQuest DSV* went. I worked for nine months on the show and drew everything from boards, to new ships, to props, and wardrobe. We had a different director every week and I learned different things from each of them.

CHAPTER 11

WHAT PRODUCERS LOOK FOR

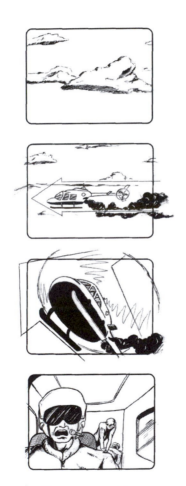

FIGURE 11.1 *seaQuest DSV* storyboards by Mark Simon. Notice how the action brings you in closer and closer. This is the opening sequence in an episode. (© by Universal City Studios, Inc. Courtesy of MCA Publishing Rights, a Division of MCA, Inc.)

There are a number of things a good producer will look at when trying to hire a storyboard artist. The way you present yourself, present your work, your ability to visually tell an exciting story, and your knowledge of the industry all play a part.

Producers usually hire storyboard artists with whom they have had good experiences. If they need to look for someone new they will ask their friends in the industry for referrals. A good reputation is the best advertising you can have.

When interviewing, the first thing that will catch a producer's eye while looking at a storyboard artist's work is not necessarily the most important—the quality of your art. Before others can tell whether or not you understand storytelling, direction, and editing, they will see how well you draw. You can't deny that good art alone can attract someone to your abilities. But if you lack the ability to work with a director or don't know how to move a story along, you won't last long as a storyboard artist. With presentation boards, unlike production boards, the quality of the art, layout, and design are what producers value.

When working with productions, producers understand that with the tight time constraints of production, you won't be drawing Mona Lisas for every frame. Storyboards tend to look rather rough during production. Be this as it may, producers still want to see quality work in your interview. The thinking here is that the better you are when you have some time to draw, the better your quick sketches will be. Your polished boards should still reflect the style of your quick boards; in other words, don't spend a week detailing five panels for your portfolio when your boards will never look anything close to that.

Good professional credits go a long way in this industry. If you apply for a job and you have a top credit to your name, you stand a good chance of beating out someone who might draw better than you do but who has no credits. Having good credits lets people assume that you have the knowledge and experience from that project, which may benefit their project.

Film and TV are artistic mediums of motion. Good storyboards need to portray that motion as well as possible. When someone is reading through storyboards they should be taken on a visual trip through the story, knowing if the camera is moving or if actions take more than one drawing to represent. You should draw as many panels as it takes to demonstrate what is happening. Don't be afraid to draw more panels. Motion in your art can be portrayed with the quality of the drawing itself, but it can be better understood with direc-

tional arrows. The arrows can tell the viewer what is moving and if it's moving within the frame, through the frame, or directly at camera. Arrows are fully discussed later in this book.

The professionalism you show in both the interview and on the job means a great deal. This has nothing to do with the way you dress on the job, since we all tend to wear shorts and jeans. Professionalism refers to the way you handle yourself when dealing with the production, such as whether you offer constructive suggestions, get along with directors, or how you present your artwork. In the interview that means having a neat and clean portfolio with professional looking storyboards in it, not a bunch of sketches thrown into a zippered bag and strewn across a desk. The way you present your business knowledge is important too. If you go into an interview and have no idea what to charge for your services, you will look like an amateur. If you state how you like to work and what your rate per panel is, chances are you will get it. I am very seldom asked to cut my rate. You will also need to be able to speak intelligently about what you do. Producers may ask about how you work, your experience in dealing with special effects, or about other aspects of your past projects. Your answers will tell her whether you have enough knowledge of storyboarding to help the production or not.

Television director Jesus Treviño agrees that production experience is beneficial. He adds, "be familiar with the lenses. I think something like that can be very helpful to a storyboard artist because, ultimately, after the storyboard is done, someone is going to have to translate that into lens sizes and camera position and make it happen." Although he does add this caution: "I think that a storyboard artist needs to be sensitive interpersonally to making the director feel comfortable about their participation. I think the worse thing a storyboard artist can do is to come in and start telling him how to shoot the sequence."

In animation, producers look for many of the same aspects that live-action producers look for, but they also need to act as if they are the actor in a scene with their art. Nina Elias Bamberger, producer for Children's Television Workshop (CTW), says,

I look for creativity. I don't really care if the characters are drawn perfectly, but you have to be able to really read the emotion in their faces. I look for movement in the storyboards. I look for if they know when to hit a close-up if something is emotional, how to show humor, and how to keep the story moving.

FIGURE 11.2 *Santo Bugito* storyboards by Klasky Csupo. Acting, instead of action, is represented here. (© Klasky Csupo.)

It's also important to take criticism well. Remember, your job is to capture the director's vision, not to push your own vision. Producers want to work with artists who are easy to work with and noncombative. When you deliver your boards, they should be presented nicely on clean, unwrinkled paper.

The most important but often overlooked aspect of boards is how well they communicate an overall series of events or actions. This aspect is sometimes over-looked because it takes someone looking at the overall work not just the individual panels. Your drawings need to tell a visual, moving story in such a way that any crew member will understand what is happening. A good producer will look at your storyboards to see if they do this.

Knowledge of the industry, integrity, and good storytelling will help you more in becoming a successful storyboard artist than the quality of your art.

CHAPTER 12

PRICING

FIGURE 12.1 Color presentation storyboards by Mark Simon for David Nixon Productions. Aerial camera move showcases location of condo complex. The problem was that there was no building yet. The helicopter move had to be composited with a miniature move on the model of the building.

Artists, like many other professionals, often undervalue their work and seldom know enough about rights and licensing. This is not a good situation for two reasons: one, you may deserve a better income if you know how to price your work; and two, you can keep yourself from getting in trouble by not accidentally using or selling art or trademarked characters that someone else owns.

There are four principal ways to charge for storyboarding.

1. By the panel
2. By the hour
3. By the day
4. By the week

If you are charging by the panel, you need to make clear how the number of panels is determined. You don't charge for the time you spend in meetings when you charge per panel. I count the total panels like this:

The total count of finished boards delivered to production, plus:

The number of boards changed by the production through no fault of mine.

If there is a change in the boards because I misunderstood, there will be no charge for the change.

Applicable expenses

Here is how I state it.

I charge $_____ per panel for preproduction rights. If you decide to change some panels because you came up with another or better idea, I charge for the new ones too. If I have to redo one because I misunderstood, there will be no extra charge. I will show you the thumbnails first to make sure that they are what you want. If I have to fax boards, make copies, take pictures of locations, etc., I will ask that you reimburse me for my expenses. Expenses include mileage if I have to drive somewhere to look at sets or locations. I don't charge mileage to meetings.

I feel this is quite fair, and they always do too. By taking care of all this business up front, there are no questions or problems.

To determine pricing rates, either ask a storyboard artist, someone in production familiar with storyboards, or a storyboard agent. There are very few of these agents, and they are listed in the *LA 411*, the Los Angeles production directory. Rates are listed in the *Handbook of Pricing and Ethical Guidelines*, Ninth Edition, published by the Graphic Artists Guild listed in Chapter 50, "Resources." Your rates will vary according to what city you work in, your expertise, and the

budget of the project. Low-budget productions pay the least and high-budget commercials pay the most.

As stated above, there are certain expenses that are reimbursable. Clients should be made aware beforehand if there may be any expenses that they will have to reimburse. On large projects you may want to write a letter that breaks down fees and probable expenses. If the client agrees to the terms, ask him to sign a copy. Agreements such as this are seldom needed or used in storyboarding. Nevertheless, reimbursable expenses may include:

- Models
- References books or magazines
- Reference props
- Location or model photos (film and processing)
- Travel and lodging to distant locations, not local meetings
- Special matting materials

The following charts show comparative fees for storyboard artists charging per panel. These rates are published in the *Handbook of Pricing and Ethical Guidelines*, Ninth Edition, from the Graphic Artists Guild. These rates do not reflect certain considerations, such as overtime and out-of-town work, and every negotiation is different when taking all the factors involved into account.

Working as a local means that you will work for a production and will provide for your own transportation, housing, and meals. Many production people will work as a local in more than one city to increase their chances of getting work. If a production pays to bring you out to a location or distant city, they will pay for your airfare (or mileage), your hotel, and a vehicle if necessary. They will also pay you a per diem amount, a cash amount per day you are on location to reimburse you for food and miscellaneous living expenses while you're away from home. Per diems range from $25 per day to $55 per day.

Storyboard artists rarely charge by the hour. When they do, the fees range from about $75 to $150 per hour.

Daily rates for storyboard artists are in the range of $500 to $650 per day in large markets for the top artists. Smaller markets may only afford $200 to $450 per day. Daily rates come up when an artist has to work on site for only a few days. In this situation, you are likely to be considered an employee rather than an independent contractor, and taxes will usually be deducted from your check.

Weekly rates vary greatly within each market and with each individual's experience. A storyboard artist is

likely to make between $750 and $2,000 per week. Again you are likely to be considered an employee in this situation. When you are on a weekly salary the production usually provides you with office space and all supplies. You should not have any financial burden at all for supplies, copies, or references. If you do, you should be reimbursed.

Generally speaking, the highest rates are paid in Los Angeles, New York, and Chicago. The smaller the market you're in the less you will be able to charge, but smaller markets often cost less to live in. Try to be aware of what a client can afford and charge accordingly. If you don't know, ask them. They may actually tell you what they can afford.

COMPARATIVE FEES FOR

Preproduction Illustration

Print Preproduction*

COMPS	LINE	TONE¹
Major campaign		
Spread	$150 - 600	$300 - 800
Full page	175 - 400	200 - 750
Small campaign		
Spread	$150 - 600	$200 - 800
Full page	100 - 300	125 - 500

* Comprehensive sketches for print advertising.

TV/Film Preproduction

ANIMATICS	PER FRAME*
TV advertising test marketing (30-second ad)	
5 x 7 (8 x 10 bleed)	$250
8 x 10 (11 x 14 bleed)	350
Moving parts	$50 - 200

* Frames consist of background and two figures.

Storyboards

TELEVISION ADVERTISING	LINE	TONE¹
Miniboards*	$25 - 40	$35 - 55
Telepads*	25 - 45	40 - 75
4 x 5	30 - 75	50 - 100
5 x 7	50 - 100	60 - 250
8 x 10 key frame	100 - 200	150 - 300
9 x 12 key frame	125 - 250	200 - 500

* Miniboards are approximately 1 x 1-¼ inches. Telepads are 2-¼ x 3-¼ inches.
¹ Tone may be color or black and white.

Television Programming

MAJOR PRODUCTION (OVER $5,000,000 BUDGET)*	LINE	TONE¹
4 x 5	$40 - 70	$50 - 85
5 x 7	50 - 90	75 - 125
Concept/key frame	100 - 120	150 - 300

MINOR PRODUCTION (UNDER $5,000,000 BUDGET)*		
4 x 5	$25 - 65	$35 - 80
5 x 7	85	100
Concept/key frame	100	120 - 500

* Per frame.

Film Storyboards*

MAJOR PRODUCTION (OVER $5,000,000 BUDGET)		
2 x 5	$40	$75
4 x 10	150	225
8 x 20	300	400

LIMITED PRODUCTION (UNDER $5,000,000 BUDGET)		
2 x 5	$35	$60
4 x 10	80	110
8 x 20	200	300

* Per frame.
¹ Tone may be color or black and white.

FIGURE 12.2 REPRODUCTION OF PAGE 121 IN GRAPHIC ARTISTS GUILD'S *Handbook of Pricing and Ethical Guidelines*, NINTH EDITION. ALL PRICES FOR ILLUSTRATION IN THE *Guidelines* ARE BASED ON A SURVEY OF GRAPHIC ARTISTS IN THE UNITED STATES AND CANADA THAT WAS REVIEWED BY A SPECIAL COMMITTEE OF EXPERIENCED PROFESSIONALS THROUGH THE GRAPHIC ARTISTS GUILD. THESE FIGURES, REFLECTING THE RESPONSES OF ESTABLISHED PROFESSIONALS, ARE MEANT AS A POINT OF REFERENCE ONLY AND DO NOT NECESSARILY REFLECT SUCH IMPORTANT FACTORS AS DEADLINES, JOB COMPLEXITY, REPUTATION AND EXPERIENCE OF A PARTICULAR ILLUSTRATOR, RESEARCH, TECHNIQUE, OR UNIQUE QUALITY OF EXPRESSION AND EXTRAORDINARY OR EXTENSIVE USE OF THE FINISHED ART. PLEASE REFER TO RELATED MATERIAL IN OTHER SECTIONS OF THE GRAPHIC ARTISTS GUILD'S *Handbook of Pricing and Ethical Guidelines*, NINTH EDITION, ESPECIALLY IN THE CHAPTERS ON "PRICING AND MARKETING ARTWORK" AND "STANDARD CONTRACTS AND BUSINESS TOOLS." THE PRICES SHOWN REPRESENT ONLY THE SPECIFIC USE FOR WHICH THE ILLUSTRATION IS INTENDED AND DO NOT NECESSARILY REFLECT ANY OF THE ABOVE CONSIDERATIONS. THE BUYER AND SELLER ARE FREE TO NEGOTIATE, WITH EACH ARTIST INDEPENDENTLY DECIDING HOW TO PRICE HIS OR HER ARTWORK AND TAKING INTO ACCOUNT ALL THE FACTORS INVOLVED. (COURTESY OF THE GRAPHIC ARTISTS GUILD.)

CHAPTER 13

LICENSING

A licensing agreement is written permission that the artist gives to a client for a specific use of the artwork for a predetermined price. Just because someone is paying for your art doesn't mean that he or she owns it. Artists have historically sold all rights for preproduction work. When I am working as an independent contractor, I state up front and confirm on my invoice that the fees I charge are for preproduction purposes only. I give clients one copy of my invoice and I have them sign and return a second copy for my records.

You should limit the rights to your art as much as possible, and you should retain ownership of the original artwork. The illustration industry standard is for the artist to retain the original art after its use, within thirty days. Production moves so fast, that it's easy to lose track of your art. Try to always keep your own copies of your boards while you're working.

FIGURE 13.1 Conceptual set design by Mark Simon of Animatics & Storyboards, Inc. I still own the design. No one may use this set design without paying my company a license fee for its use. This drawing may not be used in any marketing without a separate license fee.

Because storyboards are a piece of a collective work, the rights normally belong to the producing company when there is no contract stating rights, not the artist. The characters, the story, and the look are all owned by the production house, and the storyboard artist is simply manipulating these elements. Thus, although it's original art, it's not an original concept that the artist can own. While it is the industry standard for all the rights to be sold for preproduction art, it's not always necessary. You can state up front that the price you are quoting is for preproduction purposes only, that original art and all other rights belong to you. In other words, your drawings could not be used in advertising or in a book without your getting paid for them. Some larger companies may object. It will be up to you whether it will be a worthwhile fight for rights. You have to weigh upsetting or losing a client if they feel strongly about owning all the rights. It's not worth a big fight and losing a client. You are not likely to lose any future fees on production storyboards, since they are so specific for each project and have little use otherwise.

Whether or not you have a legal right to your artwork will depend on your legal relationship with the company for which you are doing the boards. It is important to know the difference between being an independent contractor versus being an employee, or being under a work-for-hire agreement. The Graphic Artists Guild is unalterably opposed to the use of work-for-hire agreements under which the artist is treated as an employee for copyright purposes only and receives no employee benefits.

If you are an employee, you are given a place to work and you are told when and where to work. Employees must be covered by the employer's worker's compensation insurance. This is a requirement by law. Should you be injured on the job, you may file claims for medical costs and disabilities. The employer must also withhold taxes from your checks. In this event the employer owns all rights to the work.

When you are an independent contractor, you determine your own working conditions and you are responsible for self-employment taxes. You may also have your own employer identification number. The employee/independent contractor laws are vague at best. It is best to have a signed agreement to determine license ownership. Many production companies prefer to treat people who should be considered employees as independent contractors because it saves them a lot of money in taxes. (It increases their labor budget line by around 15 percent).

Under a work-for-hire agreement, the copyright law gives the initial copyright to the artist's employer. Even in the absence of a written agreement or oral contract, the work-made-for-hire law may apply. The copyright law states:

> In the case of a work made for hire, the employer or other person for whom the work was prepared is considered the author (the word "author" has a broad meaning in the copyright law and can include "artist") for purposes of this title (the author is the initial copyright owner), and, unless the parties have expressly agreed otherwise in a written instrument signed by them (the employer or the person for whom the work was prepared) owns all of the rights comprised in the copyright.

There are two situations within the copyright law in which the term *work made for hire* exists.

1. "a work is prepared by an employee within the scope of his or her employment . . . "
2. "a work specially ordered or commissioned for use as a contribution to a collective work, as a part of a motion picture or other audiovisual work, as a translation, as a supplementary work, as a compilation, as an instructional text, as a test, as answer material for a test, or as an atlas, if the parties expressly agree in a written instrument signed by them that the work shall be considered a work made for hire."

The written agreement stated above is only valid if it is signed by both parties prior to the time when creation of the work begins. A work-made-for-hire agreement cannot be entered into after a work has been started. Some companies, such as *Playboy* in recent years, attach a work-made-for-hire statement on the back of checks giving the company all rights to the art when signed. These statements must be signed in order for the check to be cashed. This is *not* a valid contract, as proven by the *Playboy Enterprises Inc. vs. Dumas* case in California, as the contract on the back of the check was not signed before the work began.

For any works of art that you retain rights to, it is a good idea to include a copyright statement on each page of your drawings. It is not necessary since the requirement to inscribe the notice ended in 1988, but you have more rights when the copyright statement is present. Copyright is given from the moment of creation. The following is the description written by the Copyright Office at the Library of Congress regarding the form of copyright notice on visually perceptible copies (graphic artwork).

The notice for visually perceptible copies should contain the following three elements:

- The symbol © (the letter C in a circle), or the word "Copyright," or the abbreviation "Copr."; and
- The year of first publication of the work. In the case of compilations or derivative works incorporating previously published material, the year date of first publication of the compilation or derived work is sufficient. The year date may be omitted where a pictorial, graphic, or sculptural work, with accompanying textual matter, if any, is reproduced in or on greeting cards, postcards, stationery, jewelry, dolls, toys, or any useful articles; and
- The name of the owner of copyright in the work, or an abbreviation by which the name can be recognized, or a generally known alternative designation of the owner.

For Example, © 1982 John Doe. For more information and copyright forms, you can call 202-479-0700 or write to:

Register of Copyrights
Copyright Office
Library of Congress
Washington, DC 20559

For registration of graphic art ask for Form VA.

The Copyright Act of 1976, which became effective January 1, 1978, states the limits of copyrights as protection for artists and authors. This act states that any work of art is protected at the moment of its inception. The lack of a copyright notice does not negate your rights to a work of art. The only problem with not having the copyright notice on your work is that it becomes vulnerable to supposedly "innocent" copyright infringers who may claim they didn't know the work was protected. Since 1988, this is less of a worry. Legal registration of copyright allows artists to sue infringers.

Since storyboards are so specific in their purpose, and quite often are nothing more than quick sketches, licensing rights may not be a big issue. You need to make that determination for yourself. It is a good idea to start retaining rights to your art as a matter of setting a precedent. As you sell more art, it may become more valuable, and the sooner you claim a stake in your work, the easier it will be to make use of that value.

CHAPTER 14

TRADE PRACTICES

FIGURE 14.1 Poster based on storyboard frames from arcade game *Behind Enemy Lines*. (© EPL Productions, Inc.)

The following list of trade practices are commonly accepted as standards in the industry. This list is mostly from the Graphic Artists Guild's *Handbook of Pricing and Ethical Guidelines*, Ninth Edition.

1. The intended use of the art must be clearly stated in a contract, purchase order, or letter of agreement stating the price and terms of sale. This is seldom done with long-term clients prior to starting a job, but it should always be stated on the invoice.

2. Artists historically have sold all rights for pre-production work. Since this work is very product-specific, frames are almost never reusable. The higher fees available for this work have justified the loss of rights, although many art directors will return artwork for an artist's self-promotional use.

3. If artwork is to be used for other than its original purpose, the price is usually negotiated as soon as possible. The secondary use of an illustration may be of greater value than the primary use. Although there is no set formula for reuse fees, current surveys indicate that artists add a reuse fee ranging from 25 to 75 percent of the fee that would have been charged had the illustration originally been commissioned for the anticipated usage. This is seldom an issue with loose production boards, as they have little secondary value, and it's never an issue if you're an employee.

4. Illustrators should negotiate reuse arrangements with the original commissioning party with speed, efficiency, and all due respect to the client's position.

5. Return of original artwork to the artist is automatic unless otherwise negotiated.

6. Historically, artists have charged higher fees for rush work than those listed above, often by an additional 50 percent.

7. If a job is cancelled through no fault of the artist, historically, a cancellation fee is often charged. Depending upon the stage at which the job is terminated, the fee has covered all work done, including research time, sketches, billable expenses, and

FIGURE 14.1 Storyboards from *Santo Bugito*. Notice the dialogue action written under the panels to help production track what happens when. (© Klasky Csupo.)

compensation for lost opportunities resulting from an artist's refusing other offers to make time available for a specific commission. In addition, clients who put commissions "on hold" or withhold approval for commissions for longer than thirty days usually secure the assignment by paying a deposit. Only large agencies will usually consider a deposit.

8. Historically, a rejection fee has been agreed upon if the assignment is terminated because the preliminary or finished work is found not to be reasonable or satisfactory. The rejection fee for finished work has often been upwards of 50 percent of the full price, depending upon the reason for rejection and the complexity of the job. When the job is rejected at the sketch stage, current surveys indicate a fee of 30 to 60 percent of the original price is customary. This fee may be less for quick, rough sketches and more for highly rendered, time-consuming work.

9. Artists considering working on speculation ("spec") often assume all risks and should take these into consideration when offered such arrangements.

10. The Graphic Artists Guild is unalterably opposed to the use of work-for-hire contracts, in which authorship and all rights that go with it are transferred to the commissioning party and the independent artist is treated as an employee for copyright purposes only. The independent artist receives no employee benefits and loses the right to claim ownership or profit from future use of the work forever.

11. Expenses such as unusual props, costumes, model fees, travel costs, production costs, consultation time, and so on should be billed to the client separately. An expense estimate should be included in the original written agreement.

12. Animation producers want to see the entire script written under the storyboards so they and the animators can follow what is happening in the story.

13. Write any camera notes or effects under animation boards. Animation boards are the blueprint for the entire project and often times also act as translators when projects are animated overseas.

14. Checks on long-term jobs are usually paid every two weeks and freelance projects pay in thirty days. If you don't get a check after thirty-five days, call accounts payable to make sure they received your invoice.

CHAPTER 15

FORMAT

Boards are usually drawn in three ratios. A ratio is the relative proportion of the screen width to the screen height for a particular format. The three formats are Television, 35mm feature film, and 70mm feature film. There is a new wider format television that will be coming out over the next several years, HDTV. The HDTV (High Definition TV) wide format will also have the 16:9 ratio of 35mm, which will allow feature films to be shown properly in the letterbox format on standard TVs.

FIGURE 15.1 IMAGE OF CHARACTER WAS DRAWN FIRST AND THEN THE FRAMING WAS SKETCHED OVER IT. STORY-board by MARK SIMON. (© 4friends Prod., Inc.)

The ratio for TV is 4:3, for 35mm features it's 16:9, and for 70mm, or anamorphic, it's approximately 2.35:1. Anamorphic is an extremely wide shot that is compressed by a lens on the camera to fit onto a 35mm film frame. An anamorphic lens on the projector widens the shot to its intended width on the viewing screen.

Storyboard Ratios

Television = 4:3 or 1.33:1
35mm Film/ HDTV = 16:9 or 1.85:1
Standard Wide Screen in Europe = 1.66:1
Anamorphic = 2.35:1
70mm Film = 2.2:1

The standard frame sizes for television storyboards are:

Miniboards—less than 2 3/4″ × 3 3/4″
Telepads—2 3/4″ × 3 3/4″ (I usually use 3″ × 4″)
4 × 5
5 × 7
8 × 10
9 × 12

The standard animation frame sizes for TV are:

2 3/4″ × 3 3/4″
3 1/8″ × 4 1/4″

The standard frame sizes for films are:

2 × 5
4 × 10
8 × 20

These sizes are just for reference. Any size you and the client agree to is fine as long as the ratios are correct for the format of the project. I tend to use 3x4-inch boards for my television work. They stack vertically three to a page, leaving room for my logo on top and production notes to one side.

Clients usually prefer simple square boxes to outline your storyboard panels. While rounded corners may seem more pleasing, they are frowned upon. One reason is so that all storyboards match in shape when more than one artist works on a project. Another reason is that when a client cuts out the storyboard panels to paste up on a colored layout board, the rounded corners are needlessly time-consuming to cut out.

Following are samples of proper storyboard frame ratios. You can find, and copy, full-page storyboard forms in Chapter 51, "Forms." Some artists prefer not to use forms at all; they simply draw the illustration and then draw the frame over it, cropping the image where they feel it's best.

TV Frame – 4:3

35mm/ HDTV Frame – 16:9

CHAPTER 16

AGENTS AND ARTIST REPS

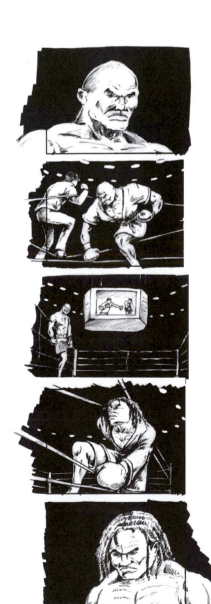

FIGURE 16.1 Commercial storyboard promoting a heavyweight fight. We did research on the Internet to find images of the fighters to draw from. Boards by Mark Simon of Animatics & Storyboards, Inc.

Are agents or artist representatives necessary? Yes and no. Part of the answer depends on the city where you live and work. Another part of the answer is how well you're able to market yourself to new productions.

Los Angeles is basically the only city that has agents specifically for storyboard artists—because it's virtually the only city with enough production being developed that agents are able to place enough clients to make a living. So if you don't live in Los Angeles, agents generally won't do you much good. A few other large cities may have production agents that take on storyboard clients as well as other industry positions. Ask a few production agents listed in your local film book whom you should talk to.

So you live in or move to Los Angeles and you want to decide whether or not to get an agent. How do you get one? What are the benefits? How much will it cost you?

Getting an agent isn't easy if you don't have much experience. In order for an agent to want to represent a client, that client has to be an easy sell to productions. Some agents are willing to take on an inexperienced artist and help train him or her. That's what happened with me. I found an agent who helped me over a period of about four months to develop my style and build a portfolio. Once my work became saleable, he started sending me out to productions.

To attract an agent, you need to present one with your current résumé and samples of your storyboards. A good agent will know immediately if they can sell you or not. Always call before you send samples and make sure you never send originals. Different agents handle seeing new potential clients in different ways.

There are five main benefits to having an agent:

1. *Marketing.* Good agents know how and where to market to potential productions. The agent will generally pick up the marketing costs for their clients' work. They should already have a good client base.

2. *Quality.* Productions know that agents prescreen artists for knowledge and ability. When a production calls an agent, they know any artist sent to them is bound to be good. You don't have to worry about selling yourself to productions; the agent has already done that for you.

3. *Opportunity.* Your agent should have more contacts in the industry than you do and thus, potentially, can bring you more work than you could have gotten on your own. As an added benefit, when a production wants another specific artist and that artist is busy, your name will likely be on the list as another choice.

4. *Negotiating.* Few artists enjoy negotiating rates and terms, although all of them should know how. An agent will handle negotiating your fee—probably for more than you could have, and for the terms of your employment and how you'll get paid. All you have to do is show up and do a great job.

5. *Consistent work.* A good agent can be marketing you while you're busy on a production. This means more money-earning days for you.

An agent will generally take between 15 percent and 30 percent of what the production pays for your position as a commission. While that may seem like a lot, a good agent should be able to keep you busier and get you more money than you would have been able to get on your own, thus your net income should be higher when using an agent.

In any contract you sign with an agent to represent you, probably the main item you need to be clear on is whether you are in an exclusive or a nonexclusive contract. Exclusive means that the agent takes a percentage of every project you work on whether she found you the job or not. Nonexclusive means that the agent takes a percentage of only the projects she finds or negotiates for you.

Artist reps are seldom called on for storyboard artists. The main reason is that storyboard art is a specialized field and productions will generally look only in trade film books or ask colleagues for experienced storyboard artists. While artist reps handle very talented artists, a good artist does not necessarily make a good storyboard artist.

Some artists are excellent at marketing themselves and can keep a steady flow of work coming through the door. If you can do this, you may not need an agent. Others won't have the option of getting an agent due to where they live or their lack of production experience. Finding an agent may not be easy, but many artists find they do fine without one.

CHAPTER 17

BUSINESS ASPECTS

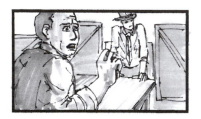

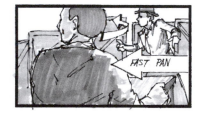

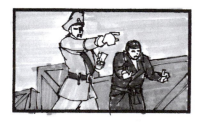

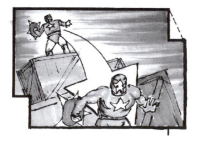

FIGURE 17.1 *Crusaders* storyboard by Dan Antkowiak.

Storyboarding is fun. Storyboarding is an essential part of the entertainment industry. Storyboarding is also a business. Like all businesses, it has to be handled professionally.

The business of storyboarding is no different than any other business, except you may enjoy it more. If you are the one hiring storyboard artists, understand that it's their livelihood and they deserve to make a living at it. To thoroughly go over every aspect of business would take an entire text, not to mention a college course. So if you haven't already, I would recommend taking a course in business. Even so, I will briefly highlight the main business aspects of storyboarding for a living.

MARKETING

Make sure you know how to advertise what you do to your potential clients. You may be the best in the world, but if no one knows you, it won't do you any good. You can get around knowing marketing if you have a good agent or work full time at a production or animation studio.

RÉSUMÉ AND PORTFOLIO

Résumés and portfolios were discussed in Chapters 3 and 4, respectively. Once you get an interview, you need to be able to prove what you can do. What you show is what the client will expect, for good or for bad. If you show some messy samples and have excuses for it, your client will expect to receive messy work.

PROFESSIONAL

Present yourself just like any other successful business. Have a good letterhead and business cards. Everything you present to your clients should be neat, clean, and professional.

CREDIT

Make sure you get a proper screen credit and that you are listed on the production crew list. Most productions

have a crew list, a list with every crew member's name, position, and phone number. This serves as a great reference for anyone trying to find crew people they have previously worked with. If you are listed in the crew list, you have a good chance of getting your proper screen credit. Many television shows don't have enough time to run a full credit list, so most storyboard artists don't see their names on the screen. Most feature films should list every crew member.

ATTITUDE

Present yourself properly in an interview and during a job. Dress is usually casual in this industry, but at least be neat and clean. This may seem like a no-brainer, but I have seen many an artist show up looking pretty "nasty."

When you're working with a production, show up on time and be a benefit to the process. Don't be combative about the art or the idea. The goal is to capture what the director wants to see and to offer suggestions.

PRICING

Know what your art is worth. The two main questions you'll be asked before starting a job are "What's your availability?" and "What's your rate?" There are many ways to price storyboards for different projects, as described in Chapter 12. Know them. Pricing too high may knock you out of the race, and pricing too low may make you seem like an amateur (it happened to me once)—not to mention making it hard to make a living. If you're going to charge for expenses, make that clear to the client up front. No one likes surprises on the bill.

TRADE PRACTICES

Make sure you know what is expected of you and the client knows what your terms are. Before you start, establish with your client when a project is due, when you should get paid, where you're expected to be and when, when you may need any information from them to get started, how they want the boards delivered, when changes are billed extra, and what expenses you expect.

DELIVERY

Make sure you deliver when you say you will deliver. If you realize you can't make your original goal, let the client know as soon as possible. There is no excuse for delivering a job late and not forewarning anyone.

BILLING

Bill a client exactly what you said you would in a professional manner. Make up or buy good invoices and keep track of them. You can use computer programs like *Quicken* to generate your invoices for you, make your own in a spreadsheet program, or have some printed with your logo. A printed invoice says a lot to your client about how professional you are.

Many clients take their time in paying invoices. You need to develop a good system for tracking who has paid you and who hasn't. You may want to put a line on your invoice that states "Amount due/payable within 30 days or late charges will apply."

ACCOUNTING

You need to keep track of your income and expenses. Expenses are not only the cost of your paper, but your drafting table, your accountant, marketing, the portion of your dwelling that you use for business (including rent, mortgage, utilities, phone, etc.), health insurance, investments, and more. Make sure you have enough money to cover downtimes in the industry (it's feast or famine). Plan for your own retirement. Every penny you can write off of your taxes is extra money that stays in your pocket. Find a savvy accountant to help you set up a system. Again, *Quicken* is a great and easy software accounting package.

MORE MARKETING

Don't wait until you're finished with one project before you start looking for another, or you'll end up with a lot of downtime between projects. The best marketing is always out there, like listing yourself in local trades and local film books.

BE CORDIAL

Make sure your client enjoyed working with you. An old adage is true: you'll make 80 percent of your income from 20 percent of your clients. In other words, returning clients are where the bread and butter is.

The more you act like a business, the more clients respect you and will be willing to pay for your time and effort. You can have fun and take your business seriously at the same time.

PART TWO

THE ART OF
STORYBOARDING

CHAPTER 18

PRESENTATION BOARDS VERSUS PRODUCTION BOARDS

FIGURE 18.1 Presentation boards by Mark Simon of Animatics & Storyboards, Inc. We used *Corel Photopaint* to blur the backgrounds. Client: Chernoff/ Silver & Assoc.

The term "storyboards" can refer to different types of work. While not all producers and directors are familiar with the difference between the terms production boards and presentation boards, there is a difference. Presentation boards are illustrations that get across the idea of the story, but not necessarily of every shot of the director's vision. Production boards, or director's boards, are generally known as boards that represent each shot that is to be filmed in a scene. These boards are the ones used by a production crew during shooting.

PRESENTATION BOARDS

It is important to know which style boards your client wants. If the client wants presentation boards, they don't need the action broken into every camera angle. They may only want key elements drawn out as part of a presentation for a client. The number of presentation boards will always be less than the number of production boards on the same project. Often, clients want presentation boards to be drawn in a larger size than most production boards (and usually in color) to allow people in a meeting to be able to see them easily across a room and to allow greater detail. They are also more impressive than the smaller black and white boards.

Clients are more likely to ask you to mount presentation boards than production boards. You may be asked to mount your individual panels onto a black piece of foam-core board. Some clients may have specific presentation formats or supplies that they use to keep their presentations uniform. Inquire about this. Mounting your storyboards allows the client to present the drawings in a professional manner to many people at once. Ask your client if they would also like a copy of the boards that they could include in their presentation package. Once you mount the storyboards, they are very hard to copy. Try to keep a set of copies ready to run through a copy machine for convenience.

PRODUCTION BOARDS

When you are drawing production boards you will need to go over every detail of each scene with the director. At times you may sketch ideas of a scene without much input. The director then is looking to you to use your knowledge and abilities to bring some fresh ideas to a project. In either case, every shot, cut-away, reaction, movement, or special effect is shown and notated on production boards.

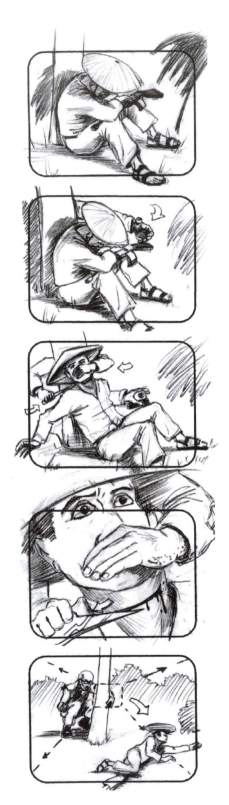

FIGURE 18.2 Redrawn production storyboards from the feature *The Walking Dead*. Boards by Mark Simon and B.C. Woodson.

Production boards are more likely to be rougher sketches done over a shorter period of time. They will very seldom be in color, unless the project has a very large budget and a lot of prep time. Segments of an animation may be boarded in color to get the visual feel of the color palette for a project. Very seldom will you need to worry about detailed backgrounds in production boards. Artists vary in their desire and ability to render backgrounds quickly; the decision is up to you. There usually isn't time for repeatedly drawing detailed backgrounds. When great detail is desired, a production rendering is usually called for. This is a larger version of one of your production panels that may be fully illustrated in great detail and color. These larger renderings are usually used to conceptualize a look for a set or special effect.

On some productions, your production boards will be mounted individually on a tackboard (foam core, beaverboard, or corkboard). This allows production to move, remove, and add elements as they go through a script. In large story meetings it is helpful to be able to view an entire scene at once, instead of flipping pages of boards. Production can also then carry these boards to a set or a location to use as a reference while shooting.

You may run into projects where you draw both presentation and production boards. During pre-pre-production, the client may need presentational boards to pitch their project or idea to a client or their superior. After the project has gotten the go-ahead and production nears, the director may ask for production boards to be produced.

CHAPTER 19

ANIMATION BOARDS

While the elements of telling a story in a visually exciting way are common to both animation and live-action boards, animation boards involve a number of elements all their own. Since animation is created frame-by-frame, storyboards are inherently more important here than in live action. Every scene, every shot, every action must be boarded out to act as a blueprint for the layout artists and animators.

As many differences as there are between live and animated boards, most of the chapters in Part II of this book are relevant to both. Proper storytelling and dynamic visuals are important in every format. Use of arrows, numbering, camera direction, and every element listed in Chapter 26, "Visual Design," is just as important in animation.

While live-action boards generally are for portraying special effects, stunts, and fancy camera moves, animation boards are very much about acting. Animation boards can seldom get away with not showing a character's reaction, how they walk, or how they chew food. Just as in a live-action show, how a character acts

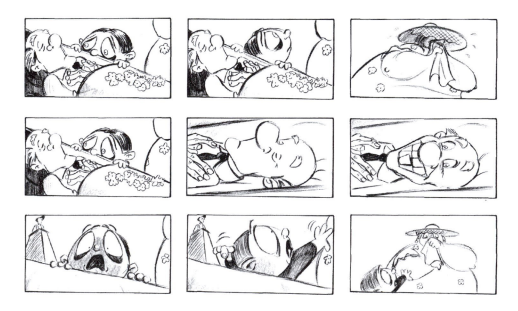

FIGURE 19.1 *Winslow* storyboards by KEITH SINTAY. (© KEITH SINTAY.)

and what idiosyncrasies they have are what the viewers tune in to see every week. All of this is what makes an animation come alive.

The quality of the acting in storyboards becomes increasingly important as more animation occurs overseas. Commercials, because of their larger budget-per-second of animation, are still produced mostly in the United States, but half-hour animated series, with much smaller budgets, are generally drawn in other countries. While the animation may be less expensive, one potential problem occurs with language and cultural barriers and misinterpretations. Quality storyboards limit these potential problems. What you see is what you get.

Animators overseas will draw exactly what they see on the storyboards. If your boards show a scene where a character has no reaction to something, the animator may draw it that way too. You can't assume the animator will know to frame a shot differently. They are told to draw exactly what's on the boards.

Animation storyboard artists generally have to be more flexible in their artistic style than live-action artists. Because each animated series or commercial has a very specific look, the storyboards need to match that look. An artist's style is often cast just as an actor would be. Since the boards act as key frame animation, the extreme poses of a character, they should look like the finished product. The boards don't have to be tight renderings, but the characters in a *Rugrats* episode shouldn't look like those in *Dexter's Lab*.

When my company, Animatics & Storyboards, Inc., was trying to make a deal with Sunbow Entertainment to draw some of the boards for a new Nickelodeon series, *The Brothers Flub*, we looked through the samples of our different artists. I had found some visuals for the *Flub* series and one of our artists had drawn some other boards that looked just like the *Flub* art. I showed those samples to the production manager and we were able to land the job.

Since every action and every shot needs to be storyboarded in animation, there are hundreds of panels per episode. For an eleven-minute cartoon, there may be as many as 600 storyboard panels. For a half-hour episode, which is usually 22 1/2 minutes of animation, there may be 800–1,200 storyboard panels. An artist will generally be given around six to eight weeks to complete the boards for an entire half-hour, including revisions.

An animation director may go over notes with a storyboard artist prior to drawing out the boards, or an artist may be left totally on his own to interpret the script. They are usually given a set of sample boards to demonstrate the look and action of the series. A direc-

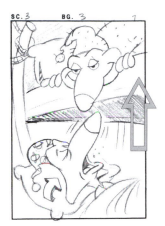
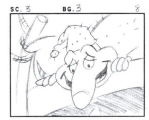
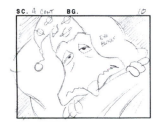

FIGURE 19.2 *Brothers Flub* storyboards by Wolverton of Animatics & Storyboards, Inc. (© Sunbow Entertainment.)

tor, producer, or storyboard supervisor will look at the boards after the first pass and make notes on action, acting, and direction. The storyboard supervisor may be the only contact a storyboard artist has on a project. The artist then makes whatever changes are necessary and delivers the final boards.

One thing that greatly helps storyboard artists is the actor's recorded audio. Some shows supply rough audio of the actors to the artists to listen to prior to drawing. This is very helpful, as an actor's inflection of

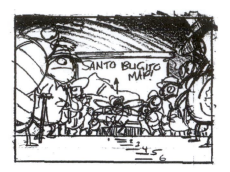

FIGURE 19.3 *SANTO BUGITO* STORYBOARD. THE FIRST PANEL SHOWS ALL THE CHARACTERS AND THE BACKGROUND. ONLY THE MAIN CHARACTER MOVES, SO TO SAVE TIME EVERYTHING THAT DOES NOT MOVE IS NOT DRAWN AGAIN, BUT IS REPRESENTED BY THE TERM *S/A* (SAME ACTION).

a line may have a totally different mood or attitude than you thought when you read the script. In one episode of *The Brothers Flub* we went back and changed a number of panels after we heard the actors. One character acted really scared in a sequence in which we had read him as being cocky. Obviously the character needed to look and act differently.

Animation boards don't need full backgrounds in every panel, or even detailed character drawings. In TV series work, each scene may have one panel of the storyboard be a copy of the background layout for reference. The action panels to follow will usually only have the background elements sketched that are needed either to place the characters into the scene or for the characters to interact with. When there are a number of characters in one shot, the first panel may show all the characters in their poses, but in following panels, any of the characters that remain static may only be represented as outlines, or sometimes not at all. When a character is stationary and only an outline is used, the letters S/A (for Same Action) are sometimes placed in the outline. This helps the animators know which character to concentrate giving motion to.

If a character needs to have some minor motion that needs to be shown, like an arm moving up or down, they don't always need separate panels for each extreme. Two extremes may be shown on one drawing with an arrow or numbers showing the motion path. Some artists also sketch the change in motion just under a panel. For instance, if you have three characters on the screen and one raises an arm, you may just have one panel of the three of them standing there. Just under that panel may be a smaller sketch of the one character raising his arm.

Overlays are also sometimes marked on animation storyboards. When a foreground element is called for,

but does not need to be animated, the storyboard artist may mark it with the letters *OL*, which stands for OverLay.

FIGURE 19.4 STORYBOARDS FROM *SANTO BUGITO*. NOTICE HOW THE SKETCHES BELOW THE STORYBOARD FRAME SHOW THE ACTION OF ONE CHARACTER'S HANDS. THIS SAVES HAVING TO REDRAW THE ENTIRE PANEL TWO MORE TIMES. (© Klasky Csupo.)

FIGURE 19.5 *Winslow* storyboards by Keith Sintay. The *OL* stands for overlay, showing the animators how to handle the foreground casket. (© Keith Sintay.)

When numbering panels in animation, the scene numbering is often up to the artist. Animation scripts probably won't have numbered scenes on them. It's important to number your boards with scene numbers for notes and easy reference. In live action, scene numbers change with a change in location or time, but in animation, background changes signal a new scene. If you have a wide shot, cut to a close-up, and then go back to the first wide shot, that's actually three separate scenes in animation.

A description of the action and the full dialogue needs to be written under the storyboard panels. This is important for keeping the audio timed to the art, not only for the action, but for the animators to

FIGURE 19.6 *Santo Bugito* storyboard. The wide artwork shows a pan up the street following a tumbleweed, and then a slight push in towards Carmen's. Showing this framing on one panel helps production understand the action. (© Klasky Csupo.)

sync the right character's lips with an audio track. For those of us who hate lettering, you can copy the script, cut out sections of the dialogue, and tape them to your boards.

On an animated television series, there may be as many as twelve to fifteen different storyboard artists working at the same time. Each artist will work on one episode at a time. If one artist were to try to draw the entire series, it would take years just to complete the boards.

On a feature animation, the first sets of boards are generally very rough. These are used to get a flow of the story without taking up much time. As the story develops and characters are designed, the storyboards will start resembling the finished animation.

Animation boards become plans for all the key animation. Most extremes are represented. Animation is so time-consuming that proper planning of every shot saves not only a great deal of money, but also a great deal of time.

CHAPTER 20

LASER SHOW BOARDS

FIGURE 20.1 *Rock Lobster* laser storyboards for projection onto a dome. Notice the flyout area on the bottom. That's the sweet spot where the viewer's eyes are most comfortable looking, although animation covers the entire dome. Storyboards by Willie Castro. (© AVI.)

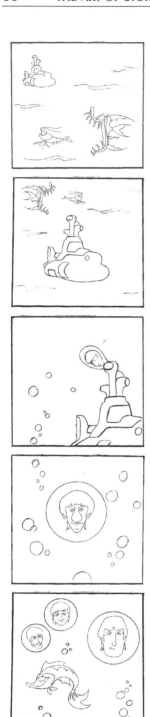

Laser light shows are a growing industry. Like many other types of productions, sometimes they tell a story, and other times they are abstract images used to enhance music at some event. Laser shows may be seen in planetariums, large theaters, and many live events.

Two styles of laser shows are handled in totally different ways. A laser show that is projected onto a flat surface is designed and storyboarded much like normal production. The three most common laser show storyboard formats are 1 × 1, 1 × 2, and 3 × 4.

The other style of laser show is projected in a dome. Because of the curvature in a dome, designs of visual movement and of individual elements are different than those projected onto a flat surface. Straight lines need to be curved to look straight when they're projected onto the dome. There is also what's known as the "sweet spot" in a dome: that's the area where the eye is most comfortable looking. Most of the action will take place within that spot. In storyboarding for laser shows, you will board the entire dome, but the sweet spot is shown as a "fly-out" to allow the artist to draw the most important elements larger.

When boarding laser shows, the storyboard artist often acts as the director along with the show's producer, and sometimes the client. For corporate events the show design is bound by the client requirements. Theme park shows often combine story elements with abstract design. Laser shows in parks and science centers tend to have the most creative freedom. While the main elements of laser shows are storyboarded, a number of the elements come together in production. Abstract images and timing to the music are often added and changed in the production studio with the producer.

The design of laser shows has to have simple images. Lasers can only reproduce so much line work before the image starts to vibrate and be distracting. Laser lines are only one width and there is no shading. Imagery is often repeated and resized throughout a show. While these simple line drawings can be animated, simplicity is the key. These design elements need to be adhered to when storyboarding.

Laser shows are a medium where knowledge of the laser industry is a must. The limitations of the science must be designed to and used to their best advantage.

FIGURE 20.2 Laser light show storyboard of *The Yellow Submarine*. Notice the simple line work used so the laser can better track the image. Storyboards by Willie Castro of AVI. (© AVI.)

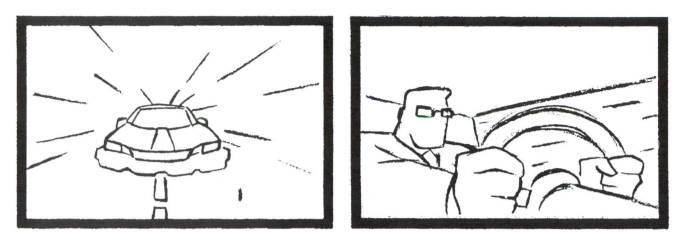

FIGURE 20.3 LASER STORYBOARDS PRODUCED TO THE MUSIC OF THE MOVIE *MEN IN BLACK*. STORYBOARDS BY WILLIE CASTRO. (© AVI.)

CHAPTER 21

COMPS

Comps, or comprehensives, are primarily storyboards for the print medium. These are usually preproduction art for magazine ads. Their purpose is much like that of presentation boards: they are to help the agency convince a client to give them the account or sign off on a campaign. Unlike production storyboards, the quality of the art in comps is extremely important.

Comps are often cut-and-paste works of art. You may render a vehicle, cut it out, and paste it onto a separately painted background. You may also place "greeked" type into your rendering. Greeked type is a term for a series of nonsensical letters, or a series of horizontal lines mocked up to look like a typed page or paragraph would look, that doesn't really say anything. Greeked type is important to make sure that the client just pays attention to the layout, not what's written. The following paragraph is greeked text.

Uaerh kjhsi ih sohoht ikhsoie h oshoi. Tlkjo soi s os oijs oiek noksn oksdokjfheh lalsk, soisje t soi soijdhhg oid wh dosj, sokjdoj gosor ks soid r sl. Ds os dof oiiso: sojhg osij thso soioihs hed.

The paragraph in Figure 21.1 is a graphical representation of "greeking" the look of text.

FIGURE 21.1 Graphic sample of greeked type. Used in layouts to show how a finished piece will look with text, without having to take the time to write it out.

FIGURE 21.2 Comp art for a mail advertisement. Notice the Greeked lettering on the envelope. Comp by Alex Saviuk.

The primary rendering tool of choice for comps is markers, although computers are being used more and more. Comp artists may use a combination of markers, colored pencils, airbrushing, and gouache to achieve the desired visual effect. Many artists will also use *Adobe Photoshop* to color and manipulate their drawings. The tools you use are unimportant, you just need to present a great piece of art to your client that gets across the idea they need.

The main person a comp artist will work with is the agency art director. The art director will supply you with a rough sketch of what she is looking for along with instructions. She will typically tell you the look of the backgrounds and sometimes the colors she wants. She should also provide you with some references for the project. She will be the one to approve your sketches before you go to finals, the completed artwork. Agencies look to comps to be visually exciting, so it's up to the artist to take the art director's

sketch and improve on it, not only in the quality of the art but in the layout as well.

Since the comp is presented to a client, it is imperative that you make the product look as good as you can. You will need to work quickly, as the turn-around time is usually one day. You probably won't have time to use templates, so you'll have to draw freehand. It will take experience to work quickly and supply the agency with the quality they require. You should remember these are not supposed to be pieces of finished art, just a general idea of how the ad should look. It is easy to add too much detail and to let the job end up taking too much of your time.

Once the comp is approved, your work may be done. There are times when the comp artist also gets to illustrate the finals as well. You know the comp was successful, at least for you as the artist, when the art director likes it and she keeps calling you to do more.

FIGURE 21.3 Presentation comp for the Golf Network for the Marketing Department to show to the executives. Notice how the computerized lettering looks better than hand drawn would have. And it didn't take much more time. The slight blurring of the background helps the words stand out. Comp by Mark Simon.

CHAPTER 22

ANIMATICS

Animatics, in a word, are previsualization or video storyboards. They are a way to see the final project in motion before going through the expense of actually shooting it. Animatics can be as simple as an edited video of storyboard frames, or as complex as limited motion animation.

Simple animatics take the original storyboards and either digitize them or shoot them with a camera. The frames can be edited together in time to the audio, with or without panning and zooming into the art. Complex animatics can be thought of as storyboards that have moving parts. They use artwork made up of several pieces that may be manipulated to provide a simple animation.

FIGURE 22.1 These are a few of the elements used to build the following frames. *After Effects* was used for the compositing and animation.

FIGURE 22.2 Frames from a SounDelux animatic. This 3 1/2 minute animatic was used to present a live-show idea to Universal Studios Hollywood. The entire show was animated, including the audience reaction. Production took only one week. Backgrounds by Joe Korte, design and characters by Mark Simon. Animatic produced by Animatics & Storyboards, Inc.

Animatics are used to test a proposed "spot" or commercial, or sequences of a movie or TV show. If you've ever been asked to preview some commercials and what you saw were beautiful illustrations that moved along with a sound track, you've seen an animatic. Some production companies, such as Nickelodeon, may use animatics to test a show without going through the expense of building and creating an entire show. This test show is then shown to sample audiences around the country to gather feedback, which determines whether the network will invest in the show or not.

A complex animatic will usually consist of a couple of backgrounds and a few moving elements on each, as well as some limited effects and a soundtrack. The moving elements on the background will be cutout figures or objects that may be moved around the background. A figure may have different moving parts. If a character moves his head, there may be two different drawings, one with his head looking in one direction and the other with his head looking in a different direction.

If a client needs printed storyboards along with an animatic, it's usually best to generate the final storyboard frames from the animatic. When animatics are produced on the computer, the proper framing, compositing, and effects that are designed into it can be easily printed from most programs.

The testing of animatics has become more popular as the advertisers involved desire greater test marketing before going through the expense of a full production. Agency art directors also get to see how the finished commercial will actually look and can make the changes they feel are necessary for the final project. Once the animatic is cut together, not only do you get to see the final result, but you also get a clear understanding of the strengths and the weaknesses of the concept.

George Lucas relies heavily on the use of animatics. He has used animatics in the development of all the *Star Wars* movies. The animatics for *Star Wars: Episode 1: The Phantom Menace* were very detailed, taking on the look of a video game. "I've done it on all my movies," says Lucas. "It's very hard for me to visualize. I'm an editor, so to me the moving image is what's important, not the frame" ("Brave New Worlds," Cheo Hodari Coker, *Premiere Magazine*, May 1999).

Once the animatic has been drawn, shot, scored (music and voices), and edited it will be tested in malls or in focus groups. These focus groups may be asked to watch a reel with a number of commercials or shows on it. Some of these commercials may be animatics. Afterwards, the test subjects are asked what they remember or think of the different things they saw. If the message behind the animatic is properly conveyed to the group, it stands a good chance of becoming a finished commercial.

Pricing art for animatics is dependent on the complexity of the project, how long it is, and how many renderings and characters there are. Artists usually price their work either according to the number of frames involved, or how long they expect to work on

the art. One background and one to one and a half cut-out characters are generally considered to be one frame. Two cutout figures and their moving parts could also be considered one frame when backgrounds are used for several scenes.

Artists need to be aware how the project will be shot. In the traditional style of animatics, production film and video have specific requirements. Illustrations for shots that have pans or zooms generally need to be larger to allow the camera room to move. Some motion and effects necessitate the use of video matting, or "bluescreening." A character may be shot against a blue or green background and digitally composited and moved into the illustrated background. A figure changing size in a background needs to be digitally maneuvered this way.

Motion may also be achieved from camera moves. Digitally this can be done with software. In the classic style of using a film or video camera, the camera usually stays stationary and the artwork moves on a camera stand, or the camera will move up and down to zoom in

FIGURE 22.3 FRAMES FOR THE *Ride of Your Life* ANIMATIC. This animatic showed a first-person trip through a theme park attraction. Design, art, and animation by Mark Simon. Produced by Animatics & Storyboards, Inc.

FIGURE 22.4 Simple camera stand. Camera is mounted above looking down. The platen below has a peg bar to mount and register animation paper.

FIGURE 22.5 SCREEN SHOT OF LIVE-SHOW ANIMATIC IN *AFTER EFFECTS*.

and out of the art. A camera stand consists of a horizontal plate mounted below a camera that is mounted on vertical tracks.

Video storyboards, or "pan and scan," are simple animatics. They do not have any moving elements, but the camera may move across or zoom in on the art. Films and TV shows may shoot video storyboards to edit into a show while they are waiting for the final footage or effects to be shot. On the second season premiere of *seaQuest DSV*, they shot and edited in my storyboards while they were waiting for the computer special effects to be completed. This was to help the editor and director plan the timing of the scenes and the entire episode.

Large areas of white tend to "flare" in the lens and are not a good idea in storyboards that will be used for animatics shot on video. The same goes for intense reds

on video. Video also has the tendency to simplify the colors in artwork and may cause it to look unnatural. Film, having a greater breadth of color and contrast, does not suffer from this problem.

Computers are now being used to produce animatics too. There are a few programs that can be used to produce animatics. The main programs used are *Adobe After Effects*, *Adobe Premiere*, *Macromedia's Director*, *OnStage*, and *Adobe Photoshop*.

After Effects is used for camera moves, animating multiple levels, compositing, and multitudes of effects. *Premiere* is an editing program for compiling your different shots, adding DVEs (digital video effects or transitions), and adding audio. *Director* allows you to easily manipulate images frame by frame, and *Photoshop* helps you to adjust and clean up scanned images and build mattes around portions of your images.

FIGURE 22.6 SCREEN SHOT OF *ONSTAGE!* PREVISUALIZATION SOFTWARE. ON THE LEFT, YOU CAN SEE HOW YOU CAN PLACE ICONS OF YOUR CHARACTERS IN DIMENSIONAL SPACE TO ACT AS A MULTIPLANE CAMERA.

OnStage is one of the few programs designed specifically for the previsualization of entertainment projects. *OnStage* is the only software among these examples that lets you set up a scene in proper dimensions (a set, characters standing on their marks, and foreground objects all in relative space), and then lets you not only animate the position of any element over time and space, but also allows you to animate the camera over time and space creating a true, digital, multiplane effect, pieces of art in dimensional space.

To produce animatics on a computer, the main elements you'll need will be a fast computer and a scanner. It also helps to have a graphics pad for touching up your graphic images and a video card to allow you to drop your video off to tape. Once you pencil all of your images, you have three choices. You can leave the image in black and white to scan and animate; you can hand-color the images, then scan and animate them; or you can scan the black and white image, color it in *Photoshop*, *Director*, or some other paint program, and then animate it.

In programs like *After Effects* and *Director* you have a number of options in editing, arranging, and manipulating your images. You can choose from a number of digital effects and dissolve and tweak each one to your own liking. You can place any image over or under any other image and change that placement while animating a scene.

You are not limited to just using hand-scanned images. You can build images in other computer programs and import them. Photos can be scanned for use as background or foregrounds. You can even use digitized video.

The sizes for the artwork used in animatics tend to range from 4 × 5 to 18 × 24 inches. The artwork can be smaller than 4 × 5, but the art may not hold up well when blown up on a TV screen. Anything larger than 8 1/2 × 14 can be time-consuming to scan, if the animatic is produced digitally.

On the television series *The Cape*, we had unprecedented use of all of NASA's original space footage. Much of each episode centered around a story based on existing space footage. While NASA's footage was great, it wasn't always enough to tell our story. Therefore we had to match some of NASA's space shots with our actors. I would sit down with the director, producer, script, and NASA's footage, and we would figure out what shots we needed. I would storyboard the new special effects scenes, and then I would produce an animatic using my approved boards. The editor would then edit the animatic together with the space footage to make sure the shots all worked together. This allowed the production to produce only the shots that were necessary and not to needlessly waste time and money on special effects that wouldn't be used.

Animatics may be as simple or as complex as you want, depending on time, money, and need. As production costs continue to increase, the need and value for testing a production prior to actually shooting it will also increase.

FIGURE 22.7 Frames from an animatic produced for NASA's Visitors Center. This animatic combined art, photos, and video to simulate how the images would look on a video wall. Client: SounDelux. Produced by Animatics & Storyboards, Inc.

CHAPTER 23

STYLES

Style can have a few meanings when talking about storyboards. It can refer to your particular style of drawing. For instance, two comic book artists may each have a very specific look. Style can also mean technique. Everyone has his or her own style and favorite techniques for drawing storyboards. Some artists prefer pencil, as I do; others use pen and ink or grey-tone markers; and others may prefer full color.

Part of the decision in which technique to use is based on the need of the project. Rough pencils can be sketches or simple line drawings. They are obviously faster to draw so more can be completed in one day. Complex art, also referred to as tone, refers to the drawing being more than just line work. It may be finished and shaded pencil work, grey-tone markers, or color.

Style can also refer to the story content provided by the storyboards. Two content styles of storyboards are narrative and image association. I often refer to these styles as production and presentation, respectively. Narrative boards (production) go over each shot in detail, dealing with each line of dialogue and action in the script. Image association boards (presentation) demonstrate the overall visual feel of the project. These boards may only highlight the key action, lighting styles, or even the color usage (called the color script in animations).

Style also relates to how a story flows visually. A Steven Spielberg film will look different than a Francis Ford Coppola film. Some directors like to tell their story with close-ups, and others always have their camera moving. Each director has his or her own style of telling a story.

Feature films use storyboards to work out production problems and detail special effects shots. There is generally no need for more detail than finished pencil. Some segments may call for more detail than others, but quite often the time available is not enough to allow time-consuming boards to be drawn. Certain panels of a storyboard, or the key frames, may be drawn out as a production rendering for use in approvals, construction, and effects. These will definitely have more detail and often color.

Commercials may ask for different styles of boards depending on how they are planning to be used. Boards drawn for presentation will usually be in color in a large format and may be mounted. Boards done for a director to use in production need not be more than pencil, as long as the shots are represented so that everyone knows what the director wants. Because commercials have the largest budget-per-second of air time of any medium, they often can spend more on storyboards.

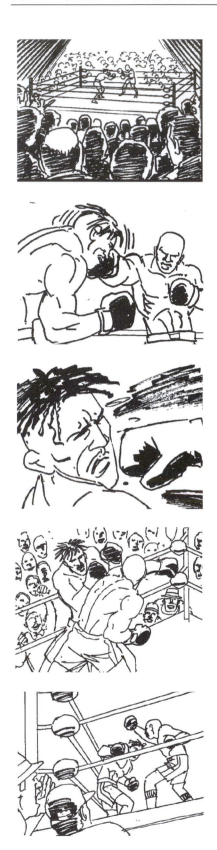

FIGURE 23.1 Storyboards by Alex Saviuk.

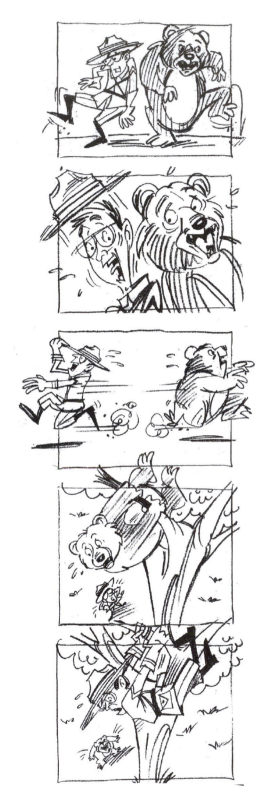

FIGURE 23.2 Thumbnail storyboards for a CVS Pharmacy project by Chris Allard.

Television is a fast-moving industry. You generally won't have time to sit around and perfect each drawing. When you are under the gun and need to get fifty to seventy boards drawn in one day, they are only going to be detailed to a small degree. Boards drawn for a TV series will usually be production boards.

Animation production boards need more action detailed in the storyboards compared to any other medium. A single action, such as a character chewing, may need three or four panels to demonstrate the humorous way the character does it. Storyboards in animations are basically like the key frames of anima-tion, showing each extreme action of a character. When an animation is in its early stages of development, the boards may be story sketches that follow the action, but are not nearly as detailed as the production boards. Story sketches help the animation team determine and keep track of the story.

The style of your technique may never vary, but the style of storytelling will change with every project. That's what keeps storyboarding fresh and fun. As a final note, when you are talking about style with a production, make sure you are all talking about the same thing.

CHAPTER 24

DIRECTING

As a storyboard artist, you will often be called upon to act as the director when working on a script. This is not to say that you will actually direct the crew, but that you will develop shot ideas and arrange the style, look, and staging of the action. Even when the director is calling the shots when going though a script, you may be expected to offer suggestions and solutions to the action in the script.

Some directors have training in or a love for graphic arts and may sketch out their own storyboards. In these cases, either you won't have a job or you will be refining their boards. Steven Spielberg has been known to supply rough boards to his artists for some scenes. Ridley Scott, Martin Scorsese, and Tim Burton also sketch their own boards. The director of *The Rocketeer*, Joe Johnston, started as a storyboard artist. He was also one of the conceptual illustrators on the first *Star Wars*. Even Alfred Hitchcock also started in the film industry as a storyboard artist.

On *seaQuest DSV*, two of our directors sketched out boards. One director, Bruce Seth Green, drew out rough boards when he was doing his shot breakdowns and did not need finer boards. This gave me more time to draw conceptuals for the production designer. The other director, Jesus Trevino, would sketch out thumbnails of some scenes and ask me to redraw them and flesh out the action.

When you are doing your own breakdowns for a script, you need to keep in mind any nuances that a director likes to use and what type of emotion any one scene is supposed to convey. Some directors like to move the camera and stay mostly with master shots for scenes, like Woody Allen. Others prefer a more hectic pace to their editing, like John Woo. Action scenes tend to demand faster edits on key action. Love scenes tend to be paced more slowly, with darker, warmer colors and contrast.

You may also look for shots that are specially motivated. If the moon is important, show a character looking up and then have a shot of the moon. You can also use a shot to portray the passing of time, such as showing the setting of the sun or slow-moving clouds.

It is crucial that storyboard artists understand the techniques of directing and editing. This knowledge is invaluable in allowing the artist to contribute to the flow of a project. It is also important that the storyboard artist understand all the lingo used and how shots work when a director is giving instructions to a artist. A storyboard artist will probably not be asked back if he or she doesn't understand the basics of directing. However, if the artist is capable of introducing wonderfully creative directing elements and adds to the visual development of the project, they will do quite well.

FIGURE 24.1 *seaQuest DSV* storyboards from the episode "Sincerest Form of Flattery." The director, Jesus Trevino, drew his own thumbnails, shown on top. I went over them with him and drew the panels shown below. (© by Universal City Studios, Inc. Courtesy of MCA Publishing Rights, a Division of MCA, Inc.)

FIGURE 24.2 Redrawn storyboards from the feature, *The Walking Dead*. The soldier looking up motivates the POV (point of view) shot of the moon. Boards by Mark Simon.

CHAPTER 25

WORKING WITH DIRECTORS

Every director has a different method of working with artists. Some have lists written out describing each shot, some prefer to tell you what they want to see, and others have no idea in advance what the shots are going to be. In any case, it's up to you to get all the pertinent information in such a way that you'll be able to accurately translate it when you're sitting back at your drawing table.

Storyboarding is seldom a one-way street. One of your roles as a storyboard artist is to offer ideas. Help the director make the best of each scene with your insight. Jesus Trevino, episodic director of *seaQuest DSV* and *Star Trek* fame, agrees but cautions artists about directors' egos:

> I think that a storyboard artist needs to be sensitive interpersonally to making the director feel comfortable about their participation. I think the worse thing a storyboard artist can do is to come in and start telling him how to shoot the sequence. I do think at the same time that a storyboard artist needs to be courageous enough to say, "You know, you might want to consider what would happen if we did this angle or that angle or if you have an insert shot of this." And I think if you convey that in a collaborative spirit, I think it would be helpful to the director.

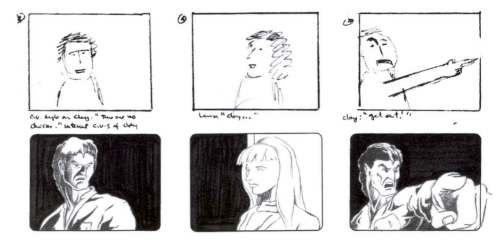

FIGURE 25.1 *seaQuest DSV* boards showing the director Jesus Trevino's thumbnails on top and Mark Simon's below. (© by Universal City Studios, Inc. Courtesy of MCA Publishing Rights, a Division of MCA, Inc.)

Another of your roles is to understand what the director wants and to illustrate it in the form of storyboards. It is important that you are able to communicate your ideas and understand a director's ideas. You can do this in a number of different ways. The most important is to have read the script before meeting with the director. You need to know the overall story before you can start on the details. Another way to communicate is acting. You may act out a scene with a director. Other times you may need to sketch thumbnails, refer to movie clips, draw out shot plans, or simply explain an idea verbally.

Understanding a director's vision is sometimes like translating a different language. Each director visualizes a story in a different way, and you need to understand these variations. Some directors may work well off of plot plans, others use lists, and some only tell you what they need. You may be lucky and have a director who draws her own thumbnails. You may run into a director who only works in concepts. Concepts are easy to misinterpret, so be sure you do everything you can to clarify what it is she wants. If you don't understand what a director wants, find a happy medium that you both can work with. Thumbnails of storyboards help. If a director can't read plans (overhead views), don't try to work with shot plans. If a director is familiar with plans, this may be your best bet for determining blocking. If you are quick enough, nothing beats a quick thumbnail showing the framing and the blocking.

One thing to be cautious of when working with directors is that many incorrectly use the term "pan." Many people in production use the term "pan" for any type of camera movement. Make sure you clarify what someone is asking for when they say that the camera pans. You might hear, "The camera pans along with the moving car." What they may mean is "the camera trucks along with the moving car." Pan means to rotate the camera on its axis. Truck, in this usage, means the camera moves along with an object. Pan is commonly used instead of the proper terms tilt, zoom, truck, crane, and track.

Another common miscommunication happens when directors talk about the size of a shot. There are very specific rules about how close a close-up is versus a medium shot and so on. Very few people stick to those rules, so it will be up to you to make sure you understand exactly how a director wants the shots framed. For example, some people look at a medium-close shot as being closer than a close-up, and others think it's a little wider than a close-up. The best way to make sure you understand is to thumbnail the framing for the director for approval. In Figure 25.3 you will see a graphic demonstrating the standard framing terminology of an actor.

Many directors make up camera shot lists when they are breaking down a shooting script. This is a written description of each shot in a scene. You may get a list from a director that looks like the list on the next page.

FIGURE 25.2 Storyboards for a Cold-Eeze commercial. The first panel shows the thumbnail sketch Mark Simon made while working with the director, David Nixon. The handwritten notes describe what needed to change. The notes were faster than redrawing the frame. The panel on the right shows the final piece.

Basic Framing Heights

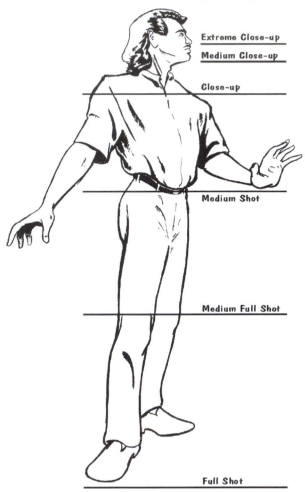

Extreme Close-up

Medium Close-up

Close-up

Medium Shot

Medium Full Shot

Full Shot

FIGURE 25.3

There are a number of production terms and abbreviations in the shot list: CU is Close-Up, FG is Foreground, POV is Point Of View, LA is Low Angle, and HA is High Angle (these are explained in greater detail in the Glossary).

- LA shot behind propellor as Wilde's boat beaches itself up towards lens.
- Reverse, Wilde's feet drop CU into frame as he runs upstage.
- Track camera left with Blaylok through the trees. See trees pass in FG.
- Track camera left through the trees with Wilde.
- Wilde's POV as he gains on Blaylok. Push into a medium shot.

- Back to tracking shot with Wilde as he tackles Blaylok.
- LA from inside a gorge of the men as they fall over the ridge.
- HA of the gorge as the men fall. Pan with the men as they roll down the hill.

This list is much more detailed than you may get from some directors. Often, directors tend to be quite cryptic in their descriptions. Each director is different. Try to get as much visual information as you can.

These director's notes may break down the action shot by shot, but they leave out a lot of information that he may want in the final picture. The director may have many more details in mind, but he may not have written them down. Information that he has left out may include which characters are in which shots and in which direction the action should take place. This is when you need to ask a lot of questions and add your own notes to the shot list. Not asking questions will result in redrawing a lot of boards. You should never guess about a shot. Problems arise when the director doesn't give you as much information as he thinks he has and you haven't asked enough questions. Don't rely on your memory. Write everything down and you won't have to worry if you remembered everything or not. You will be going over a lot of shots with the director, and it can get very confusing when you sit down at your drafting table hours later.

The following is another director's shot list. Again, it was missing many important details needed in order to storyboard the scene the way the director saw it. Asking lots of questions about the shots is the way to better understand her vision. The storyboard artist's notes are added in parentheses. You can also see how the final boards turned out in Figure 25.5. (You may need to turn to the glossary to decipher the abbreviations below.) Mohawk runs at and past camera. (He enters at the far end of the alley and runs right up past camera.)

- Reverse. (He runs away from camera towards a dead end.)
- Close-up reaction. (He turns to see the car lights hitting him. Show lighting effect.)
- Car approaches. (Lights flare into lens and car is a silhouette.)
- Mohawk keeps running. (HA as the car chases him in its headlights.)
- He runs to the dead end. (He tries to climb the fence as the front fender of the car enters frame.)

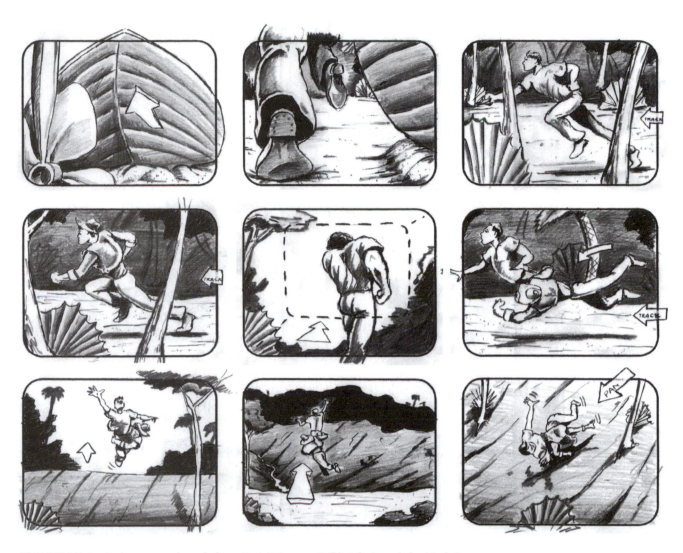

FIGURE 25.4 Redrawn storyboards from Fox's TV movie, *Wilde Life*. Boards by Mark Simon.

- CU struggle to climb. (He is reaching for a hand-hold. We see the car in BG.)
- Reverse OTS behind car passengers. (Silhouette of guys in car. Mohawk is blinded by headlights beyond.)

The set of storyboards in Figure 25.5 were based on the shots just described. You should refer to the boards while going back over the previous shot list.

Most directors will not hand you written shot lists. Half of the time you will be working with a director who has not thought much about the specific shots by the time you meet with him. When you go over a scene to be boarded, the director is then forced to figure out what he wants to see. It is your job to capture what he says and quickly make it legible for yourself for later, when you need to decipher your notes and make sense of the scene.

Commercial director David Nixon works with storyboard artists this way: "I usually like to just give an artist my vision verbally and let them sketch a little bit. I let them start and then we hone it in from there."

When going over scenes with directors, don't worry about taking too many notes. Don't fool yourself that you can remember everything a director says. Even though the shots make perfect sense and you can't see any other way to draw the scene when you're with the director, you may very well forget it by the time you're ready to draw your boards. Between the sheer volume of shots being described to you at once (I've come out

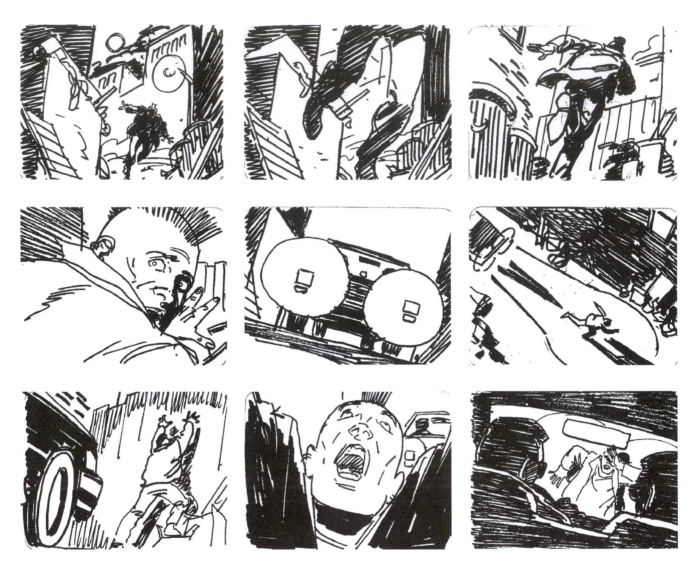

FIGURE 25.5 Without the storyboard artist's notes, these boards could have looked completely different. It's up to the artist to make sure he or she understands exactly what the director wants. Boards by Alex Saviuk.

of meetings with more than 130 specific panels to draw) and how many times the director may slightly change the shots as she describes them to you, it is all too easy to forget details.

Don't feel bad about asking her to repeat herself. It's better to be safe than sorry. You may also want to repeat back to her what you've written to make sure you've understood her clearly.

You may also act out scenes with the director to get a feel for the blocking of a scene and how the characters need to interact. On *Wilde Life*, the director and I rearranged the furniture in his room to simulate a battlefield. He and I jumped over the furniture and acted like kids as we developed the action in each scene. I have even used toys to block scenes. Using toy cars and action figures, we can simulate a scene and view how a camera may see it.

On another movie, the director wanted his action scenes to have the look of the Hong Kong action director John Woo's films. We looked at different John Woo scenes on video and used those as a reference for how to set up certain shots in our movie.

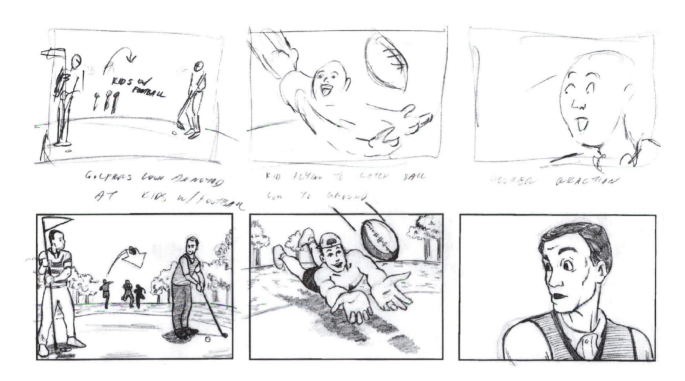

FIGURE 25.6 The top storyboards were thumbnailed by Mark Simon during a meeting with David Nixon. The finals, below, were drawn by Mark Simon and Dan Antkowiak.

If you're sketching thumbnails, you can go over the sequences with the director to get a quick OK from him that you both understand the same concepts and shots.

Thumbnails are quick, rough sketches that are your best notes. If a director does her own sketches, go over them and add your own notes to make sure you understand exactly what she wants. Even with just stick figures in your thumbnails, a director can look at them and tell you if the shot is what she had in mind. She may tell you she wants a tighter shot, or maybe that the character should face the other way. If the director wants a frame to be tighter, you simply sketch in a tighter frame inside your thumbnail until it's right. If other elements need to change, you may simply write a few notes about it and change it in your final drawings. You will most likely have fewer changes if the director is able to see sketches before you finish the boards. I would suggest that you combine thumbnails with written notes. I may show the major action in one sketch, but my notes may expand on the action, which may result in more details and drawings in my finished ver-

sions. Written notes may also contain a portion of a character's dialogue. Notes on my thumbnail sketches may show who is who in my drawing. Thumbnails may need a character's name marked on them.

Floor plans are two-dimensional designs of the layout of a set or location. These are also called plots or plot plans. When a director is telling you where he wants the camera and where the actors are, it may be difficult to imagine exactly what he is talking about without reference. Instead of taking any chances of misunderstanding you should use a floor plan, when appropriate, and mark out character and camera positions.

Many directors like to work with floor plans, as does director Jesus Trevino: "The first thing I do when I get on a show is get the floor plans for all of the existing sets. I'll get their floor plan, and then I'll miniaturize them, and then I'll incorporate them into my shot list."

The floor plan can show blocking and camera moves. Don't try to figure out too many shots on one plan; it quickly gets confusing. Make sure you mark

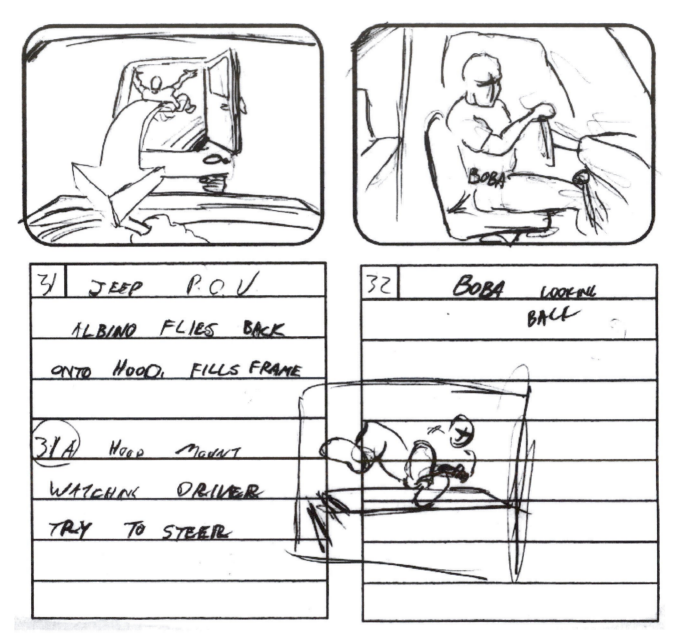

FIGURE 25.7 Redrawn 20th Century Fox's *Wilde Life* boards. As I drew these thumbnails for the director, he kept giving me notes and additions as to what he wanted to see. As you can see above, he wanted to add a shot between #31 and #32. I sketched #31A for the added shot. My written notes helped me understand my rough drawings later on.

each camera position in relation to the shots in your written notes or thumbnails. You should clearly mark each character, too. If you use more than one floor plan, mark them. By referencing a floor plan you will know exactly who and what the camera will see. Your boards will be that much more accurate and beneficial to the production.

Key:

FIGURE 25.8A CIRCLE REPRESENTS CHARACTERS: RAY, PIPPINS, THE MOB. MARK CHARACTER NAME INTO CIRCLE.

FIGURE 25.8B CAMERA PLACEMENT AND THE DIRECTION IT'S POINTING.

When you work with floor plans, it's a good idea to give a copy of them to the director along with your storyboards. Use of floor plans can help not only you as the artist, but also the rest of the crew. The artist can conceptualize what the camera would see. The director can use it for her shot list. The cam-

era department can use it to plan their set-ups. The gaffers will know what they need to light. The art department will know what they need to dress and prep.

The following images show a floor plan and the boards drawn from it.

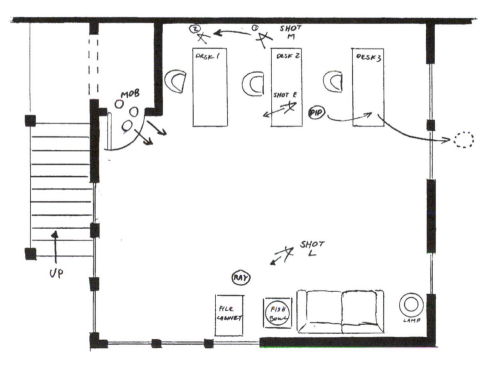

FIGURE 25.9 REDRAWN FLOOR PLAN FROM *THE WALKING DEAD*. CAMERA ANGLES, ACTOR BLOCKING, AND MOVEMENT OF BOTH THE ACTORS AND THE CAMERAS ARE PLOTTED. SHOT M SHOWS A CAMERA MOVE FROM POSITION 1 TO POSITION 2.

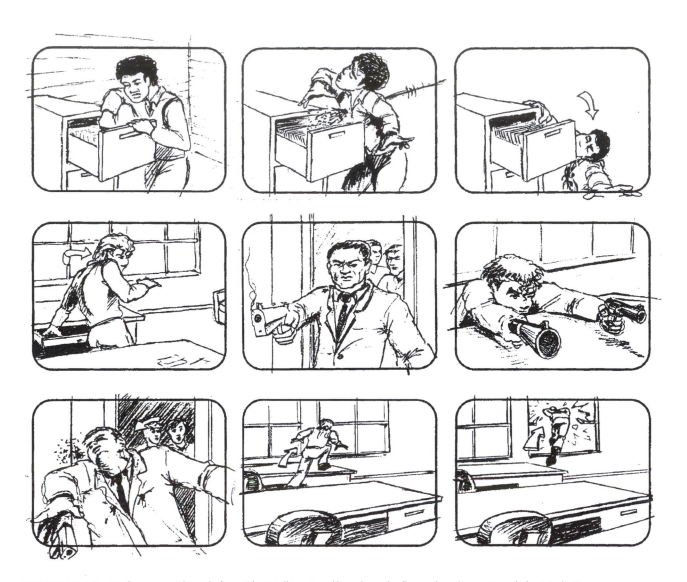

FIGURE 25.10 Redrawn storyboards from *The Walking Dead* based on the floor plan above. Boards by Mark Simon.

Working professionally with directors not only makes your storyboards more effective for the production, you will also enjoy each project more—and you are more likely to be called again for subsequent projects.

CHAPTER 26

VISUAL DESIGN

Drawing boards does not just mean sketching the characters going through their paces. You need to be able to work visually with the director, producer, production designer, stunt coordinator, effects coordinator, or whomever, and give the project a visual dynamic. The viewer, director, or other crew member needs to be drawn into the action, and their interest in the visual story must be carried throughout the scene.

The thirty-four design elements detailed below are used to create effective and exciting storyboards. These elements are common not only to storyboard production, but to directing and editing as well. They are organized under various design goals.

CREATE VISUAL INTEREST BY VARYING SHOTS

1. Use extreme close-ups to heighten emotion: if a character is crying, bring the camera in to see the tears.

2. Give the viewer a sense of place by using an establishing shot. This is a wide shot showing the layout of the location of the action.

3. Use over the shoulder (OTS) shots during conversations and confrontations to give the viewer a sense of being part of the action.

FIGURE 26.1 The panels, shown in order from the left to the right, show an extreme close-up, an establishing shot, and an over-the-shoulder shot. *seaQuest DSV* boards by Mark Simon. (© by Universal City Studios, Inc. Courtesy of MCA Publishing Rights, a Division of MCA, Inc.)

4. Introduce interesting camera angles to disorient viewers or make them feel uncomfortable, when justified by the script. The POV of a drunk character may be tilted to the side and sway around. (Angles that are off the horizontal axis are called canted frames, or Dutch or Chinese angles.)

5. Use point of view (POV) shots to allow the viewer to see what the character is seeing. POVs always need to be motivated by first showing the character looking at something.

6. Vary the distance of your shots. A film becomes visually boring if you always see characters from the same distance.

7. Mix wide, medium, and close shots in the same scene. Don't be afraid to really pull the viewer in if it enhances the scene. Mixing different width shots can make a scene dynamic.

FIGURE 26.2 The panel on the left shows a canted, swaying frame showing that the character is out of sorts. The panels on the right show the soldier looking up to motivate his POV.

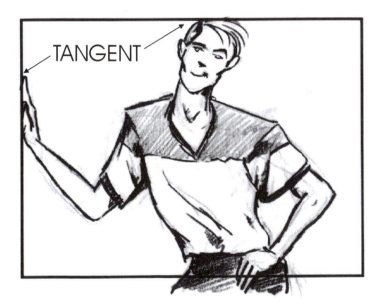

FIGURE 26.3 Stay clear of tangents such as the ones shown.

8. Tangents. Don't have any part of a character tangent, or adjacent to, the edge of the frame. It gives the visual impression that the edge of the frame is a wall or floor.

INTRODUCE MOVEMENT

9. Keep the camera moving to prevent the film from feeling static. The amount of camera movement will be dependent on the director's style.

FIGURE 26.4 3D arrow shows the movement of the character. *seaQuest DSV* board by Mark Simon. (© by Universal City Studios, Inc. Courtesy of MCA Publishing Rights, a Division of MCA, Inc.)

10. Use 3D arrows to show movement of the camera or of a character.

11. Move the camera to follow or lead a character. The viewer feels a sense of being a part of the scene.

12. Pan the camera to track an object as it approaches and passes the viewer to give a sense of what a character sees; for example, if a car approaches, passes, and recedes into the distance.

13. Involve the viewer by moving into the action. For example, in a fight scene, using OTS and POV shots gives the viewer a sense of being in the middle of the action.

14. Make the viewers feel as if they are in jeopardy by creating shots where objects or people move towards the lens. These are usually POV shots showing a character in peril. More recently in films, debris from an explosion or accident will fly directly at the camera, making the audience want to duck.

15. Move the camera with an object, carrying the viewer along. Kevin Costner's *Robin Hood* has a great shot where the camera rides an arrow into the bull's-eye of a target.

16. Do not cross the visual line, which means maintain a constant sense of direction for an object or person moving across the screen. It is disorienting to the viewer if direction suddenly appears to change: for instance, if a car travels from the left of the screen to the right in a chase scene, and then in the next shot it's seen traveling from the right of the screen to the left. It is easy for this to occur inadvertently when shooting, because these shots may

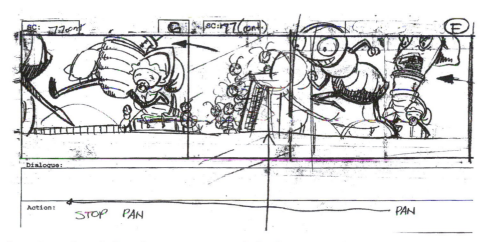

FIGURE 26.5 *SANTO BUGITO* boards show the camera moving with the characters as they run across the frame. (© Klasky Csupo.)

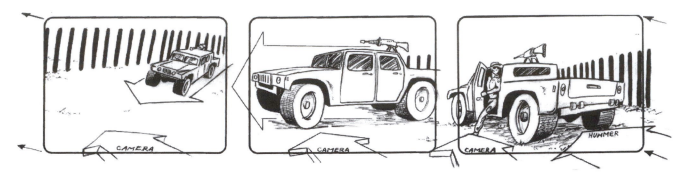

FIGURE 26.6 *seaQuest DSV* boards show the camera moving in and panning with the Hummer as it passes the camera. Boards by Mark Simon. (© by Universal City Studios, Inc. Courtesy of MCA Publishing Rights, a Division of MCA, Inc.)

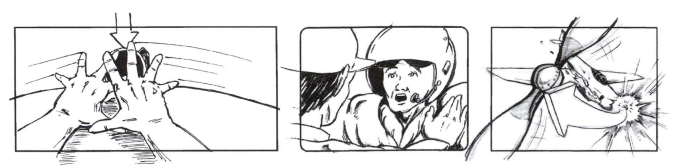

FIGURE 26.7 In order from the left to the right, the first panel shows a POV of a character trying to grab a falling cup. The next panel shows an over-the-shoulder shot of a man confronting a pilot, and the last panel shows a propeller flying right at the viewer. Panel 1 by Dan Antkowiak. Other panels by Mark Simon.

FIGURE 26.8 From the left to the right, the first panel shows the camera flying with an arrow at a man. The next two panels show the line of action being crossed. The choppers on the left are moving camera right, and the choppers on the right are moving camera left. In back-to-back shots, objects need to move across the screen in the same direction.

be separated by days during shooting and only appear together when edited. This is precisely the type of problem that can be prevented by using a good storyboard. Straight-on shots are neutral angles that allow movement in either direction to follow.

USE ARTISTIC DESIGN ELEMENTS TO GIVE THE FILM A DISTINCTIVE LOOK

17. Design a visual balance in each panel. The panel should be a work of art, not necessarily in the finished quality of the rendering itself, but in its composition. Don't place characters dead center in a frame. Place them in the frame on the side that allows more room in the direction the character is looking.

18. Use inserts or cut-aways to an object or person that advances the story or fleshes out the characterization, as was done so brilliantly in *Citizen Kane*. An extreme close-up of a nervously shaking hand on an outwardly calm and composed character gives the viewer information beyond what the dialogue reveals. A pan showing objects in a character's home or office tells the audience information about the character without requiring dialogue.

19. Add depth to shots by placing objects in the foreground. For example, a shot of scenery in the distance gains perspective if framed by trees close to the camera.

20. Give the viewer perspective by tilting the frame up to emphasize tall objects, down to emphasize short objects, or sideways to indicate disorientation or confusion, as in the case of an intoxicated character. (For pan or tilt shots, use more than one panel to depict the beginning and end of a camera move. For a tilt, one drawing may encompass two panels stacked vertically, while a pan may require two drawings side by side.)

21. Ground the viewer in the middle of the action by using reverse shots, wherein the camera appears to be between two characters.

22. Use the silhouette of an object that a character is looking through as the border of a frame. For

FIGURE 26.9 FROM THE LEFT TO THE RIGHT, THE FIRST PANEL SHOWS GOOD VISUAL BALANCE WITH SPACE LEFT IN FRONT OF THE CHARACTER. THE SECOND PANEL SHOWS A CUTAWAY, AND THE THIRD SHOWS HOW A FOREGROUND TREE ADDS DEPTH TO A SHOT. ART BY Klasky Csupo, Mark Simon, AND Alex Saviuk, RESPECTIVELY.

FIGURE 26.10 THE PANEL ON THE LEFT SHOWS A LOW CAMERA ANGLE LOOKING UP TO EMPHASIZE Poseidon's SIZE. THE FRAMES ON THE RIGHT DEMONSTRATE USING TWO CONNECTED PANELS TO SHOW A PAN. *SEAQUEST DSV* BOARDS BY Mark Simon. (© BY Universal City Studios, Inc. COURTESY OF MCA Publishing Rights, A Division of MCA, Inc.)

FIGURE 26.11 The first two panels show the man looking through the keyhole, which motivates his POV through it. The last panel demonstrates how the character's arms and body are foreshortened. The first two panels by Mark Simon. The last panel by Chris Allard.

instance, if a character is looking through binoculars, cut to a POV shot bordered like the view actually seen through binoculars.

23. Motivate your shots, meaning keep the action and the camera angles in sync. For instance, show a character looking up and then have the camera angle look up. Or shoot a character standing on a balcony and follow with a shot looking down from the balcony. These second shots would be considered motivated. Always be on the lookout for an action or situation that might motivate an inventive or unusual shot.

24. Use foreshortening, a device in which one element of an object is so prominently featured in the foreground of a shot that it blocks the view of the entire object, as in the depiction of an outstretched hand being much closer to the camera than the rest of the actor. This can be very dynamic.

Be Inventive

25. The story should be completely understandable without words, based on the storyboard alone. If it isn't, change it. The visuals should be able to convey the story.

26. Use more than one frame if you need to show a character's complete reaction. Even if there is no overt action in a shot, if a character's reaction is critical to advance the story, detail it on the board.

27. Use quick cuts between objects and characters to create suspense, and to accelerate the action.

28. Show only portions of a character to build suspense or fear, as in showing a hand with a gun coming around a corner, or a character's face slowly emerging from the shadows.

FIGURE 26.12 *Santo Bugito* boards show multiple expressions. (© Klasky Csupo.)

FIGURE 26.13 THE shadowy figures add to the fear in the scene. Boards by Alex Saviuk.

29. Show a person or object, of which the characters are unaware, moving in from the edge of the frame, to heighten suspense. For example, show a character looking away from the camera as a dark, shadowy figure moves into the extreme background. Seeing the character's peril before the character senses it involves the viewer emotionally.

30. Have an object move close up into the frame and stop, as in a car pulling up towards the camera and stopping, with its headlights filling the frame. This is a dramatic way to introduce a character into a scene.

ANIMATION BOARDS

31. Frame your boards accurately. Animators, especially overseas, take the framing of each shot directly from storyboards. If you illustrate characters' heads too close to the top of the frame, their heads will most likely be partially cut off in TV safe. (TV safe is a grid marking on field guides that lets you know where some TV reception will likely crop the image.) Your boards need to make allowances for TV safe.

32. Keep your drawings "on character." Your storyboards will basically be the key frames for the animation. The closer your drawings are to the character sheets, approved illustrations of how the characters should look, the more it helps the animators.

33. Animated movements and visual gags. The main reason to animate a show is because animation can do things live action can't. Your boards need to exaggerate to the degree the producers of each cartoon allow.

34. Show expression change and acting nuances. Some of the funniest moments in animation are the subtleties. Animation demands many more storyboard panels per action than live action because all the characters' acting has to be illustrated.

There is no one correct way to illustrate any scene. A good storyboard artist can help make a scene more interesting as well as present the production with enough information to help it run more smoothly. A good artist does not necessarily make a good storyboard artist. Fine storyboard work is executed by a person who understands how production works and can visually get across all of the information mentioned here—and a person who works well with a director to capture his or her vision for the production. The storyboard artist also adds his or her own expertise to make each project that much better.

FIGURE 26.14 FRAMING for TV with the TV safe zone shown.

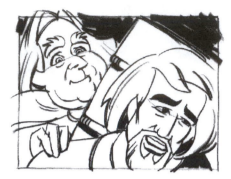

FIGURE 26.15 *Pilgrim Program* storyboards are "on character." Boards by Chris Allard.

FIGURE 26.16 *Suburban Cinderella* boards show exaggeration. Boards by Mark Simon. (© Animatics & Storyboards, Inc.)

FIGURE 26.17 *Santo Bugito* boards show multiple expressions. (© Klasky Csupo.)

CHAPTER 27

REFERENCES AND RESEARCH

FIGURE 27.1 Mark Simon using a small mirror for reference.

As a storyboard artist you need to know how to draw any number of items quickly and accurately. This does not mean that you have to work only from memory when you are illustrating. Of course, it helps to have a great memory of how everything looks, but using visual references takes the risk out of missing any details.

No artist can draw everything from the top of his or her head. We need references for what different objects, animals, and characters look like in different positions. Early on I used to think that using a reference was like cheating. Not so. Using references allows your boards to be drawn more quickly and more accurately.

There are many different types of references artists can use. References can be photos, mirrors, objects, video, living beings, sound, or just about anything else.

Mirrors are the most prevalent source of references, and thus artists are their own most often used models. Most illustrators will have at least one mirror at their desk. A makeup mirror may be on the desk for hand and expression references. A wall mirror may hang to one or both sides of the desk.

Some artists have been known to design intricate configurations with their mirrors to view themselves at all angles. Holding a mirror in front of you and looking at a mirror behind you will show you what your backside looks like. A mirror on your ceiling is helpful in getting a bird's eye view of yourself (but it is also dangerous). A bunch of properly angled mirrors will let you see yourself from numerous sides all at once.

Of course, you can't always pose for yourself, especially if your character is of the opposite sex or is some sort of reptile. That's where live models, both animal and human, come in. When I need a female character reference I ask my wife to pose for me. I've also used neighbors and friends for child and elderly reference. Even my dogs have been models at one time or another.

Of course, there are also art classes that have live models to draw. You're never too old to continue to improve. Many animation studios offer life drawing classes as a part of employment. In the early days at the Disney studio, these classes were part of the daily routine. These Disney classes started in 1932 in the home of animator Art Babbitt. Walt soon offered the artists the use of a soundstage at his studios on Hyperion Avenue in Hollywood. By 1934, this school was converted to a full-time basis, with part of the schooling taking the artists to the zoo.

Many artists, myself included, spend a lot of time at the zoo sketching the animals and the people watching them. I also do a lot of character sketches whenever I'm at the airport. Any place where people of different cultures gather is great for sketching.

FIGURE 27.2 Life sketching with ink at the airport by Mark Simon. I carry my sketchbooks around with me all the time.

For the animated film *Bambi*, Walt Disney had trainers bring in deer and other animals for drawing sessions. More recently, Jim Fowler did the same thing for Disney Feature Animation with lions and other animals for the movie *Lion King*. This obviously helps artists get a feel for the look and movement of the characters.

Besides using real animals for reference, skeletons are often used. Skeletons teach artists the support structure of an animal and how they're capable of moving.

Sketching from a live reference is the best way to get a good feel for the volume of your subject. When a subject is moving, you're forced to sketch quickly to capture what you see. This helps speed you up and keeps you from overworking the art. Some of your best sketches are likely to come from quick live-action studies.

FIGURE 27.3 Life sketching with ink at the zoo by Mark Simon. Drawing an animal in motion keeps you fast and teaches you to keep your lines to a minimum.

Even though sketching live models is the best, the advent of cameras was a great advance for artists. All of a sudden an artist could pose a model, take a picture, and send the model home. Models were no longer needed for posing for hours or days at a time. Using photos to draw from instead of models saves artists time and money. In addition, when you use a photo you can draw from it and keep it for later use.

Polaroid photos made this even faster. Now you could not only take a picture of a model, ship, or plane, but you could see and work with that picture in a few minutes. Now we don't have to use an entire roll of film and drive to the corner store and wait for one-hour processing. Polaroids, per photo, are fairly expensive compared to getting normal film processed, but they save you a lot in time.

Now, there's even a faster, and ultimately cheaper, way to take photo references with digital cameras. Digital cameras are getting faster, less expensive, and better every day. In general, the image quality is better than Polaroids, and you can endlessly keep taking pictures on the same memory card without spending an extra cent on film or processing. The only ongoing cost is the expense of printing the pictures on either a laser or color printer. References seldom need to be in color, so a color printer is not always necessary.

To capture moving references, motion film or video is needed. These days, video is much less expensive and faster than film. The problem with video is that it has a tendency to have very blurred images when you look at them a frame at a time. Some of the better cameras have

FIGURE 27.4 The ridiculous number of cameras I own. I use each one depending on what my needs are. From the far left, clockwise, 35mm fixed lens camera (I can beat this one up); video camera; Polaroid 600; Polaroid Spectra (better but more expensive); 35mm Minolta SLR (great camera); Advantix camera (fixed lens and foolproof); digital camera; and panoramic camera.

fast motion options on them that speed up the shutter, decreasing the blur. Resolution of the tape format also has a lot to do with how clear the image is. VHS cameras capture with the lowest resolution. Higher resolution cameras, in order from the lowest up are Hi-8, 3/4", 1", D-1, Beta, and Digi-Beta. Some of these cameras get rather pricey, but even the lowest resolution video can be a great help.

Good VHS decks, and most professional quality video decks, offer great slow-frame and still-frames to study motion. If you have access to a video capture system on a computer, you can also print out individual frames to study. Running a video slowly back and forth is an excellent way to get a good feel for how an object moves.

Back in the late nineteenth century, Eadweard Muybridge shot numerous studies of motion on film with both people and animals. His nude figures generally walked, ran, or jumped in front of a grid back-ground. Most of the actions he shot were recorded from more than one angle, giving the viewer multiple perspectives of every movement.

There are two great texts of his motion photos, *The Human Figure in Motion* and *Animals in Motion*. Each contains over 4,000 wonderful references of motion. *Animals in Motion* has reference photos of horses (with and without riders), dogs, cats, lions, kangaroos, deer, jaguars, elephants, raccoons, eagles, and many others. These action photos were taken at speeds of up to 1/2000th of second to keep each image clear.

On the limited edition laser disc of *Snow White and the Seven Dwarfs*, there are wonderful examples of the reference film that Disney shot and the footage they illustrated from it. This footage includes Snow White running and a heavy man dancing a jig. The dancing man is a great example of fabric follow-through and bounce. Walt also filmed the actions of three real dwarfs as reference for how they walk and move.

FIGURE 27.5 DVDs and CD-ROMS showcasing storyboards.

Many DVDs have storyboards and conceptual art as a bonus feature. Some even run the storyboards along with the movie. Some of these DVDs will also run in a computer, offering other features. Over the years some special effects movies have produced "making of" CD-ROMs that include storyboards, art, and effects, including *The Mask* and *Stargate*.

There are times when you need reference of inanimate objects. You often need to draw objects such as cars, bikes, buildings, planes, props, and trees. There are times when you need to see reference not only of an object, but how it interacts with a person. You may need a model to hold a prop gun or sit on a bike.

As you take photos of reference material, you should catalogue them. This way you can build your own supply of references. If you set up a good system, you'll find yourself turning to it more and more often. You need to make sure that it's organized properly so images are easy to find.

Break your references into major and subcategories, such as:

People	Sports
Men	Football
Women	Baseball
Kids	Soccer
Hands	Basketball
Feet	Vehicles
Animals	Cars
Dogs	Trucks
Cats	Planes
Goats	Trains
Etc.	Boats
	Locations
	... and so on

I keep my references in photo boxes so they are easily accessible and quick to replace.

FIGURE 27.6 ONE OF MY MANY PHOTO REFERENCE FILES.

FIGURE 27.7 ORGANIZED MAGAZINES FOR REFERENCE.

Mail-order catalogues and magazines are also great sources for references. Instead of having to wander around looking for things, I can just look in some magazines. I also keep my reference magazines organized according to source material: people, tools, guns, sports, and so on.

Books work the same way. Our company's studio has many, many books on different types of architecture, interior design, countries of the world, history, nature, art, and cartoons. Even our old encyclopedias are helpful when we need some obscure reference.

Some books are used for style reference. When making *The Lion King,* the Disney creative designers also studied the painters of the American West. From their paintings, Disney directors and designers drew inspiration for their background layouts and color composition.

Comic books can also be a great reference. Most storyboard artists are, or were, comic book fans. I learned how to draw from comic books. The characters are ideal examples of the muscular system even if exag-gerated and the backgrounds and vehicles are wonderfully drawn in perspective.

Thanks to computer technology, reference material is even more plentiful. You can use CD-ROM clip art and CD-ROM encyclopedias, which have not only still images but often video, too. The Internet is a rich source of material. A good example is when our company needed to illustrate a jeweler's magnifying cap. We found a whole assortment of examples on-line on a page selling jewelers' tools. Anything we find on-line, we also print out and save with our photo references. This keeps us from having to look for the same item twice.

Some of the best reference you can have on hand is the type you can manipulate in 3D. Models, toys, sculptures, and dolls can be held and posed in any position. Many artists have the wooden hands and the figure reference. The hands are pretty good, but the full figure doesn't portray the body very well, and it's not nearly as flexible as it could be. Better figure references are dolls and action figures.

FIGURE 27.8 A small portion of the reference books in my library. You will find these, and others, listed in Chapter 50, "Resources."

For male references, the best used to be the classic full-size G.I. Joe. He was fully flexible with sixteen joints, and he had real clothes. Currently, I find the Spiderman to be the best action model. One Spiderman in particular has sixteen axes of motion—and muscles—but no clothes. This smaller action figure is also easy to carry around in a briefcase.

For female reference, nothing is better than Mattel's workout Barbie and workout Theresa. These fully flexible dolls stand twelve inches tall, have real hair, and have a full line of clothes available for them.

For vehicles, any toy store will have multitudes to choose from. Whether it's a spy plane, a 1930s hot rod or a battle ship, it's available. When we were storyboarding the CG (computer graphics) animation effects on Amblin's *seaQuest DSV*, the ship was fairly difficult to draw in varying perspectives. By the second season, the toy stores had models of the ships that we then built and used as reference at our drafting tables. The model

also came in handy when working with the directors. We could move the ship around to plan the shots before they were storyboarded.

Maquettes are some of the best references. Maquettes are sculptures of animated characters. Studios have special artists to carve these maquettes and make sure they are perfectly on character for the artists to draw. Smaller studios may outsource maquettes or have the artists sculpt them. An advantage to sculpting a maquette yourself is that it gives you a better three-dimensional feel for the character just by modeling it.

The fastest way to carve maquettes is to use Sculpey. Sculpey is a polymer modeling clay that stays soft until it is baked in an oven. You can bake Sculpey in a regular home oven in just a few minutes to a hardness that can then be sanded, added to, and painted. Paint it with acrylic and spray varnish on top.

You can also use nonhardening modeling clay to sculpt reference. On *seaQuest DSV* I sculpted a dolphin

FIGURE 27.11 Author Mark Simon's hand as he starts to draw the *seaQuest* ship. The model helped speed up drawing this complex shape.

FIGURE 27.9 Clip art samples from the *CorelDraw* files that come with Corel products.

FIGURE 27.10 Dolls and action figures that are much better reference than the woody character available at art stores.

as a reference for the Darwin character. The clay was great because it offered me a malleable character that I could bend just like a dolphin.

Another great reference source, which may not be quite as obvious as others, is audio. The audio of the recorded character's voice can give you insight into what the character may be doing. Listen closely for the character's tone, mood, and speed of voice. When we were storyboarding Nickelodeon's animated series, *The*

FIGURE 27.12 Maquettes of the *Suburban Cinderella* characters modeled by Mark Simon. Used by our animators during production. (© Animatics & Storyboards, Inc.)

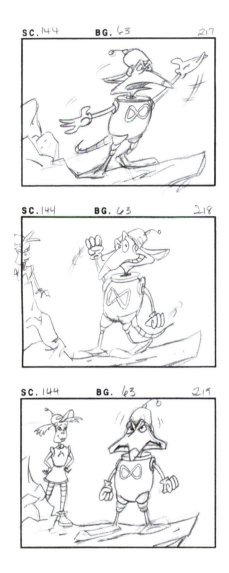

FIGURE 27.13 *BROTHERS FLUB* STORYBOARDS BY WOLVERTON OF ANIMATICS & STORYBOARDS, INC. (© SUNBOW ENTERTAINMENT.)

Brothers Flub, we didn't get the audio until after we had boarded a number of scenes. Hearing the way the voices interact gave us a totally different idea of how some scenes would look. We went back and redrew some of the boards using the inspiration we got from the audio track.

Using reference material can not only improve the quality of your boards, but it can also increase your output. Artists having a hard time sketching a character or object tend to draw slowly and keep redrawing the same pieces over and over if it doesn't feel quite right. No one is expected to know how to draw everything. A little reference can help a lot.

The production you are working on may have reference material for you as well. Always ask; it could save you a lot of time. For instance, when I'm drawing storyboards for the major Orlando theme parks, I ask for references of their parks and characters. Productions could also have set plans, location photos, or other research that they have already accumulated. If the production has video footage of something you need, try to make a video print of it.

Using references saves you time and allows you to make more money in less time. And perhaps even more importantly, reference helps you deliver better-looking boards.

CHAPTER 28

ILLUSTRATED CAMERA TECHNIQUES

Camera moves and transitions can be shown with special markings on your storyboards. The use of arrows to show camera, or object, movement is the most common use of special markings. Other illustrated camera techniques in storyboards include the cross-dissolve between scenes, or the shot cut.

Arrows indicate to the viewer the direction the camera, actor, or object is moving. There may be many arrows in each panel, or you might not need any. However, any time there is movement in a frame, you should use arrows.

There are many different styles of arrows you can use. I use different types depending on the specific need of the drawing: 2D arrows are fine for movement to the sides or up and down; 3D arrows are usually needed for every other motion.

FIGURE 28.1 SAMPLE ARROWS THAT CAN HELP A STORYBOARD BE UNDERSTOOD.

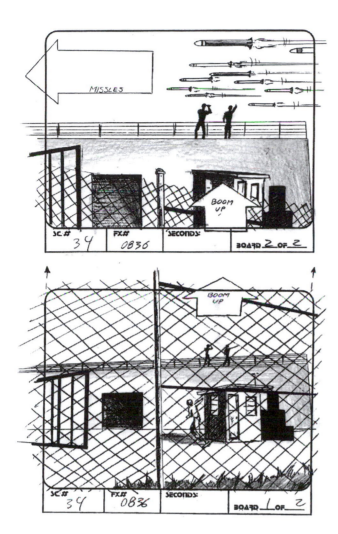

FIGURE 28.3 Arrow and numbers on board show motion of character's hand.

FIGURE 28.2 seaQuest DSV boards demonstrating a boom up over a fence. Boards by Mark Simon. (© by Universal City Studios, Inc. Courtesy of MCA Publishing Rights, a Division of MCA, Inc.)

Unlike road signs, an arrow pointing up does not mean move straight ahead. You need an arrow pointing away from the viewer to show something moving straight ahead or away from the camera. You can use the different arrows shown in this section as guides for showing movement in your storyboards.

If you just place an arrow in a storyboard, that may not be enough to tell the viewer what is moving or happening. Let's say you're trying to show that the camera tilts up. You can draw an up arrow in, and maybe out of, the frame. All that says is that something is moving up. If you simply write "Tilt" inside that arrow, it becomes perfectly clear that the arrow is referring to a

camera tilting on its axis and pointing up. If you wrote "Crane" in the arrow, it would mean that the camera itself moved vertically. An object, or character, is shown moving when you write the name of that object in the arrow to tell the viewer to what or whom the arrow relates.

Another style for showing what object an arrow represents is incorporating the object within the arrow itself. The arrow then almost becomes a road for the object to follow.

Arrows can also be used to show something or someone turning around or spinning, or to illustrate an erratic route. A two-headed arrow shows the cycle an object makes, such as someone's arm waving back and forth.

The dissolve, or cross-dissolve, symbol in storyboards shows the viewer when one image is supposed to dissolve into the next image. This is done with an X placed between the two consecutive frames, generally

FIGURE 28.4 Sample of a dissolve between two panels.

connecting opposing corners. Dissolves are used to soften transitions between scenes or to show that time has elapsed.

The symbol for a scene cut, normally only used in animation boards, is a small triangle pointing down between two consecutive panels. This means that there is a cut between two backgrounds.

Camera moves can be shown in a few ways. Pans, tilts, and tracking can be shown by drawing one image over two or more frames and using arrows to show the camera movement. Zooming in or out can be shown by outlining the framing of both extremes in one frame and using arrows to show the direction of the zoom. Camera shakes can be illustrated by drawing multiple canted frames around a panel.

These camera and transition symbols, when used properly, help make storyboards more valuable and easier to understand.

FIGURE 28.5 Symbol for "cut" between animation storyboard panels.

FIGURE 28.6 *seaQuest DSV* example of illustrating a tracking shot. The camera follows from framing 1 to framing 3 along the route shown. Board by Mark Simon. (© by Universal City Studios, Inc. Courtesy of MCA Publishing Rights, a Division of MCA, Inc.)

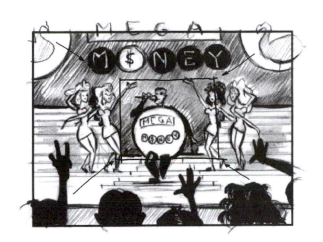 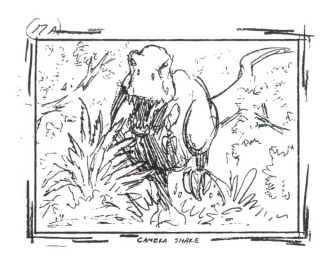

FIGURE 28.7 The first panel shows zooming into a medium shot of the man in a ball-suit. Panel by Mark Simon for a Lotto Mega Money commercial. The second shot shows a camera shake as the dinosaur approaches. (Panel © EPL Productions, Inc.)

CHAPTER 29

NUMBERING

Numbering may seem simple enough. Just mark down a new number for every drawing and that's enough, right? Wrong. Improperly numbered boards can become a major waste of time for productions.

There are three main reasons to properly number your boards. One is to make it easy to view the boards in the correct order. Two is to keep them in the correct order. The third reason is to help the production break down the number of shots needed for any particular scene. If a script is broken into scene numbers, use those scene numbers as reference.

In live action, if you are going to be numbering both the panels (drawings) and the shots (individual camera setups) you will need to have two different types of numbering. Not every director wants storyboards numbered according to each individual shot, so ask first.

Numbering for the continuity of your panels, the order in which they should be viewed, means each new panel should have a new number. Let's say you draw fifteen panels for a scene that are numbered 1 through 15. When you are finished, the director tells you that she wants to add two drawings in the middle. These will be consecutive shots placed between panels 6 and 7. These two new panels will be numbered 6A and 6B. There are two reasons to add the new numbers this way. One, you won't have to completely renumber. This may not seem like a hassle with only fifteen panels, but when you have forty or more and you add a few shots, renumbering will get old real fast. The other reason has to do with the crew working off the same information. Many times storyboards get distributed to a number of people before changes occur. If you number the new boards as I have described, the crew will be able to insert the new drawings in the proper place without renumbering their notes.

In live-action production, you have a new shot each time the camera starts rolling from a new position. Each scene is likely to have numerous shots. Each shot may need more than one panel to illustrate the action. When you are numbering the different camera shots in a scene, it is best to use a different numbering format. I like to mark each new shot clearly, such as: Shot A, panels 1–3; Shot B, panels 1 and 2; and so on. This way there is no misunderstanding as to which numbering is for consecutive drawings and which is for shots.

In Figures 29.1 and 29.2 you will see:

A numbered sequence of boards.

The same sequence with added panels and new proper numbers.

(1) Shot A (2) Shot B (3) Shot C

(4) Shot C (5) Shot C (6) Shot D

(7) Shot E

FIGURE 29.1 Redrawn boards from Fox's *Wilde Life* TV movie by Mark Simon. Panels are numbered and broken into separate shots.

Both sets of boards have the shots numbered as well.

In animation boards, every time there is a new background, change in time, change in camera position, or change in the width of the shot, it's considered a new scene. Every scene starts with panel 1.

Proper numbering benefits the entire production and ensures easy insertion of new and revised boards.

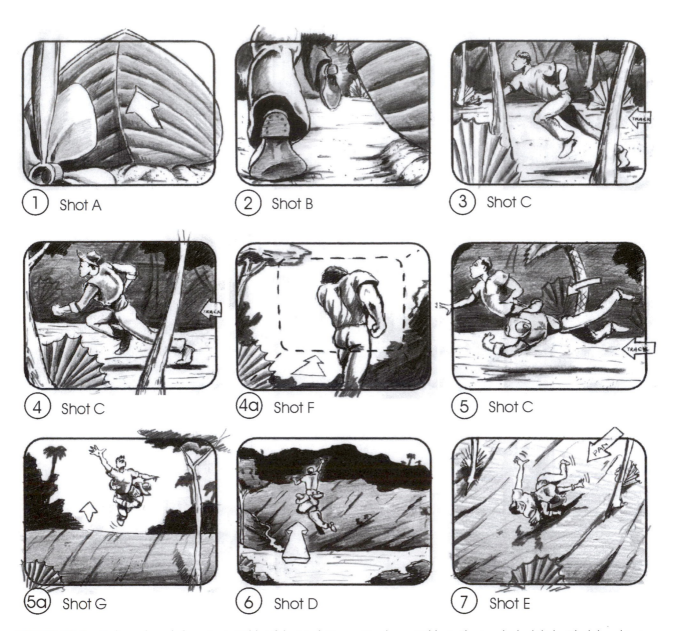

FIGURE 29.2 Redrawn boards from Fox's *Wilde Life* by Mark Simon. Our hero, Wilde, is chasing the bad dude, Blaylok—this time with two extra shots added in at the director's request.

Scene 47, Panel 1 Scene 47, Panel 2 Scene 48, Panel 1

Scene 49, Panel 1 Scene 49, Panel 2 Scene 50, Panel 1

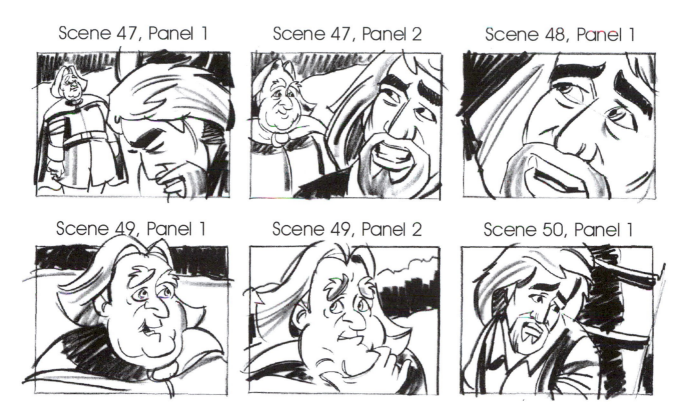

FIGURE 29.3 Boards from *The Pilgrim Program* demonstrate how scenes are numbered differently in animation than in live action. Boards by Chris Allard.

CHAPTER 30

CONTRAST AND MOOD

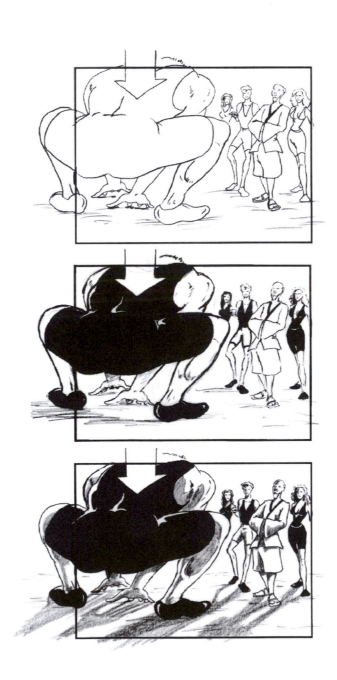

FIGURE 30.1 BOARDS BY
MARK SIMON.

Contrast and mood is also known as chiaroscuro: the pictorial representation in terms of light and shade without regard to color, the arrangement or treatment of light and dark parts in a work of art. That's great, but what does it mean to a storyboard artist? The term itself doesn't mean much, since most clients have no idea what it means. The concept, though, means a lot when it's used properly.

While a client may not understand why some images jump off the page when they look at them, they remember the ones that do. Contrast can be used to simply make an image stronger without affecting the feeling of a scene. It can just as easily be used to set a strong visual tone for the scene.

In Figure 30.1, the top storyboard panel shows a simple yet well-drawn sequence. All of the lines in the drawings are of about equal weight. There are no black or hatched areas. When you look at the overall feel of the art, it's rather airy and your eyes don't flow in any special direction over the art. The drawing may be good, but it is light.

The middle storyboard makes use of contrast without changing the feel of the scene. The lighting seems to be the same but the drawing has more power. The black and shaded areas move your eyes around and make the art more interesting.

The bottom panel uses contrast to change the feel, the emotion, of the scene. The art now reflects intense and moody lighting. The illustration of shadowed areas, streaks of light, and partially masked features gives this sequence a more ominous feel. Filmmakers and lighting designers use the same elements to draw viewers into the mood they are trying to set. Dark areas give the sense of something ominous. A sense of fear and anxiety is much easier to get across in a darkly lit scene. Light and airy scenes are more jovial and light-hearted. A change in contrast and lighting from light to dark can be used to show characters change as they become more twisted, sad, or morose.

While it is rather difficult to find many examples of storyboards, besides in this book, there are places you can find great examples of contrast to help set the tone and make the images "pop." Comic books. There are many gifted artists working in comics, and they use contrast extremely well to show mood and character. Some artists use it more than others. Frank Miller and Todd McFarlane are masters, as are some older artists such as Gene Colan and Bill Sienkiewicz. Comics are quite a bit like storyboards, both in storytelling and in art. While storyboard art isn't usually as detailed as comic art, the use of artistic elements such as contrast works equally well in both.

CHAPTER 31

SPECIAL EFFECTS

Special effects are probably the most important aspect of filmmaking to storyboard. Effects can be extremely complicated, mixing many different elements into the same scene or shot, and they can be quite pricey to produce. For these reasons, storyboards are needed to plan out every portion of every effects shot so that there are fewer problems and fewer expensive reshoots.

Whether miniatures or computer graphics are used for an effect, they will be designed and built in different ways, depending on the needs of the shots as shown by the storyboards. For example, if a submarine is shown shooting a torpedo, it needs to be designed into the model. It's cheaper to build it in during the initial design than to rebuild a model or have to build a new one. If the torpedoes are not needed, there is no reason to incur the extra expense to incorporate them. While this is a simplistic example, it gets the idea across.

Some effects blend live action and miniatures or computer graphics. It is very expensive to have a full live-action crew standing around trying to figure out how to shoot different live elements of an effect without storyboards having already laid out the shot. Storyboards prepare crews for what they will need and also allow potential problems to be dealt with before they occur.

An example of how storyboards help design an effect can be illustrated with a sequence from *seaQuest DSV*.

This bizarre scene had the ship going up against Neptune. The underwater backgrounds and the ship would all be done by computer graphics. The Neptune character would be an actor on a stage against a bluescreen. The bluescreen is used to digitally remove a background from around a character; thus allowing the character to be placed in any environment. The shots where the ship, background, and Neptune were all interacting had to be meticulously planned so it would all work. Here is a brief rundown of what happened.

I met with the director, Casey Rohrs, to get his take on the script and what he wanted to see. I helped design the layout of the scene by suggesting extreme and exciting camera angles. I took his notes and started boarding out the scene. I talked with the head of the effects department at Amblin Imaging about what we wanted to see in the scene. We determined what had to be shot within certain parameters to make the shots work without resorting to rotoscoping. Rotoscoping is a technique of altering an image frame by frame either to remove or alter something that is in the way or shouldn't be seen. Rotoscoping is very expensive and time-consuming, so we were trying to design the shots so that each element could be digitally placed

FIGURE 31.1 *seaQuest DSV* boards help lay out the effects: which elements are live and which are CGI (computer graphics). Boards by Mark Simon. (© by Universal City Studios, Inc. Courtesy of MCA Publishing Rights, a Division of MCA, Inc.)

on one another easily. Some shots were easy. In the first few boards, you see the background, the ship, and Neptune. In those first few shots, nothing in the foreground moves in front of Neptune. This was an easy effect. The computer graphics made the background and the ship. The live-action footage of Neptune was simply placed into the image. The storyboards were important here to make sure that the placement of each character was correct and that both the live-action crew and Amblin Imaging knew what to shoot and create. The tricky shots came up when the ship crossed in front of Neptune. Those shots had three planes of images to combine. The background plate was developed on the computer. The next plate was that of Neptune reaching forward trying to grasp the *seaQuest* ship. The top plate was of the ship trying to escape. Amblin Imaging had to render the ship against a digital bluescreen, just like Neptune, in order to place it on top of the other images. One thing we had to watch for in shooting was that Neptune's hand could not cross in front of the ship. In the preproduction meeting with these storyboards, items like this were brought up so the crew knew the parameters. The actor was also shown the boards so that he knew how his actions fit into the composited scene. The shots where you see a close-up of Neptune's hands reaching for the ship had the same considerations. His hands and fingers could only be seen on one side of the ship at a time. The first shot shows his hand in front of the ship, but his fingers do not wrap around behind it. The next shot shows his hand just behind the ship, but his thumb does not cross in front of the image. After studying these boards, Amblin Imaging asked that we provide a model in the shots representing the size of the ship that the actor could reach for. Luckily the retail models at Kmart were the perfect scale, and that's what we used.

As you can see, the boards served as an invaluable tool in this sequence. Problems were circumvented, shots were made more exciting, and different crews in different states were able to work efficiently together. This is the magic of storyboards.

Effects can also be entirely live action. Let's say you have a scene where the script calls for a bridge to explode. The UPM (unit production manager) needs to know how much money and time to budget for an effect such as this. A stunt coordinator may be asked about the cost and time needed, but without story-

FIGURE 31.2 *seaQuest DSV* board shows the CG (computer graphics) ship in the foreground and Poseidon reaching for it. We made sure not to have his hand cross in front of the ship, which would have meant expensive rotoscoping around his fingers. Board by Mark Simon. (© by Universal City Studios, Inc. Courtesy of MCA Publishing Rights, a Division of MCA, Inc.)

FIGURE 31.3 My hand holding the *seaQuest* ship as I draw it.

copters flying around, or any number of options. Story-boards determine the exact look the production needs to get, and with them the stunt coordinator can properly plan and budget, and thus the UPM can schedule the stunt accurately. These same storyboards allow the live effects team to design and build the proper FX equipment, the props guys to know what they have to provide, the AD (assistant director) to plan for all the extras and background talent, and the rest of the crew to preplan accurately for the scene.

Some effects may be a combination of live action and foreground miniature work, such as a high shot of two men walking up to a giant castle. The men and the ground around them may be the only life-sized elements in the picture. The castle may be a miniature placed closer to the camera so that it appears very large in comparison to the men. If both elements are in focus and the life-size actors do not move behind the miniature (the art) the shot will look real. Storyboards are the best way to previsualize which shots are needed from what angles and which shots will need this time-consuming miniature

boards, a precise estimate would be hard to give. A director may want a truck to flip and then explode, heli-

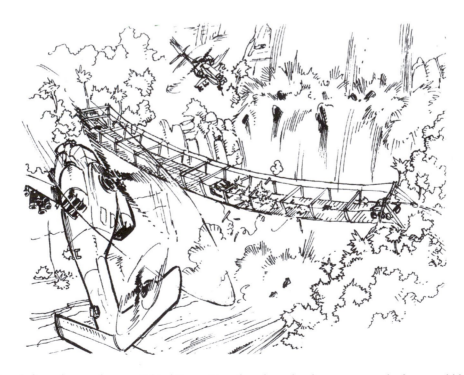

FIGURE 31.4 Boards from the arcade game *Behind Enemy Lines* show how the choppers enter the frame and blow up the bridge. (Boards © EPL Productions, Inc.)

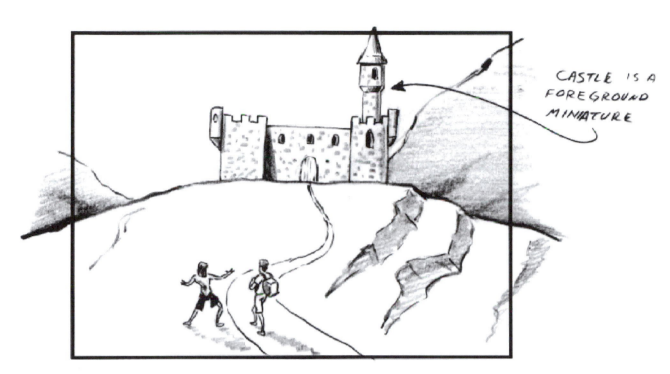

FIGURE 31.5 Storyboard shows characters approaching a castle. The side note shows that the castle is actually a miniature close to the camera, which only appears to be sitting on the hill. As long as the characters don't walk up the hill so high that they disappear behind the castle, the effect will work.

effects rig. Having each shot ready on time also saves productions valuable time.

There are many different types of effects that may be boarded. Some are quite intense and others are quite simple, but even the simple ones need to be planned. An effect that the prop master can take care of, such as an earring falling off an actress on cue, may not be difficult, but many times such things are not written into a script. A director may come up with situations to enhance a scene. He will tell his vision to the storyboard artist who in turn illustrates it for the crew. Many crew heads have been thankful for storyboards when they see something they did not previously realize they needed to prepare.

CHAPTER 32

CONCEPTUAL ILLUSTRATION

Storyboard artists often serve the role of conceptual artist on projects. Conceptual art illustrates the designer's vision for the director and producer to agree upon. This may include rendering set ideas, enhancements to locations, character designs, wardrobe, props, and more. On feature films this position is often called production illustrator.

Since a storyboard artist is generally the only crew person specifically hired simply to draw, the job of illustrating ideas naturally falls to him. Once an idea has been agreed upon, the accepted rendering is often used to design and build the final product.

The approved drawings are given to the producer and director to work from. Copies go from the production designer to the art director, who makes notes on them regarding construction materials, swing flats (parts of the set that can be removed for access by the camera), colors, and any changes. The drawings are then given to the set designer, who draws blueprints of the set, or location, which tells

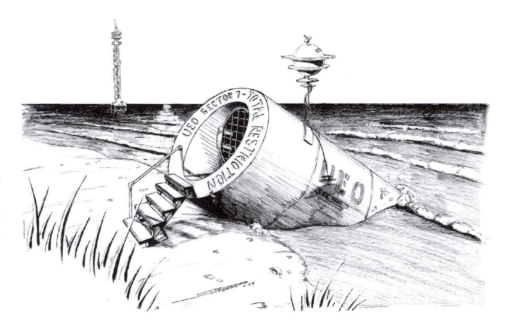

FIGURE 32.1 Concept art for second season premiere of *seaQuest DSV*. This set was never built due to script changes. The tower in the background existed at the location. Production Designer: Vaughan Edwards. Artist: Mark Simon. (© by Universal City Studios, Inc. Courtesy of MCA Publishing Rights, a Division of MCA, Inc.)

FIGURE 32.2 *seaQuest DSV* location videos were shot and frames were printed, which I used to illustrate over to show how the CG effects that would be added. Production Designer: Vaughan Edwards. Artist: Mark Simon. (© by Universal City Studios, Inc. Courtesy of MCA Publishing Rights, a Division of MCA, Inc.)

the rest of the crew all the construction details, size, color, placement, and so on. The blueprints and the conceptual art are then passed on to construction. The blueprints inform construction how to build the set, and the conceptuals show them how it should look.

On the series *seaQuest DSV*, I started as their storyboard artist about a month before production started. Directors do not usually start preproduction on TV shows until about a week (two weeks if it's a two-hour show) before shooting starts. This left a lot of time for me to work directly with the production designer, Vaughan Edwards. Vaughan would give me thumbnails of his ideas for the sets. I would then sketch them. He would make notes and I would do the finals. He would then take the final art to the producer to get the final OK before blueprints were drawn. I wound up drawing from verbal descriptions, sketches, and blueprints (sometimes sets are designed without illustrations first, so I would sketch the sets using the finished plans as reference). I also sketched ideas for wardrobe and props. Once the director came on board I started working with him on specific scenes. There were times when the director had an idea to enhance a location and what he wanted to see. The designer and I would both sit down with the director and come up with ideas. I would then render the location and the director would get clearance to proceed.

To illustrate how a special effect should be included in existing footage, you can mock up the final look on an actual frame. Illustrating and compositing can be done by hand or in the computer. On *seaQuest* we printed out color frames from a video printer and I pasted images onto the prints to show where the CGI needed to be placed. More and more artists are using computers for the same effect. Using *Photoshop*, foot-

age can be manipulated very quickly and easily. Elements can also be composited onto an entire scene within *After Effects* to produce an animatic.

On commercials, a storyboard artist may work off of general ideas as much as a finished script. These boards set the tone of the commercial. The illustrations conceptualize not only the look of the set and locations, but the camera angles and lighting as well. These are then shown to the client for approval. Presentation boards are described in detail in the chapter on Presentation Boards vs. Production Boards.

Conceptual illustration not only covers drawings of sets, but also of creatures, props, costumes, and vehicles. Anything that needs to be designed, built, changed, enhanced, or created needs to be illustrated first.

FIGURE 32.3 Panel shows camera moves and specific lighting needed on location for David Nixon Productions. Artist: Mark Simon.

FIGURE 32.4 From left to right, alien creature illustration, which was then turned into a crew shirt. The metal skull concept was used to reveal a character as an android. The futuristic helicopter was used in backgrounds. All images designed and used on *seaQuest DSV*. Artist: Mark Simon. (© by Universal City Studios, Inc. Courtesy of MCA Publishing Rights, a Division of MCA, Inc.)

Famous artists whose artistic styles films like to rely on are sometimes called upon to illustrate or paint production art. H. R. Giger was hired to create the biomechanical designs he's so well-known for for the *Alien* movies. Even Salvador Dali was called upon by Disney.

His paintings were not of specific designs or characters, but were used as visual guides to inspire the staff artists.

Another recent example would be Disney's *Hercules*, whose conceptual illustrator and production designer was British cartoonist Gerald Scarfe. Scarfe is

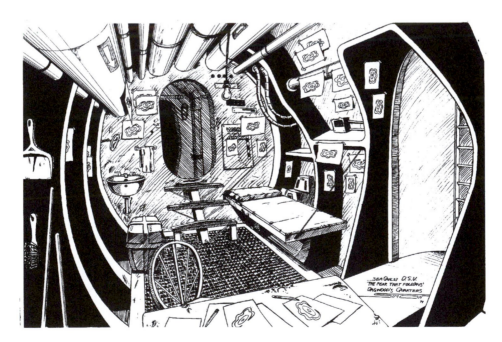

FIGURE 32.5 Dagwood's quarters in *seaQuest DSV*. Set design and placement of props on walls and table for episode "The Fear That Follows." Dagwood was drawing images that he covered his walls with. This was a redress of a hallway set. Production Designer: Vaughan Edwards. Artist: Mark Simon. (© by Universal City Studios, Inc. Courtesy of MCA Publishing Rights, a Division of MCA, Inc.)

well known for his political cartoons in the *Sunday London Times*. He also worked on *Pink Floyd's The Wall*. One of the natural elements in Scarfe's art is the use of serpentine curls, which was heavily used in *Hercules* to give it a distinctive look.

Syd Mead is a famous visual futurist who got his start designing cars at Ford. He is responsible for the conceptual art for such movies as *Blade Runner,* V'ger in *Star Trek the Motion Picture, TRON,* and *2010: The Odyssey Continues*. His work designing futuristic cars, products, and living conditions have been sought after by Hollywood executives.

Originally, Syd Mead was designing just the high-tech vehicles for *Blade Runner*. When the director Ridley Scott saw the background vignettes in the drawings,

Syd was asked to create ideas for the street sets. Syd's next assignment was visualizing all of the hardware accessories in the densely detailed movie.

Conceptual artists may have different titles on projects depending on what type of project it is and what their overall contribution is. On animations, the main conceptual artist is usually the production designer. On films he may be the production illustrator, illustrator, or storyboard artist. Many production designers do their own beautiful illustrations, like the great Ray Harryhausen of *Jason and the Argonauts* fame. Whatever your title may be, the purpose of your work is to design and inspire. Even on the lowest budget productions, great illustrations may lead to phenomenal looking sets.

CHAPTER 33

FRAME DESIGN

Another title for this chapter could be "Balance." Visual balance on a theater or TV screen does not necessarily mean centering an object on the screen. More often it refers to giving room to an object or character in the direction he or she is facing.

When you look at a painting, you probably don't see one object in the center and equal sized and numbers of objects surrounding it. What you probably do see is a placement of objects on the canvas that is visually pleasing to the eye and lets your gaze move about the image equally. Frame design in storyboards moves your eye too.

The biggest difference in the frame design of film or TV and that of comic books or paintings is that you are designing the look over a sequence of moving images, not just a single image.

FIGURE 33.1 Foreground hands add an interesting balance to the frame. Lotto Mega Money commercial boarded by Mark Simon of Animatics & Storyboards, Inc.

FIGURE 33.2 PROPER FRAMING IS SHOWN WITH SPACE LEFT IN FRONT OF THE CHARACTER. STORYBOARD BY KEITH SINTAY AND MARK SIMON.

When you have a close-up of a character looking camera right (viewer's right) you should frame the character on the left-hand side of the frame. This leaves room in front of where the character is looking, which gives the shot a nice balance.

OTS (over the shoulder) shots have the foreground character very close, and very large, to one side and up close to the camera. The character(s) they talk to are on the opposite side and are much smaller. The frame will balance, even though the images are not evenly placed in the frame. This is called asymmetrical balance.

Using extreme angles, foreshortening, and interesting layouts makes scenes visually exciting.

The balance of the frame may also change during a shot. When something is moving in the frame it may start small in the distance and move to an extreme close-up or pass right by the camera. How an object or character moves across the frame and affects the visual design is also a key feature of an exciting set of boards.

Directors look for the storyboard artist to add exciting staging to their shots. Always look for interesting angles and setups for shots, as long as they work within the overall look of the project.

FIGURE 33.3 OVER-THE-SHOULDER SHOT SHOWING ASYMMETRICAL BALANCE BETWEEN THE ONE MAN IN THE FOREGROUND AND THE TWO MEN IN THE BACKGROUND. STORYBOARD BY DAN ANTKOWIAK.

FIGURE 33.4 Panel shows an interesting angle through a woman's legs. Board by Dan Antkowiak.

CHAPTER 34

COMPUTERS AND SOFTWARE

FIGURE 34.1 Screen shots and frames from *Storyboard Quick* software by PowerProduction software.

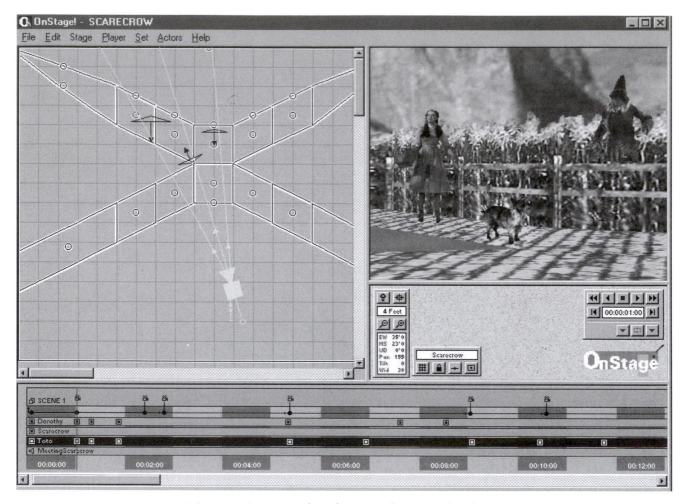

FIGURE 34.2 Screen shot of *OnStage!* by StageTools software.

Computers are being used more and more in producing storyboards. Artists are using computers to enhance their art and nonartists are using them as production support.

For people who can't draw, there are some, albeit few, software packages for developing storyboards. Most of the images in these programs are rather stiff compared to custom hand-drawn boards, but they are quick and easy to master.

Three-dimensional rendering programs can render beautiful boards of logos, flying objects, and so on, and may be great for what you need. But they will take much longer and cost you much more than developing ideas with a pencil and paper. If you are putting together a high-budget presentation, you may want to have the crisp output from an expensive 3D system but even then you should develop your initial ideas quickly and cheaply by hand and then have them rendered from

a computer. *Storyboard Quick* and *OnStage!* are two programs for the artistically deficient, although each can also be used by artists to support their work. *Storyboard Quick* uses libraries of characters and props and allows you to choose the angle, drop characters anywhere in the frame, zoom into any element of the scene, add captions, duplicate frames, and print out multiple storyboard formats. You can also import scripts directly into the program. It works on both the Mac and the PC. *OnStage!* also has libraries of characters, but it is made more for using custom images. *OnStage!* not only helps you build scenes frame by frame, it helps you lay out the scenes on a floor plan, track your camera moves, and produce an animatic of the action. (See Chapter 22, "Animatics," for more details.) The director can see the set in a plane view and move the camera around a set. This is a fantastic system for multiplaning (moving art on different dimensional planes), which is

FIGURE 34.3 THE bottom sketch for the video game *Stellar Quest* was scanned into *Adobe Photoshop* and painted in the program. (© EPL Productions, Inc.)

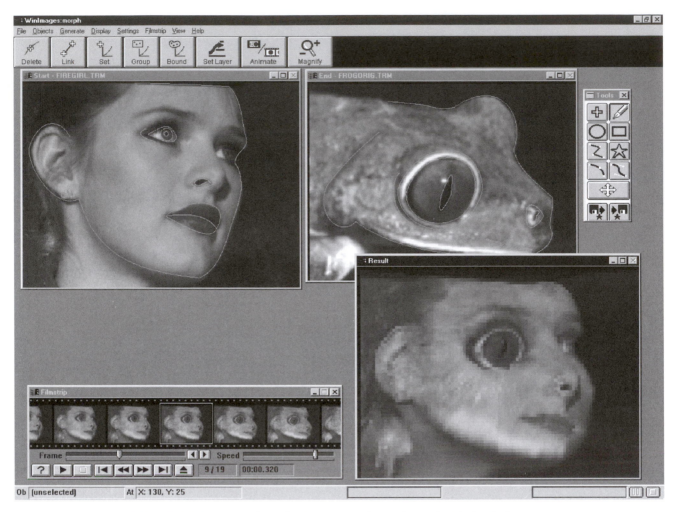

FIGURE 34.4 Screen shot of *WinImage* morphing software by Black Belt Systems.

found in very few of even the highest end animation systems. *OnStage!* is a Windows 95/98/NT-based system that flies with an OpenGL card. (If you don't know what an OpenGL card is, you don't have it and don't need it.)

There are disadvantages to computer-generated storyboards as well, as they tend to look stiff. You are also not able to be as visually flexible in what you can portray as an artist drawing freehand. There are only so many positions and expressions of each character or item in program catalogs and aside from drawing a new image and importing it into the program, you are stuck with somewhat limited images. Computer programs are also not as interactive as a storyboard artist who can offer ideas and clarify what is wanted. As fast as computers are, they are not as fast as a good storyboard artist.

Artists who use the computer to enhance their art need a few important pieces of equipment. There's the computer, of course, and you can never have too much memory or a large enough hard drive. Large monitors are a must; you have to see what you're working on without squinting or your eyes will get too tired. A graphics pad is quite helpful. Many people find them hard to use at first, but try it anyway. They make graphics programs much more like working on paper. You can't do much of anything without a scanner. If you need to do a lot of scanning, be aware that low-cost scanners are extremely slow and give you limited abilities to adjust your scanned image. And don't forget a good printer. No matter how good you may be able to make your images, without being able to print them well, they won't look good. Try to find a laser printer

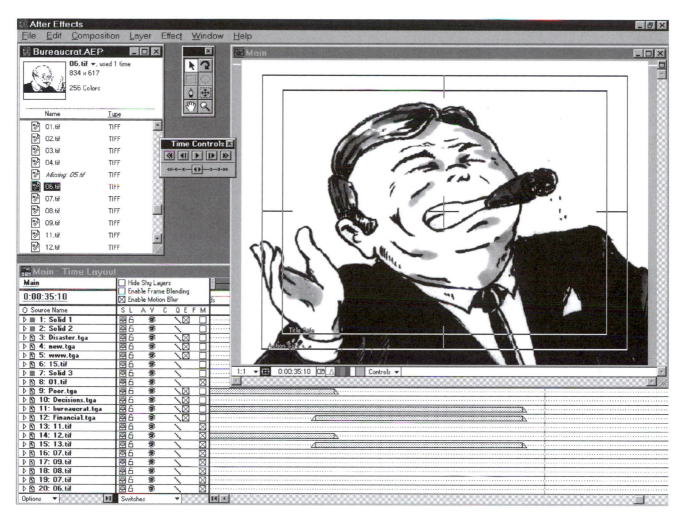

FIGURE 34.5 SCREEN SHOT OF *Adobe After Effects* FROM AN ANIMATIC PRODUCED FOR DONER PUBLIC AFFAIRS BY ANIMATICS & STORY-boards, INC. ARTIST: MARK SIMON.

with at least 600DPI that will run heavy paper (Hewlett Packards are great). Color printers are getting better all the time, so shop and compare.

The most important piece of all is obviously the software. Many artists use paint programs to color their boards. The most popular paint program is *Adobe Photoshop*. It's the graphics industry standard. *Corel PhotoPaint* and *Fractal Painter* also work very well. Cleaning up stray lines, coloring an image, compositing, warping a portion of an image, and blurring the background are all easy and look impressive with these programs. Adding professional text to a storyboard frame is easy in any paint program or in *Adobe Illustrator* and *CorelDraw*.

Morphing programs can also be used to warp drawings or photos to better suit your needs. If you're producing animatics you may need morphing to build video files. Programs such as *WinImage, SuperGoo,* and *Squizz* offer great morphing and warping tools.

Still images aren't the only ones computers are used for. Moving images are also manipulated with computers to make animatics, animation, and special effects. *After Effects* is the most common software for compositing moving images. You can produce simple pan-and-scan animatics, and you can produce feature film effects with it. *After Effects* will run on both Macs and PCs. You can also print frames from your composites to serve as storyboards.

Computers are also incredibly helpful in supporting your business. Besides the word processing, which makes updating résumés a breeze, you can track your billing, balance your checkbook, lay out your own storyboard forms, design your advertising, and more. If you need to copy your gray-tone boards on a black and white copier, just scan and print your boards. Scanning breaks the image into tiny dots that copiers can reproduce, whereas gray markers normally look like black smudges when copied. If you are also connected to the Internet, you can E-mail your scanned boards to clients in any part of the country instantly.

Artists and nonartists can benefit from using computers as storyboard support, but computers can't replace the creative mind in the development of a well-designed scene. Computers are only tools, but they can be very powerful tools.

Board by Alex Saviuk. Alex's idea to add the hand coming out of the slot to get the mail helped make this a more successful presentation. Alex's background is as a comic book artist for Marvel and DC. He has drawn for *Spiderman*, *X-Files*, and others.

Board by Mark Simon. Client: The Golf Channel. The "More" campaign was meant to show the word *more* passing over a golf course background. I used a digital blur on the background to help the letters stand out, and I used Corel to place the text so it looked nicer than my chicken-scratch. The shadows behind some of the words help give the panel a three-dimensional look.

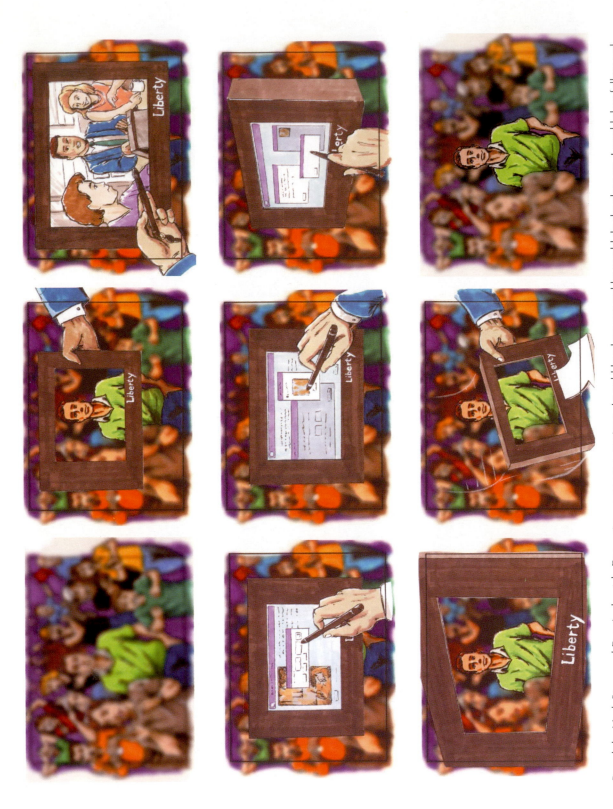

Boards by Mark Simon and Dan Antkowiak. Dan assists me on many projects. I would lay them out and he would do the clean up. I would then follow and do the color and digital work. The commercial was meant to show how this Liberty hand-held device makes everything more clear. I drew one background and blurred it two ways. The first blur was over the entire panel. The second blur covered everything accept the man. The foreground hand and unit were placed over the top.

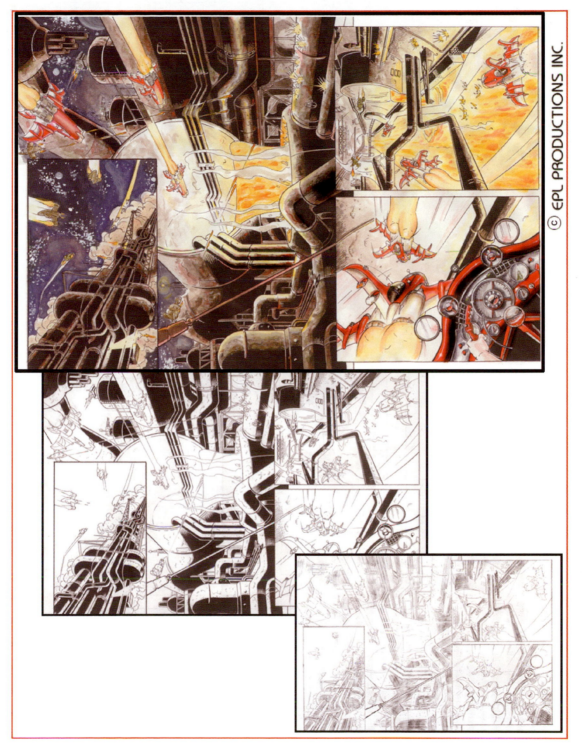

© EPL PRODUCTIONS INC.

Boards by EPL Productions, Inc. This storyboard was developed like a comic book for a video game presentation by Gene Lynch. You can see how it was penciled, inked, and colored for the final piece.

Boards by Chris Allard for Ocean Spray Cranberry Sauce. The turkey is trying to keep the oven door closed and won't come out unless Ocean Spray Cranberry Sauce is on the table. From these boards it was decided to use a puppet for the spot.

Boards by Chris Allard for Friendly's Ice Cream. This board was about the renovating of the Friendly Restaurants. In the spot the food comes alive after store hours and starts the makeover.

CHAPTER 35

TRICKS OF THE TRADE

FIGURE 35.1 Foreground and background elements were blurred in *Corel Photopaint* to add depth. Storyboards by Mark Simon.

As in every industry, there are tricks that the pros use to help them get their work done quickly and with quality. Everyone works differently and with different tools, so many of these tips won't pertain to you. Make use of the tricks that work within your style and with what you have available to you.

QUICK DRAWING

- *Tracing reference photos.* Why waste the time it takes to draw a detailed background if you have a photo of that background you can trace over.
- *Tracing your own art.* There's no need to redraw something you've already drawn once.
- *Nonreproduction blue pencils.* Light blue pencil lines are usually not picked up by copy machines. You can quickly rough in the shapes in your storyboards with a blue pencil and go directly to your cleaned up drawings without having to worry about erasing your layout lines.

PENCILS

- *Soft leads.* The softer the lead, the better and darker it reproduces. Just beware that soft leads also smear easier.
- *Mechanicals.* Mechanical pencils never need sharpening.

CAMERA DEPTH

- *Digital blurring.* Use a computer paint program to blur part of an image
- *Use of light and dark.* Dark recedes.

INKING AND COPYING

- *Copiers.* Copying pencil drawings acts like inking, giving you clean crisp lines that won't smear under most color markers.
- *Feeders.* Don't run original pencil art through feeders on most copiers. Most feeders drag the paper and will smear your art.
- *Script.* Reduce and tape the script onto your boards instead of rewriting it all.

COMPUTERS

- *Clean up.* You can scan in your rough sketches and clean them up in *Adobe Photoshop.* This allows you to digitally color and manipulate your art. You can also layer images over different backgrounds without redrawing the backgrounds each time. Other bitmap softwares used for digital coloring and manipulating are *Fractal Paint* and *Corel Photopaint.*
- *Layering.* Again *Photoshop* and *Photopaint* are used a lot to layer new characters over the same backgrounds, as are Macromedia's *Director, OnStage,* and many 2D animation programs such as *Adobe After Effects. Director, After Effects,* and *OnStage* are also used to animate layers for animatics.
- *Halftone.* Scan your images and print them out. This breaks the image into tiny dots, like a newspaper photo, which copiers can reproduce better.
- *Morphing and warping.* Programs such as *WinImage, SuperGoo,* and *Squizz* allow you to morph

FIGURE 35.2 The pencil sketch was imported into *Adobe Photoshop,* cleaned up, and painted. (© EPL Productions, Inc.)

FIGURE 35.3 USE of computers to place lettering on boards looks more professional. Board by Mark Simon.

multiple images together for still frames or video files for print and animatics. They also allow you to stretch and manipulate single images.

- *Lettering.* Signage and logos look nicer when done with a computer. Lettering in perspective is much better and more accurate when done with software instead of by hand.

CAMERAS

- *Reference.* We all need references to draw from at times. I keep four different types of cameras around for different situations.
- *35mm camera.* When I'm going on big location scouts and I don't need immediate photos, I use a 35mm camera; 35mm film is cheap to print and you can usually get the prints back within an hour.
- *Polaroid.* When I need a quicker turnaround of photos, I bring my Polaroid. Polaroids develop quickly, but they're not as clear and are pretty pricey.
- *Digital camera.* I also use a digital camera for quick turnarounds. The newer digital cameras take great pictures, and you never have to pay for film or developing. I just download the images I want onto my computer and print out what I need.
- *Camcorder.* The last camera I use is a camcorder. When I'm trying to capture something that's in motion, sometimes the best way to do it is to frame-by-frame advance a video of the motion. I then pause the tape on the frame I want to draw.

FIGURE 35.4 I used myself as a model for this image, which was used in an animatic for a client.

MIRRORS

- Use yourself as a reference.
- Using two mirrors allows you to see your own profile and back.

FIGURE 35.5 Door peepholes have extremely wide-angle lenses in them, which help small objects look large.

WIDE-ANGLE SHOTS

- *Door peephole.* Look at your reference through a wide-angle door lens and you get a totally different perspective of an object. This works great when you're trying to get an idea of how a miniature (like a submarine or space ship) would look up close if it was lifesize.

ERASERS

- *Electric erasers.* It still amazes me how many people don't know about electric erasers. They are super fast for erasing small and large areas. They also work great for making reflection lines in glass and water renderings.
- *Kneaded erasers.* They don't crumble and make a mess like other erasers. They work extremely well on soft pencil leads.

REVISIONS

- *Keep your originals.* Clients often call back with changes after delivery. It's easier and faster to make changes if you still have the originals. If clients ask for the originals, tell them you prefer to hold onto them in case they ask for any revisions.
- *Draw only with pencil.* It's easier to erase a pencil line for a revision than it is to white-out an inked line or start over.
- *Paste revisions over originals.* Use a glue stick or spray adhesive to adhere new panels over the old ones. Animation boards often have sticky notes stuck over just a portion of a panel that needs to be revised.

APPROVALS

- *Fax.* Sending a fax to a client for notes and approvals saves you precious time. If you're going to fax roughs, don't do much of your work with a blue pencil—it can't be copied or faxed.
- *Meetings.* Always try to get approvals before you finish your work. This will make your changes easier and waste less of your time.
- *Thumbnails.* Rough sketches with a client help limit miscommunications and speed every project along.

FIGURE 35.6 I roughed out the thumbnails in my initial meeting with the director. By the time I left to finish the art, I already had approvals on the entire board. Lotto Mega Money storyboards for Bone Fish Productions by Mark Simon of Animatics & Storyboards, Inc.

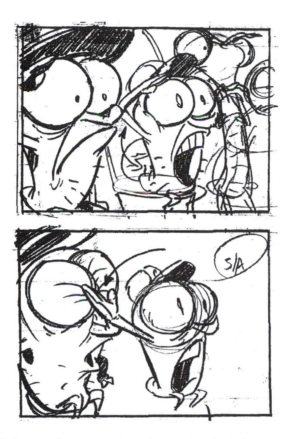

FIGURE 35.7 *SANTO BUGITO* boards show not having to redraw elements that don't change on an animation storyboard. An S/A (same action) is placed over areas that stay the same. This saves a great deal of time. (© Klasky Csupo.)

ANIMATION BOARDS

- *Lettering.* For those of us who hate lettering, you can copy the script and cut out sections of the dialogue and tape them beside your boards instead of hand writing out the entire thing.
- *Moves.* Show multiple extremes of simple moves in one frame, such as an arm starting in a lower position and moving to a higher position.
- *Character motion.* If only one character moves in a scene, draw all the characters in the first panel and then just draw outlines of the stationary figures. This helps draw the animators' attention to the character to be animated.

GENERAL BUSINESS

- *Expenses.* Keep track of all your business expenses: advertising, printing, copies, etc. They are a tax write-off.

- *Vendors.* Know where important vendors are before you need them, such as late-night copy stores and weekend drop-off points for overnight deliveries.
- *Communications.* Have your own fax machine and E-mail for sending and receiving images to and from clients.

There is no such thing as cheating when you're producing storyboards. Do whatever it takes to give your director the images he or she needs. Storyboards are not art that will be sold for its own merit. It's important that you deliver quality boards in a timely manner. The less time it takes you to do tedious tasks, or to redraw the same image over and over, the more time you'll have to improve the layout, story, and quality of your art.

CHAPTER 36

PRESENTATION AND DELIVERY

FIGURE 36.1 Example story-board layout sheet available in most art stores. Not practical for professional use. The black background, shape, and size are problems.

There are many suitable ways to present your boards to your clients, as long as they're neat, clean, professional, and on time. You can buy booklets of storyboard forms, which have a number of different layouts. Some have three per page, and others have up to twenty panels per page. You need to determine how you like to work best, and find out from the client how they prefer the boards to be presented. You may want to use the tiny panels for thumbnails and notes, and the larger panels for your finished pieces. Most storyboard artists use their own layouts, since most forms that art stores carry have dark negative areas that don't reproduce very well.

Keep in mind that it is infinitely easier for a production to run copies of letter or legal size paper than many of the off-sizes offered by some of the storyboard-form booklets found in art stores.

You should use a form design that allows plenty of room for notes. Even if you do not write notes on the storyboards, your client probably will.

If storyboards are mounted, they are difficult to copy en masse. I may offer to mount them on poster board as a professional courtesy. If a client prefers to have storyboards mounted on a better stock material, I will charge for the added expense, plus 10 to 30 percent. This would be invoiced under Applicable Expenses or Reimbursable Expenses. Don't mount originals; they're hard to copy mounted. Always give your clients a set of storyboards they can run through a copier.

Each page of your storyboards should have five specific pieces of information. (1) You need to include the project name on each sheet. Both you and the pro-

duction company are likely to be working on more than one project at a time, and you don't want to confuse boards for different projects. (2) Put your name and (3) your phone number on each sheet. This makes every page an advertisement for you. (4) Number each page. Even though each panel is marked, it is easier to quickly put storyboards in order by using the page numbers. (5) Finally, you need to include the scene number on each page. The scene number is crucial to the production for reference to the script. Some scripts are not broken into scenes, however, so scene numbers are not always necessary.

Another element of your presentation is how you finish off your boards. Are you giving your client rough pencil, finished pencil, grey tone, or color boards? This is up to you and your client. High-budget projects like to have at least grey-tone boards, if not full color. If you have a lot of panels to draw in a short period of time, you probably won't be able to give them color boards, since they take so much longer to draw. Make sure you and your client are clear about what they expect you to deliver before you get started.

When mailing finishes to a client, include a stiffener in the envelope to keep your work flat. Never fold finished art.

Deliver your invoice with your finishes if possible. Try to get clients to sign one copy of the invoice and leave a second copy with them. This can be helpful if there's any confusion later about your billing.

The way you present your finished boards is the last thing clients will remember about you. The happier they are with your final delivery, the more likely they are to call you again.

PART THREE

Interviews

Storyboard Artists

CHAPTER 37

Mark Moore: ILM Storyboard Artist

Credits: *Dragonheart, In the Mouth of Madness, Star Trek Generations, etc.*

Au: How did you get started storyboarding, Mark?

MM: I started in fine art, then graphic design, some architecture, then finally industrial design.

Au: What supplies do you use?

MM: I use Col-erase light blue pencils to begin with.

Au: Do you prefer finishes in pencils or inks?

MM: I prefer pencil, because of the constant revisions.

Au: What kinds of projects do you usually work on?

MM: Feature film special effects.

Au: What do you think are the most important qualities for a storyboard artist to have?

MM: The ability to draw *everything* in perspective and to draw quickly.

Au: How do you prefer to work with directors?

MM: I usually work by fax, which allows quick feedback time.

Au: Any good war stories?

MM: Try drawing the USS Enterprise from every conceivable angle!

Au: What sorts of references do you use?

MM: Usually model kits—looking through a wide-angle door lens.

Au: What books do you recommend to other artists?

MM: *The Art of Star Wars, Empire,* and *Jedi. The Making of Jurassic Park. How to Draw Comics the Marvel Way.*

Au: Do you use computers to assist you? What programs do you use?

MM: *Adobe Photoshop.*

Au: Any helpful hints or tricks of the trade?

MM: Scanning rough sketches in, then cleaning them up in *Adobe Photoshop.*

Au: How do you like to work, thumbnails to sketches, blue pencil, etc.?

MM: Blue pencil first, then Berol 314, Xerox, then Berol Prismacolor markers, Prismacolor white pencil, and a little white out.

CHAPTER 38

CHRIS ALLARD:
STORYBOARD ARTIST

Credits: *Anatasia, Ingalls Advertising, MCI, TJ Maxx, Parker Brothers, etc.*

Au: How did you get started?

CA: I started as a Junior Illustrator for Ingalls Advertising in Boston thirteen
 years ago.

FIGURE 38.1 Chris Allard

Au: What supplies do you use?

CA: I use every medium. Basically Pentum sign pens, Berol Prismacolor pencil (black), Prismacolor markers.

FIGURE 38.2 Thumbnail storyboards for Craisins, dried cranberries that drive people crazy when they eat them. Boards by Chris Allard.

Au: Do you prefer finishes in pencil or inks?

CA: Both. If the board is humorous, I prefer pencil (it keeps the energy in the drawing). If it's a dramatic board, ink (shadows, etc.).

Au: What kind of projects do you usually work on? Film, TV, animations, commercials?

CA: I just finished an animation project in Los Angeles. I usually work on commercials.

Au: What was your favorite project, and why?

CA: It was for a client (Friendly's Ice Cream) where I was developing an animated family called "The Grumps." Not only did I art direct the storyboards, but I created four puppets too.

Au: Tell us about your work on the Fox Animation Feature *Anastasia*.

CA: I was hired by Don Bluth to work on *Anastasia* at Fox Feature Animation in Phoenix back in 1995. I was part of the start-up team for the project. Housed in a $100 million animation studio was awesome. I really didn't see much of *Anastasia* at the studio because the script was still being worked on. Most of my time was spent working on other projects. I was honored to have been selected from over 10,000 applicants as a storyboard artist under the very talented Mr. Bluth for *Anastasia*, but I returned to Boston because I'm happiest working a lot and under very short deadlines. That's the biggest difference I've found between working on feature animations and TV commercials.

Au: What do you think are the most important qualities for a storyboard artist to have?

CA: To communicate visually an idea to sell to a client. I've found that many art directors are young and don't have the experience (or patience), so I make sure a storyboard has the things they forget.

Au: How do you prefer to work with directors?

CA: Roughs (or thumbnails). Sometimes an art director will "act out" a script (with no roughs).

FIGURE 38.3 Boards for *The Pilgrim Program* film. Boards by Chris Allard.

Au: How much of your work does an agent bring in?

CA: I do not have an agent, but I'm looking into it.

Au: Any good war stories?

CA: How about drawing fifty-three storyboards in a weekend? And then find out the account people canceled the meeting for that Monday. Or drawing storyboards in a cab on the way to the airport for account people who were boarding a plane. I once had an art director who decided to change a storyboard of blonde, blue-eyed family members to a family of color. He took a marker and tried to fix the problem. What a mess!

Au: What sort of references do you use?

CA: When I have time, I go on the computer to find references. But my strength is my speed. I usually have an hour or so to do three or five boards, so I fake it.

Au: What books do you recommend to other artists?

CA: *The Animation Book* by Kit Laybourne. Any book by Preston Blair, and the good words of Chuck Jones.

Au: Do you use computers to assist you?

CA: I'm afraid I'm in the dark age—sorry.

Au: Helpful hints or tricks of the trade?

CA: I usually will do roughs of a storyboard (real rough) that I then will trace over (with Graphic S translucent marker paper). I find that the roughs have a real energy to them because I'm not afraid if it's not perfect.

Au: How do you like to work, thumbnails to sketches, blue pencil, etc.?

CA: I like thumbnails (or roughs). Even stick figure roughs are good, because I get somewhat of a feel for the direction an AD wants to go for.

CHAPTER 39

JOSEPH SCOTT: STORYBOARD ARTIST

Credits: *Klasky Csupo, Rugrats, etc.*

Au: How did you get started?

JS: I applied as a graphic designer for a position at an educational game studio. When I arrived with my portfolio, I saw some folks animating at their desks. This caught my eye. I applied for a clean-up animation position and got it. During three years at this studio I began to learn about storyboarding. In May '98 I applied as an SB artist at Klasky and I got it.

Au: What supplies do you use?

JS: Pencils. Paper. Post-its. Copy machine.

Au: Do you prefer finishes in pencil or inks?

JS: Pencil.

Au: What kinds of projects do you usually work on? Film, TV, animations, commercials?

JS: TV cartoons. I hope to work on a feature soon.

Au: What was your favorite project, and why?

JS: The Rugrats show *Discovering America*. The characters were fun to draw. The story had great personal appeal to me.

Au: What do you think are the most important qualities for a storyboard artist to have?

JS: The ability to draw with an economy of lines. Quick sketch ability to relay ideas and action.

Au: How do you prefer to work with directors?

JS: Work out a portion of a script (thumbnail drawings). Then go to the director, hash out any problems, continue onto some more of the script.

Au: How much of your work does an agent bring in?

JS: Agents are vampires. I'm sure they serve their purpose somewhere, somehow (especially foreign artists looking to move to America to work in animation).

Au: Any good war stories?

JS: Very few people will put their ass on the line for you—know this!

Au: What books do you recommend to other artists?

JS: *Shot by Shot* by Steven Katz. *Disney Animation: The Illusion of Life* by Thomas and Johnston. *Hitchcock* by Truffaut. *Animators' Workbook* by Tony White. *How To Draw Storyboards for Animation* (paperback).

Au: Do you use computers to assist you? If so, what system and programs do you use?

JS: No. I do at home when creating my own animatics. I would use *Photoshop* and *Premiere*.

Au: Helpful hints or tricks of the trade?

JS: Constant life drawing—human and animals. Watch and analyze cartoons and movies for action and interesting camera shots.

Au: How do you like to work, thumbnails to sketches, blue pencil, etc.?

JS: Thumbnails. Sketches. Blue pencil. Clean-up blue pencil with B pencil (mechanical).

CHAPTER 40

WILLIE CASTRO: LASER STORYBOARD ARTIST/ ANIMATOR

Credits: Storyboard Artist and Production Manager of AVI, Audio Visual Imagineering

FIGURE 40.1 Willie Castro

FIGURE 40.2 LASER SHOW BASED ON THE MOVIE *MEN IN BLACK*. STORYBOARDS BY WILLIE CASTRO FOR AVI. NOTICE THE SIMPLE LINE WORK NEEDED FOR THE LASER. (© AVI.)

Au: How did you get started?

WC: I got started doing animation in Tallahassee, Florida, at a place that produced CD-ROMs. I

moved from animation to storyboards as projects called for it.

Au: What supplies do you use?

WC: A 2B drawing pencil. Pilot fine point felt markers. Regular copier paper, personal templates, a copier, an X-acto knife, and lots of glue sticks.

Au: Do you prefer finishes in pencils or inks?

WC: I prefer pencil. My art has more energy with pencil—I like the sketchy look. If I have to fax a board to clients, I'll ink it.

Au: What kinds of projects do you usually work on?

WC: Laser shows for theme parks, corporate events, and science centers.

Au: What was your favorite project, and why?

WC: The laser show we did for a Swedish theme park, Liseberg. I designed a bunch of animated appliances in a show about electricity. It was fun music and imagery. I had free creative rein.

Au: What do you think are the most important qualities for a storyboard artist to have?

WC: Good drawing skills. A good sense of design, composition, and staging. When boarding for lasers, you need to have a strong knowledge of the medium and the ability to think in abstract forms.

Au: Any good war stories?

WC: Unrealistic deadlines. A client gave us two days to completely design and board a five-minute laser presentation, and then waited here in town for the boards before heading back.

Recently, a large brush fire circled and threatened our building on a day we had to get a show out. The firemen were trapped outside between the flames and our building trying to save the building while we were being evacuated. We were loading up lasers to save them while trying to finish the show at the same time. The fire got close enough that it scorched

the plants against the building, but we didn't lose anything.

Au: What sorts of references do you use?

WC: Books. Icons and imagery from client brochures. Clip art for styles. Art resource books—you name it. We sometimes look at video for reference.

Au: Do you use computers?

WC: Yes, *Adobe Photoshop* for our color boards.

Au: Any helpful hints for storyboard artists?

WC: Learn to draw three-dimensionally. Do a lot of cut and paste—the copier is your friend. Have a sense of humor about the whole thing.

CHAPTER 41

JESUS TREVINO:
TELEVISION DIRECTOR

Credits: *Babylon V, seaQuest DSV, Star Trek Deep Space 9, Martial Law, feature films*

FIGURE 41.1 JESUS TREVINO

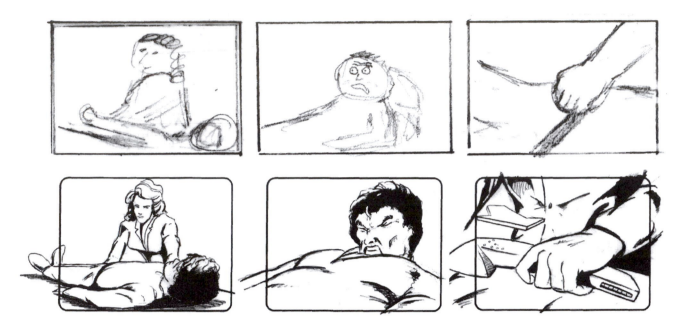

FIGURE 41.2 THE TOP PANELS WERE DRAWN BY JESUS TREVINO AND WERE THEN GIVEN TO MARK SIMON TO REDRAW, BOTTOM PANELS, ON *SEAQUEST DSV*. (© BY UNIVERSAL CITY STUDIOS, INC. COURTESY OF MCA PUBLISHING RIGHTS, A DIVISION OF MCA, INC.)

Au: From having worked with you I know you sketch out your own rough storyboards. Do you always do your own sketches?

JT: Whenever I have the time. Sometimes when you're doing an episodic TV show, the turn-around time between the time I actually get a script and the time I have to go to camera may vary anywhere from five days to three days. I've even had them give me a first draft of the script a day or two before I'm supposed to go film it. So when you have that kind of problem, it's impossible to even have the time to visualize a lot of the stuff. When I have the time, I do try to sketch out the scenes. One reason for doing storyboards is just to give the producers or the powers that be, the writers, or whoever you're working with a sense of what you're going to do and how you're visualizing it.

Au: Did you find it helped you out?

JT: Yeah. I think that as a director, one of the things that we do is we develop a shot list. And my experience has been that the more detailed and the more prepared I am with a shot list, the better job I can do. It doesn't mean that I will always adhere to the shot list. We can alter it as

we need to. But then in terms of planning how the scene is going to be shot, the art director is going to provide me with the environment that I need to film in. The DP [director of photography] is going to give me the lighting or whatever camera moves or dollies, Steadi cam, or whatever we need to make this scene work.

And obviously, on a lot of this stuff, you don't want to show up on the set and think, "God, it would have been great if we would have ordered a crane for this shot," or "Gosh, it would have been great if I'd had a mesh screen to shoot through for the beginning of this sequence." And clearly when I have a script ahead of time I can think those things through, and I can think of how I'm gonna make this scene come alive with everything from, not just the actors, but props, set dressing or whatever. And so I think here's where all of those elements become so important in terms of a storyboard. It's that old adage that a picture is worth a thousand words. And I can sit there and yammer at 'em and let them know that this is what I want, but if I show it to them in a picture, they instantly get it.

Storyboards have become more of a crucial factor in recent years as I've done more science

fiction stuff and as science fiction gets more involved with computer animated imagery (CGI). What winds up happening is it becomes a prudent cost factor to know exactly what you're gonna do. Clearly, if you have a sequence you shot on stage or on a location and they want to add CGI to it, they can do it, but often the way that you shoot it will determine whether that CGI shot that they're adding is a really expensive effect or not.

I found storyboards brought the costs down considerably when we were doing *Third Space*, which was a two-hour TNT *Babylon 5* movie that I directed. The storyboard artist's name was Eric Hillary. There was a sequence where the hero, played by Bruce Boxleitner, is entering this alien artifact and he's in a space-suit. I wound up creating on stage a number of partial sets of what the inside of this alien arti-fact would look like. It's like a giant space sta-tion. Then I built them with the bluescreen in mind. So based on the storyboards, I designed quite a number of shots where he was in the shot and part of the set was in the shot and the rest of it was bluescreen, and we knew that they were going to CGI in the bluescreen part. And so we did this and were able to design a cost-sensitive rendering of this whole sequence, where he goes into this artifact and confronts this giant monster.

In terms of this particular episode, we were working with a real low budget and the first drafts were too expensive, so we had to go back to the storyboard, and in a sense we were cutting on the storyboard. We were say-ing, "Well, if we do it this way and we omit these shots and we do this over here and if we build just this part of the set here and let CGI do the rest, then we can still accomplish this sequence." I really do think that storyboard-ing, in my experiences with the producers, is vastly underrated.

Au: Based on that, do you feel that storyboards more than pay for themselves on a production?

JT: I think that if you have a production that has a need for storyboarding, for example, the CGI needs of *Babylon 5*, then I think it does. If every time you do a show you're saving all this money in terms of helping visualize it and con-

FIGURE 41.3 *seaQuest DSV* boards by Mark Simon. (© by Universal City Studios, Inc. Courtesy of MCA Publishing Rights, a Division of MCA, Inc.)

ceptualize it, then I think you do. I spoke with the producers of *Babylon 5*, who produced five years of the episodic series and each year there are twenty-two episodes. They did not have a storyboard artist on staff. But when we were doing the two-hour movie, I spoke to them and they agreed that we needed a storyboard artist.

They did it for economical reasons. They figured that the investment of a storyboard artist would pay off in the long run.

Where I saw this a lot was working with the *Star Trek* people. I've felt I can make the convincing argument not to be a pennywise and a pound-foolish. The producers saw us doing particularly difficult CGI sequences, and they always wanted us to do storyboards. Typically what would happen is I would do my chicken scratches and I would work with one of the people in their art department. I think on both shows, *Deep Space Nine* and *Voyager,* they had an individual in each art department that could do storyboards. So I would hook up with that person and we would make sure we were minimizing the cost in the CGIs and make sure that we would know exactly what we needed.

Au: When you go out and you're walking a set or a location, do you like to have a storyboard artist with you as you are trying to preplan things and figure out what you're going to do?

JT: Usually I like to think about it before. I guess this applies to not just a storyboard artist but also to an art director and the DP. I mean, in practical terms, when you're doing episodic TV, you're lucky if you can get a DP to go with you because they're shooting the previous episode. But the art director usually goes with you, and we can talk about kind of what we want. But a lot of times I guess my style is to think about the location and often I'll go back by myself and walk the location or the set and visualize. What I like to do as a director is imagine. I look at the words and I try to convey or understand what I'm trying to accomplish in this particular scene. And then I try and figure out where I should put the camera and the sequence of shots that would best convey it, and sometimes it requires me to just walk in a room. What if I put the camera in this corner? Or what if I put the camera in that corner? That takes time. And so a lot of times I don't want people around while I'm doing that because it's just kind of a personal exercise.

Au: Right. Well I remember on the "Siamese Dream" episode when you and I were working on *seaQuest DSV,* when we were doing those

shots over at the shark tank at Sea World. On the initial walkthrough we had two busloads of people. I remember walking the tanks with you and discussing shots, but obviously you were often off by yourself doing your own sketches that I ended up working from. But just having been there with you, I know, helped me a lot.

JT: It's very helpful after I've walked the location. I was so lucky to have a staff person like you around. Because in most of the places that I go to, because of the nature of the episodic and because of budgets, I'll have three art people and one of them is the designer/costumer/set dresser/prop master. I mean these guys get really overextended. So to be in a position where you can have one body who can walk with you and help visualize is a luxury. Often what I'll do though is once I've kind of conceptualized where I'm going, I may take the art director with me and kind of explain to him the whole process. That's where I think my chicken-scratch drawings come into play. Then it is very helpful.

Au: What's your feeling on a storyboard artist offering suggestions of shots or how something might be better?

JT: Oh, I think that's very good, and I actually remember working with you. You would suggest some of those shots, and I think that because storyboarding comes from the cartoon tradition, from comic books, I think that sometimes you have a visual insight into how better to characterize a sequence when you're talking only through pictures.

Au: Yeah, well it's visual storytelling. One of the things I always tell people, "It's called storyboards, and not just art, for a reason."

JT: Exactly. I do think that we are working in a medium that is, by definition, collaborative. As a director, I know that I would be pompous and totally erroneous to think that it's my vision. I mean, first of all, there is the writer's vision. Then that gets modified by my participation, and then it gets modified by the DP and the actors and the art department and everybody else, so at the end you have the raw material and the editor puts it together. So you

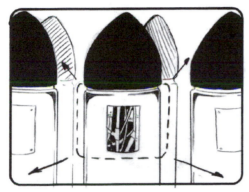

FIGURE 41.4 *seaQuest DSV* boards by Mark Simon. (© by Universal City Studios, Inc. Courtesy of MCA Publishing Rights, a Division of MCA, Inc.)

really do have a collaborative effort here, and I do think that I welcomed your participation as a storyboard artist when you were able to signal some shots that I hadn't thought of.

Au: When you're working with storyboard artists, do you ever look for them yourself or are you usually provided with somebody?

JT: Usually, there's someone in the art department—again this is all specific to episodic TV. Usually, the shows that require extensive CGI or post special effects will have someone on staff who plays that role. Sometimes they're people who are specifically trained as storyboard artists, and other times it will be someone in the art department who has a facility for drawing and will kind of be recruited into fulfilling that role.

Au: What do you think makes a good storyboard artist, and what do feel storyboard artists really need to know?

JT: I think that a storyboard artist needs to be sensitive interpersonally to making the director feel comfortable about their participation. I think the worse thing a storyboard artist can do is to come in and start telling him how to shoot the sequence. But I do think at the same time that a storyboard artist needs to be courageous enough to say, "You know, you might want to consider what would happen if we did this angle or that angle or if you have an insert shot of this." And I think if you convey that in a collaborative spirit, I think it would be helpful to the director and it won't be perceived as, "Oh, this guy's trying to direct my film."

Au: Do you feel that production experience makes a storyboard artist more valuable?

JT: Oh yeah, I think it does. I do think it would be helpful in terms of visualizing what the camera can do, and also I think a day on the set can't hurt in terms of seeing how all the different things work.

Au: When you're breaking down a scene, do you act it out to get a feel for it?

JT: Sometimes what I'll do is put myself into the character and I'll literally walk around the room talking the words and try to imagine if he came to this door what would he do?

Au: Do you have other little tricks that you might use to get an idea across to either production or a storyboard artist for what you're looking for?

JT: I do floor plans, and usually the first thing I do when I get on a show is get the floor plans for all of the existing sets. Then I'll miniaturize them and incorporate them into my shot list. My shot lists have a tendency to be really pretty detailed.

Let me give you an example:

Scene 7 interior, Stones Hotel room 1A—close angle on toothbrush in bathroom, 1B—rack focus to find Stone in mirror hold for appearance of devil, 1C—rack to devil in background for his lines, 1D—rack back to mirror for Stone's reaction and allow him to exit frame, dolly around to two shot, frame two shot.

I literally break it out into that detail, and I'll have a little floor diagram that will show the bathroom, and the bedroom, and where Stone is standing, where the devil's standing, what camera angle I'm opening with, and I'll number the camera angles with a little B. I'll label it 1a, 1b, 1c, and I'll change the camera direction 1d. And so the DP comes into it and he instantly knows where I'm going to do all that.

Au: That's actually something that I've got a section on in this book. Using floor plans to work with directors is invaluable. Don't you feel that when you're really prepared—you've done all

FIGURE 41.5 *seaQuest DSV* plot plan given to directors to familiarize them with the sets and for their use in plotting camera positions. Camera plots are given to the director of photography (DP) and are used by the storyboard artist when necessary. Production Designer: Vaughan Edwards. Art Director: Richard Fojo. Compiled by Mark Simon. (© by Universal City Studios, Inc. Courtesy of MCA Publishing Rights, a Division of MCA, Inc.)

your shot lists, you've completed your story-boards—that when something else does come up and you need to make a change, that it's so much easier?

JT: Absolutely. That is why I go to the extent that I do in preproduction. And now I'm free to work with the actor or whatever other eventuality or unknown thing comes up, and I think that's a lot preferable over having to just be there and spend all your time figuring out what you're going to do. It makes the day go by a lot faster.

Au: I was looking at the "Sincerest Form of Flattery" episode of *seaQuest DSV* that you and I worked on. I had done up a series of story-boards based on some of your sketches and a breakdown for the second unit director. Does that make you feel a lot more comfortable to allow someone else to shoot something from one of your episodes if you hand them story-boards?

JT: Definitely. A good example is I used to do *New York Undercover* and they would do anywhere from two to three days of second unit work. Second unit traditionally will involve the principals, but they don't say lines. It's a chase sequence, and some bank robber is holding up a bank. So I film the dialogue and get him out the door and get our heroes out the door, and then second unit will do a bunch of shots of them running through the streets, etc. Considering that I've shot the beginning and the ending of this sequence, I have a very clear idea how I'd like the middle part to go. And there it's really helpful when your second unit has something to work with.

Au: There was a book we had put together on *seaQuest DSV*, the directors' book, that had reference photos, drawings, and all of the set plans. Was that helpful?

JT: Yeah, that to me is another luxury. As I recall, you gave me three-dimensional views of the rooms too.

Au: We did that as well as the plans themselves. That way you could see what it looked like as well as the layout of it.

FIGURE 41.6 *seaQuest DSV* storyboards by Mark Simon. (© by Universal City Studios, Inc. Courtesy of MCA Publishing Rights, a Division of MCA, Inc.)

JT: If the art department doesn't have it and time is of the essence, I'll do it myself, and I often do.

Au: Let me move on to the *Third Space* movie of *Babylon 5*. You've got the storyboard scene of

Odoe turning into the bird and flying. Was that bird CGI?

JT: The bird: what we did was had the Odoe character actually take a leap into the air. We had his hands outspread in a way in which we were going to go to CGI and have his hands replaced with the wings of a CGI bird. And that bird was going to fly just for a few frames in that shot. Then the next cut was a sequence of shots of a real live falcon that we brought on the set. I designed a bunch of shots. Basically you have a falcon trainer and he sits at one end of the room, and you have these dead pieces of meat over here and you dangle it in a way and you put it on where you want the bird to rest and he flies over and you get the shot. So what the CGI was helpful for was doing the transition effects for the CGI, but also to help us understand where practically in the environment we were going to be able to fly the bird, where we were going to simulate the flight of the bird, like the bird's POV. So the storyboards were very helpful.

Au: I'm sure it helped the bird trainer too.

JT: Oh yeah. We were concerned because we didn't want the bird to get loose inside this huge sound stage, and also we wanted to make sure that we got the shots we wanted. And I think

we were successful in that. But then again the storyboard was key to designing that, to knowing exactly how much we needed to sell the concept and not spending a lot of time getting shots that we ultimately wouldn't use or wouldn't be as important in the sequence.

Au: Do you have any comments for people who are thinking about using storyboards or are storyboard artists themselves?

JT: To other directors, I think storyboarding is an invaluable tool for refining and shaping the director's vision. Apart from the logistical production and budgetary implications that a storyboard can have in terms of making a production better, there is also the impact that storyboarding can have in making a production more economical and achieving the best results possible. I think that the storyboard process forces the director to ask himself questions that need to be asked about how the final product is going to be visualized. I think that it's an exercise that, apart from these other considerations, is just invaluable for the director in terms of helping him shape, question, refine, and determine what his vision is for that particular sequence he's designing.

Au: That's great. Thank you Jesus.

CHAPTER 42

DAVID NIXON:
COMMERCIAL DIRECTOR

Credits: *Owner, David Nixon Productions, produces commercials, training videos, and infomercials*

FIGURE 42.1 David Nixon.

Au: What are you looking for most in a storyboard artist?

DN: I look for someone who can take my vision and put it down in black and white on a page, because the critical thing with advertising is to get your idea out of your head and into the eyes of the client.

Au: So when you're interviewing storyboard artists, what specific qualities sway you to choose one over another?

DN: I think in an interview I'm mostly looking at the things they've done to see the style and then the flexibility of the person. The storyboard artist should bring a ton of creativity with them. I'm not looking for someone who can just push the buttons and draw and I have to give them everything. I'm looking for somebody who can take a little bit of my vision in and add part of theirs and come up with something that actually works.

Au: Do you feel that knowledge of the entertainment industry, directing, and editing is important?

DN: Someone couldn't bring these creative ideas to you unless they've had a lot of experience beforehand in all those different production areas. They bring a little bit of themselves along. To give you an idea, you may throw out an idea of what you're thinking of and they'll say, "Oh, OK, last year we did such and such and it looked like this." So that adds a ton.

Au: When interviewing a storyboard artist, what do you want to know about them? Their work? How should they present themselves?

DN: I want to see as many different looks in their storyboards as possible. Because this industry is not about one certain style, it's about reinventing yourself in every project you do. That would be one key. The second key would be to get inside their head. I want to find out if they can take my vision and very quickly sketch it out. I know a lot of times when you and I sit, you'll just say, "OK, tell me where you are

FIGURE 42.2 Cold-Eeze commercial presentation boards. Sample of my art extending outside the frame. David Nixon used these boards to sell the client and get the special effects house to bid on the germ dots that the little girl, in panel 2, gets onto her mother.

going here." Then, you'll sketch some things really quickly, less than thumbnail ideas, and show it to me and say, "Is this what you are thinking?" That's what I'm looking for. I'm not looking for the guy who will say, "Give me a script and I'll go away and tomorrow I'll bring you back a whole storyboard." It doesn't work that way. An artist can bring in all these great boards and show me books and books, but I don't really know that he can do it until I actually sit with him and draw out some things. That may even be something cool they take to the interview. That they actually say, "Throw me an idea and let me sketch this out real fast." Now that's kind of intimidating because you're being put on the spot, but I think that would be very impressive for a director to see.

Au: What's most important to you in the boards you use? Is it the quality of the art? Is it capturing the angles? Or something else?

DN: Well, I think the angles are a very critical thing. A lot of people look along a two-dimensional plane. You have to get into a three-dimensional look, the way the camera sees it. The quality of the artwork isn't as big, even though it has to have the quality that will impress the client. Because when I go and show these boards to a client, a lot of times that's what makes or breaks them in hiring me, as a production company. It has to have a certain look that they'll go, "Hey, this guy knows what he's doing." And that comes from the storyboard artist. It's not so much in the time spent in coloring it or making it all perfect. You have a certain standard you have to hit. But it's more the angles and the look of it. One of the things I like in your boards, that I haven't seen anywhere else, is the way you draw outside the box.

Au: Well I know that a lot of your work is film and not videotape, and one thing we've done together that you seem to really like is showing the actual depth of field in the drawing.

DN: Exactly. You always want to focus in on one subject. There may be a lot of things going on in that frame, but there's one key thing and usually it's what the client is selling. So that depth of field idea either separates the product or the talent from the background, or makes it

stand out and sparkle so the client goes, "Oh man. That makes my throat lozenge look incredible."

Au: How do you find storyboard artists?

DN: Usually, like anyone else in the industry, it comes word of mouth. I don't usually go by lists of people or books or whatever. I usually talk to someone else in the industry and say, "I'm looking for such and such. Who do you know that you've used and you like?" So word of mouth is the critical thing, and you'll find the more people you work with the more you like, and you'll keep using those people over and over.

Au: How do you like to work with storyboard artists? Do you like to sketch up your own thumbnails? Do you like to work off of floor plans?

DN: No, because I'm not an artist myself. I usually like to just give an artist my vision verbally and let them sketch a little bit. I may say, "No, not quite from there. From over here instead," or "A little more of this, or a little less of that." I just verbally give it to them. But really they're bringing their vision to paper, and I let them start, and then we hone it in from there.

Au: On what type of project have you used storyboard artists the most?

DN: Most of the time it's been a thirty-second or sixty-second commercial where we have the budget to actually bring in an artist and do the storyboarding. And it's a bigger deal to sell the client at that point, too. So if the client's spending $300 grand on a thirty-second commercial, they want to know before you do anything that it's going to look the way they like it. So you have to draw those storyboards up to say, "Okay, here's our vision, here's what we're expecting to do."

Au: Give me an example of how using boards has helped you.

DN: Well, every time it comes down to the look of the boards for a high-end commercial. In fact you were involved in the Cold-Eeze commercials where when we did the first set of boards

you weren't available. We had somebody else do them and they didn't work. We came to you at the last minute and said, "Can you free yourself up enough to do these?" So I think in every instance that we've done a high-end commercial the storyboards have sold either us as a production company, or sold a specific concept that they couldn't really visualize. When we did the World of Denim thing, that was a longer form thing, all three-minute pieces. But again, there were specific concepts that we were trying to get across. So it was the storyboards that actually, in black and white, sat there, and we could talk to the client and we could talk through it and they could say, "Oh, now I get it. Lets go for it."

Au: What about in the production? Do you carry the boards with you when you're shooting?

DN: Oh yeah. And what happens is we'll make up a production book and the storyboards are duplicated and they're part of the production book. All the key players get the production book: the client, DP, set designer, and all the way down the line. They can see up front what they're expected to do. And each person gets a little different idea from that board than the other person. The camera man will see things in a storyboard that he'll think, "Oh, I need this specific lens." And the set designer will see something in the boards and will say, "We need to use this color or this background." The makeup artist may have a different item to bring to the set when she looks at the board. Then on the shoot, we duplicate the boards up large and put them on a big hard board, and we put them by the monitor and we refer to that constantly. Especially right before the guys start to light the scene, the DP will bring in the gaffer and the key grip and we'll look at the storyboards. So we use them all the way through the process to make sure we are staying on the subject and on principle and concept.

Au: Obviously storyboards are not a real cheap thing—I mean it's a budget issue at times. Do you find that in the long run you wind up spending less money on a project by using them?

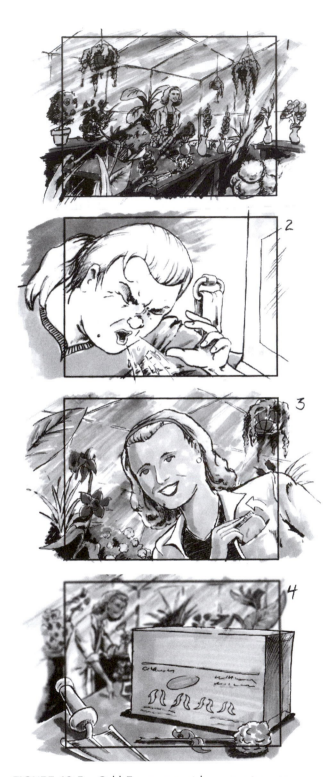

FIGURE 42.3 Cold-Eeze commercial presentation storyboards. Notice the soft focus in the background of panel 4 that helps pull attention to the product in the foreground. Boards by Mark Simon of Animatics & Storyboards, Inc.

DN: Definitely. The interesting thing is, when you look at it up front in the bottom line of a project, a lot of people blow off storyboards because they say, "Oh jeez, that's another thousand bucks we gotta spend." But when you're talking hundreds of thousands for the project, it's a very small amount that, in the long run, saves you a lot more than what you spend on the boards. Because if you don't do the boards, everybody that's involved in a production has a different look in their head. The original producer may have a certain look, the director may have a certain look, the DP has a different look, all the way down the line, and that gets into problems when you actually get on the set and you're shooting. So the storyboards formalize everybody's vision of what we're going for. It brings up a lot of interesting things in the preproduction meeting that you miss later on if you don't have boards. I know a lot of times that we have sat down in a prepro meeting with all the principal people and we've looked at the boards, lots of questions have come up. What about the lighting? What about the lenses we need? What about moving the camera? Is this a dolly shot? Is this a crane shot? You alleviate a lot of those problems that, if you don't think about you get on set and somebody says, "Oh man. If we would have thought about that we would have had this specific thing." So I think the boards are critical for money saving, or at least, staying on budget.

Au: What do you feel is the best kind of training for a storyboard artist?

DN: I think other than the classical art training that you need, a storyboard artist needs to absorb as much real experience on set as possible. Because you get the ideas of the camera angle by actually going to the set and seeing how commercials are shot. So that you can actually get behind the lens and see how they're formulating it and look on the monitor and see what's actually happening. I don't think you could get that in your head by just formal art training. And maybe even then get into the edit too, because a lot of these things are shot to be edited. I think for a storyboard artist that would be critical. Take three or four projects all the way through. See what the original concept was. Go to the set and see how they're

actually shooting it and what they're getting down on film or tape, and then go to the edit and see what the final product is working out to be. Because there are a lot of problems in the edit that you have to deal with just because of real-world shooting. You can't get exactly what's in your head. Because it is not just about drawing pictures, it's about how we're going to take something that somebody thought up in their head and actually create it on film and end up with something plausible or even better than what that original vision was—and that's not very easy. It's a difficult process of how you get around the real-world problems of lighting and talent and sets and all those different things.

Au: You had mentioned that the first set of boards you commissioned for Cold-Eeze didn't work. What were the problems and why didn't you like them?

DN: The artist we used, or actually that the client gave us, was technically a great artist but didn't have that idea of how the camera sees certain things. They did everything from a two-dimensional, front-on, eye-level view. So it was a very flat board and it lost the excitement. In fact, when the client saw it—and we were embarrassed to show the client—we should have stopped the whole process and said, "No, these aren't good enough. We're going to go back to square one. We're going to miss the deadline, but it's going to be better." There was no movement in the board at all. It was just static, static, static, static. The storyboards have to show how you are going to grab the audience. So you have to use all those techniques of movement, of light, of flow, color, and excitement to grab that audience.

Au: Now on Cold-Eeze there were a number of special effects that needed to happen. Obviously you used the storyboards to get approvals, but then you also used the boards when you went to the postproduction house. How did you use the boards there?

DN: We gave the postproduction people the boards up front and said, "Here's our vision. Here's what we're going to shoot." This was before we shot anything, and we said, "OK, specifi-

cally in this situation, we want to show a little girl sneezing, and we want to show the sneeze coming out and floating around, and then we want to show her transferring that to the Dad's face, and then he gets a cold." And that's how we got across that idea of that effect.

Au: Now did they also use these storyboards to come up with a bid for you and give you ideas on what you needed to do to begin production?

DN: Absolutely, that's what they built the whole thing around. And then in the postproduction process they used them to stay on track. We had our postproduction guys come to the set while we were shooting, and they were consulting us on certain things, but then when we went to the edit they had the board sitting right there. It's really your bible.

Au: There's a big difference between rough production boards and more polished presentation boards. Do you prefer production boards that have crisp, clean, clear lines, or can they be a rough style that captures the energy?

DN: As far as the production value of those boards, it's more about capturing the action and the setting. It's not about the level of art. It's not about the crispness of the lines or the color of the lines. It's about capturing how you're actually going to shoot the movement of the camera, the depth of field, whatever it is.

Au: On the boards for World of Denim, the beginning and end of the sequence were very visual because you have a guy looking at some pictures, then you push into the pictures for the next video sequence. Obviously that's a very difficult thing to describe.

DN: There was some prepro we had to do there because we had to shoot the scenes that were going to be in the brochure that he's looking at. The setup is that he's in an airplane, picks up this magazine, and he sees the product in the magazine, and he starts daydreaming and that comes to life. Well, we had to obviously shoot all of those scenes ahead of time, print them up in the magazine before we shot the shots of him in the plane. So we had to know where we were going there so that in the initial shoot we shot

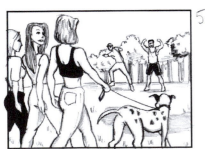

FIGURE 42.4 World of Denim production boards. David Nixon used these boards to explain the concept to the client, plan his shots, and figure out the effects. Boards by Mark Simon of Animatics & Storyboards, Inc.

specifically for the images that were going into the magazine and made sure that was going to work. Then those pieces would come alive in postproduction of the guy dreaming, and those actual scenes came alive and now they're moving. That's a special effect where you have to have the board to know why you're doing certain things and how you're actually going to shoot something to make it work later in the edit.

Au: This set of boards was done in black and white. Did it make any difference in selling the concept to the client?

DN: Not at all. This was only to tell the story. We didn't have to impress the client—we already had the job. Whereas in the other instance (Cold-Eeze) we were up against three or four other companies, and so the storyboards worked to get us the job.

Au: For the people who are reading this, not only artists but also other directors and UPMs (unit production managers), are there any other specific comments you'd like to pass on dealing with storyboards?

DN: Well, I think we have found over the last twenty years of doing projects like this, where we haven't done storyboards and we've done storyboards, the whole productions where we have done storyboards go so much easier to the point where we've stayed on budget. We've been able to be a lot more creative. There's a whole concept to doing production where prepro is king, and the novices don't know that. They get their money for a project up front or whatever, and they just go out and start shooting. And you get on set and think, "Oh man, if I would have thought about that I could have done this," or "I could have had this extra piece of equipment." So I've found over the years that the storyboard process is where it makes you stop and think about that whole concept and that whole story to the point of coming up with better ideas. Not only to make the storytelling better, but also better ideas on how to do it, how to shoot it, how to edit it that can save you money, or keep you on budget. So I would encourage people to storyboard as much as they can because it formalizes that whole thinking process that saves you in the end.

CHAPTER 43

NINA ELIAS BAMBERGER: CHILDREN'S LIVE ACTION, PUPPET, AND ANIMATION PRODUCER

Credits: *Sesame Street specials and videos, Dragon Tales, creator of Big Bag*

FIGURE 43.1 NINA ELIAS BAMBERGER.

Au: How important do you feel storyboards are to the process of animation?

NEB: Not at all! Just kidding. I think they're vital in the sense that now so much animation is being done overseas. The storyboards are the blueprint for the series. They convey the emotions. They convey the creative direction of the series. Since often times, like in *Dragon Tales,* we ship to several studios in order to get the work done on time. The storyboards are what will guarantee uniformity throughout the series and it's quality control. And it also gives the producers the opportunity to fine tune what they want the series to look like before it's out of their hands for a while.

Au: When you refer to uniformity, you don't mean just look, but also acting.

NEB: Yes, it's acting. It's the personality of the series. What the viewers will come to expect the characters to act like, the quirks in their personalities, locations, also how the series is directed. Do you cut to close-ups most of the time, and that's your series? Are you in wide shots most of the time? Do certain characters usually demand close-ups? What's the humor? Storyboards can show you where the humor is and how you can convey it. They're vital. And spending the time fine-tuning and revising your storyboards is the most important thing you can do. In studio production you say preproduction is the most important, and in animation I would say that perfecting your storyboards before they're shipped is the most important.

Au: Now, what do you look for in a storyboard artist?

NEB: I look for creativity as far as I don't really care if the characters are drawn perfectly, but you have to be able to really read the emotion in their faces. I look for movement in the storyboards. I look for if a director knows when to hit a close-up if something is emotional. How to show humor, how to keep the story moving. It's very easy to have a bland storyboard. I think it's very difficult to have a well-paced and well-directed storyboard. Make the characters

come alive—I guess that's what I look for the most.

Au: Do you look more for story than quality of art?

NEB: Yes, absolutely.

Au: What does a good storyboard artist need to know?

NEB: I think a good storyboard artist needs to read the series bible, needs to read some scripts, and needs to really understand the characters and where the stories and series are going. Continuity. They need to know pacing, how to convey the story, the variety of locations that are available to them. Understand personality. Tell a story. Know their audience, so if they are doing a preschool series they need to do things differently than they would an action series for six to nine year-old boys.

Au: How do you find storyboard artists?

NEB: You talk to people in the business and find out who is a good artist. I mean that's really the way the whole business works, from writers to directors to artists. It's who you know and who you know is good. Our storyboard artists are usually supplied by the production houses.

Au: And you rely on the production houses?

NEB: Absolutely, completely. And I wish storyboard artists would sign their name more frequently so I could say, "Use this one again."

Au: When dealing with the overseas animation houses, do you feel that storyboards really help eliminate miscommunications because of the language barrier?

NEB: Yes I do. I've worked with a variety of people and sometimes, no matter how clear the storyboard is, it's good to have a director go down to the site and to see how the storyboards are being executed. That's the optimum way I think to do it, especially in a new production, but the storyboards are the blueprint. There is really nothing else. Yes, you have the model sheets, obviously, but if your storyboards are

too loose you have a bigger opportunity for error.

Au: Pick any one of your animation projects and lead me through the storyboard process. Who gets what and when? Who signs off?

NEB: Well, once the script is finalized and the voices are recorded and finalized, the artists get the audio. The director always looks at the boards before they are shipped out to me. So when I come back with comments, the director can come back at me with responses because they know what's been sent out. It's the directors' responsibilities that these boards are even, cohesive, that they look like one series, even though in some instances we may have three storyboard artists and in other instances seventeen storyboard artists. So it's the directors' responsibility not to ship me anything that looks like it doesn't belong to the series. And then we get our first storyboard based on the recorded script. Then we send pages of notes on the storyboard. Some productions send back the revisions. Other productions just send you back the finished storyboard when it's locked. I prefer getting the pages back.

Au: Give me an example of how boards can save a show or a scene.

NEB: I think how a storyboard can save something is mostly through humor. I think there are so many ways to direct something, to really make a gag work or to add to it. And I think that if an artist is creative, they can make a bland story come to life. They can find things in it; they can add things to it; they can see things in it that weren't in the script. Of course, emotion is also very important. I mean, if you play a scene really wide and you don't really get to know the characters versus if you play it close and the audience understands what they're feeling, it's two different shows. And I actually believe you could board the exact same script, have two different storyboard artists, and completely end up with two different shows.

Au: We're actually doing that experiment in this book. I know I'm going to get completely different boards.

NEB: I'm sure you will. I think it's a great thing. I also think pacing changes everything. You can move a story or it can be deadly. Just by changing the shots and locations it's completely different pacing.

Au: Being a producer, do you work with the storyboard artists directly?

NEB: Never.

Au: Are your notes on storyboards always written? Or do you ever do thumbnails or any graphics to convey revisions you'd like to see?

NEB: I find that they get offended by it (doing their drawings for them).

Au: The directors or the storyboard artists?

NEB: Both. I have done it before, and I found that they got more offended by that. It's kind of their arena, and the directors I've worked with enjoy the written word and don't want me to show them what a character could look like or if we positioned it this way or that way. They are the artists.

Au: Do you ever rely on the storyboard artist to design props or characters, or are they always given those designs?

NEB: No, that's a good point. They're given to them by the artists in the animation house. It's a separate group that just does props and it's a separate group that just does backgrounds.

Au: What do you feel would be good training for a storyboard artist?

NEB: I would think that to watch a ton of television is probably a good idea.

Au: That's a hardship

NEB: Yeah. There's such a variety of animation out there that I think that it is really important to study it. And I think that the more you do, the more you really scrutinize what's on television, the better. The old as well as the new. Because there was so much brilliance actually done a while ago, and so many times you can

bring out what used to have been done twenty years ago and people think you're new and fresh. But they knew what they were doing, many of the old animators, so I think that's one way to really learn. An internship. If you can get any kind of internship with an animator, that would be fabulous training. Trying to do stuff on your own and experiment is great training.

Au: Experiment with animatics?

NEB: Yeah, and even put it on video. Drawing boards and editing them on video and looking at the flow—and there are a lot of cheap things you can do. So I think that would be great training and serve you in the future.

Au: That's actually what I did for myself. It works really well. You get an instant idea of how your boards work. Do you ever use storyboards to sell creative ideas or get approvals?

NEB: Yes. When we were creating a new short animated series a year or two ago. I did sell it with storyboards. I had the artists and directors do storyboards. I had five different animated series

I was pitching against each other and they all had storyboards.

Au: Have you ever felt the need to do color storyboards for animation?

NEB: No, because if you approve the color backgrounds, props, and colors of main characters you should be able to visualize it.

Au: Do you have any last comments?

NEB: I would just say that good storyboard artists are hard to find. And I've worked with animation production companies all over the world. And some of the biggest in different parts of the world, and good artists are hard to find. I think that sometimes the gems come from smaller production companies or a small house, and they're just so dedicated to making their projects that often times you get great stuff. It's not a production factory. But the bottom line is that when you have a good artist you can tell immediately—flip through the board and it's a joy. So I encourage more people that could be good storyboard artists to do it, because there is a need for good storyboard artists.

PART FOUR

EXERCISES

CHAPTER 44

EXERCISE 1: VISUAL STORYTELLING

This exercise will help you develop your own visual storytelling ability. You will be given a short description of a scene, and you will need to furnish all the details yourself—since you are now the director and the storyboard artist. You may want to do this exercise more than once. You can use what you draw here to start your storyboarding portfolio.

THE SCENE

It's late at night in a big city. In a dark alley there are only a few lights on and no activity. Someone sneaks up the alley, climbs up onto something, and jimmies open the window. As this person is crawling into the window, he either falls inside or knocks something over.

You do not need to limit yourself to only the information given here for your scene. If you want to enhance the scene with some character interaction, fantasy elements, or anything else, feel free to do so.

DIRECTING THE SEQUENCE

To give yourself a real test in your storytelling abilities you could direct the scene in more than one cinematic style. Try storyboarding the scene the first time through as an ominous, dramatic scene. Then try boarding the same scene as a humorous sequence.

Your sequences should look almost completely different. The humorous version should have exaggerated movements and reactions. You may want to add a comic foil, a second character, to the scene.

There are no right or wrong answers. Everyone will see this scene differently. Have fun.

CHAPTER 45

EXERCISE 2: TV WESTERN

You will board out Scenes 1–5. Scenes 1, 3, and 5 take place in a Western town. Scenes 2 and 4 are in a movie theater. The character in the movie theater projects himself as one of the Western characters into the movie he's watching. Your boards must show how the shots should be edited between the Western scenes and the theater scenes to be the most fluid and effective. It is also important to show why the lead character in the Western looks like someone else all of a sudden. Your boards should be around thirty-eight panels long for these five scenes. This is not to say that you have to have exactly thirty-eight drawings, but it is to let you know that if you have only drawn twenty, you have left out a lot of visual information. Illustrating some motions may also take more than one panel to draw. For example, in scene 1, the shot of the saloon doors and Lash flying through them and toward the camera should be three panels. Everyone's boarded version will be a little different. There is no one right answer.

An example set of boards is provided for these scenes. You should refrain from looking at them until you've tried to board the sequence on your own.

NOW SHOWING
WRITTEN BY JENNI GOLD (ALL RIGHTS RESERVED)

Note: All scenes are color except those designated in black and white (B&W).

```
1      EXT. WESTERN SALOON - NIGHT - B&W                    1

       The swinging doors of the saloon fly open as LASH, a
       handsome cowboy, falls into the street. He is pursued
       by a drunken desperado named LUTHER. The townspeople
       anticipate the upcoming violence. Luther towers over
       Lash.

                         LUTHER
               Get up, you yellow-belly son of
               a sow.

       Lash wipes the blood off of his mouth and slowly gets
       up.
```

> LASH
> Look, Luther, I don't need no trouble
> here.

> LUTHER
> Well, you got trouble mister.

> LASH
> Just take yo-self on home and sleep off
> the whiskey before I have to hurt you.

> LUTHER
> I'm gonna show you a world of hurt. Now,
> draw.

The steely eyes of the weathered desperado squint. A hand twitches
as it hovers over a six-shooter.

2 INT. MOVIE THEATER - DAY 2

A man's hand slowly reaches into a bag of popcorn. Although LARRY
MILLS is transfixed by the action on the silver screen, he manages
to get the popcorn into his mouth. Larry is wearing a long-sleeved
white shirt with a bow tie loosely hanging around his collar.

3 EXT. WESTERN STREET - NIGHT - B&W 3

Lash and Luther study each other as they await the optimum moment
to reach for their guns.

4 INT. MOVIE THEATER - DAY 4

Larry stares at the screen.

> LASH (O.S.)
> I don't think you wanna do this, Luther.

Larry's lip movements are synchronous with Lash's off-screen dia-
logue.

5 EXT. WESTERN STREET - NIGHT - B&W 5

(Now Larry Mills, the audience spectator, becomes Lash, the charac-
ter, and is dressed in Lash's clothes.)

Hiding on a nearby hotel's roof, there is a COWBOY aiming a rifle
directly at Lash/Larry. Luther draws his gun first, but Lash/Larry
is quicker. Shots RING out. Luther keels over and lies motionless
in the dusty street. The cowboy on the roof cocks his weapon.

Instinctively, Lash/Larry ducks and spins around towards the hotel.
The cowboy on the roof narrowly misses his target, thus allowing
Lash/Larry a chance to shoot back. Lash/Larry fires and the cowboy
falls to the ground in a twisted heap. Lash/Larry picks his hat up,
shakes off the dust, and walks to the saloon and enters.

DISSOLVE TO:

DIRECTOR'S NOTES

"The character in the movie theater, Larry, makes faces while watching the movie, mimicking the characters on the screen. Larry is alone in the theater, and the shots should have a lonely feeling to them. When Larry steps into Lash's part in the movie, his actions should be over-amplified. Make sure that you show a few close shots of Lash before Larry steps into his role. The first shot of Larry as Lash should be a close-up, so the viewing audience realizes what has happened. This transformation should take place right after a close-up of Larry in the theater."

"The horse should be tan with some mottling in its coat. The drunken cowboy, Luther, is wearing a stupid looking floppy hat that is sitting far back on his head of receding hair. The hat has a wide brim that is flipped up in front. Luther's gun belt is worn loose and low. Luther also has a scruffy mustache and beard. Lash, the hero, is very clean, except for the dirt on him from his fall into the street; he is clean-cut and his gun is chrome. There should be at least one good close-up of the chrome gun. He is NOT wearing fringe, but his outfit is slick. Lash's outfit is white and tan to contrast Luther's darker clothes. The townspeople come out of the saloon to watch what is happening. There should be no less than twelve extras."

"The cowboy on the roof who gets shot needs to land on something that is breakaway, made to easily break into pieces, and can hide a stunt pad inside or beneath it. The stunt pad is to protect the actor from the high fall."

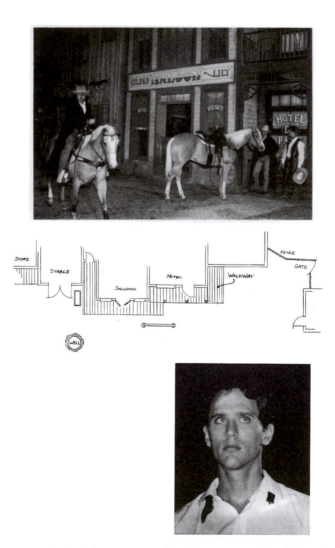

FIGURE 45.1 WESTERN LOCATION ON THE BACK LOT AT UNIVERSAL STUDIOS ESCAPE IN FLORIDA. THE BOTTOM IMAGE IS OUR STAR, LARRY.

SHOT-BY-SHOT Description

SCENE 1

Start on a shot of the saloon doors filling the frame. Lash comes flying out of the saloon and right into the camera lens. As his face fills the frame we cut to the reverse angle to see a close-up of the back of Lash's head as he flies away from the camera and onto the road.

Medium shot of Lash on the ground as he looks over his left shoulder back towards the saloon.

Low angle looking up at a medium shot of Luther coming out of saloon. Luther stops in the doorway with his hands on the swinging doors.

Wide shot of the townspeople gathering in the street.

Camera is low behind Lash. Over-the-shoulder (OTS) of Luther approaching Lash. Tilt up on Luther as he approaches and keep Lash's head and right shoulder in frame.

Luther's point-of-view (POV) of Lash getting up. This is a medium shot looking down at Lash and tilting up with him as he stands. Lash is wiping blood off his mouth as he stands.

Head on close-up (CU) of Luther.

Medium close shot of Lash, Luther's POV. Lash is pointing at Luther.

Extreme close-up of Luther's eyes.

Close-up of Luther's right hand twitching over his gun.

SCENE 2

Close-up of a man's hand slowly reaching into a bag of popcorn. This is a matching cut from Luther's hand over his gun. (Both hands are placed the same way in the shots: same size, same position.)

Medium close-up of Larry watching a movie screen as his hand moves up into frame with popcorn in it. We are in front of Larry and he is looking just off camera left at a screen we can't see.

SCENE 3

Camera is looking over Luther's left shoulder at a medium-full shot (head to knees) of Lash. Camera slowly moves clockwise around the men until the shot is looking over Lash's shoulder looking at Luther.

Close-up of Lash looking from camera left to camera right as he starts his next line. Camera is just off to Lash's right.

SCENE 4

Close-up of Larry as he lip-syncs with Lash. Shot is framed exactly like the last one of Lash, except Larry is looking from right to left.

SCENE 5

Close-up of Lash, but now he looks like Larry—and will for the rest of this scene. Shot is framed like the last two, but we are off to Lash/Larry's right and we are a little wider. Lash looks to his right away from Luther.

Lash's POV of a man on the hotel roof aiming a rifle at Lash. Wide shot.

Medium shot of Luther drawing his gun.

Wider than a full shot of Lash as he draws and shoots. We are behind Luther and to his left. Luther is in frame on camera right.

Extreme close-up of Lash's gun barrel with bullet and smoke coming out of it.

Full shot of Luther keeling over and falling toward camera. We cut just as he hits the ground in a puff of dust.

Wide shot of Lash as a bullet hits the ground beside his leg.

Lash's POV of man on the roof cocking his rifle.

Medium shot of Lash dropping to his right side and firing at the man on the roof.

Wide shot of man falling off the roof and landing on some crates below which are in a wagon. The crates crumble as he goes through them, and dust and chicken feathers fly everywhere. We follow the man down as he falls.

Medium shot of Lash. We follow with him as he stands and brushes off the dust. We are looking at him from just off his right.

Three-quarter shot behind Lash as he looks from the two fallen men over to the saloon and he starts walking to the saloon. This is a static shot, a little wider than full.

SAMPLE STORYBOARDS

These are the sample storyboards for *Now Showing*.
Boards by Mark Simon and B.C. Woodson.

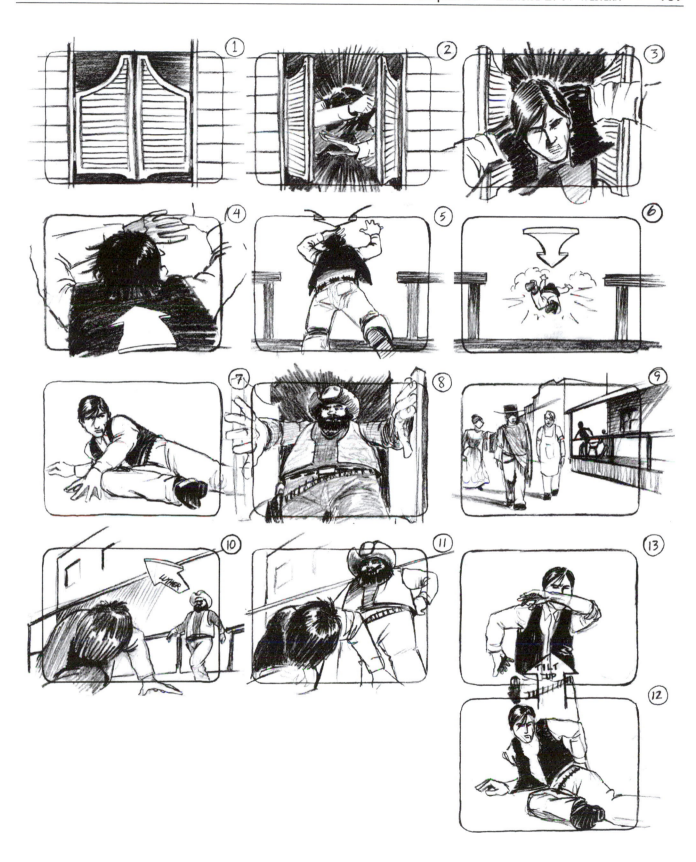

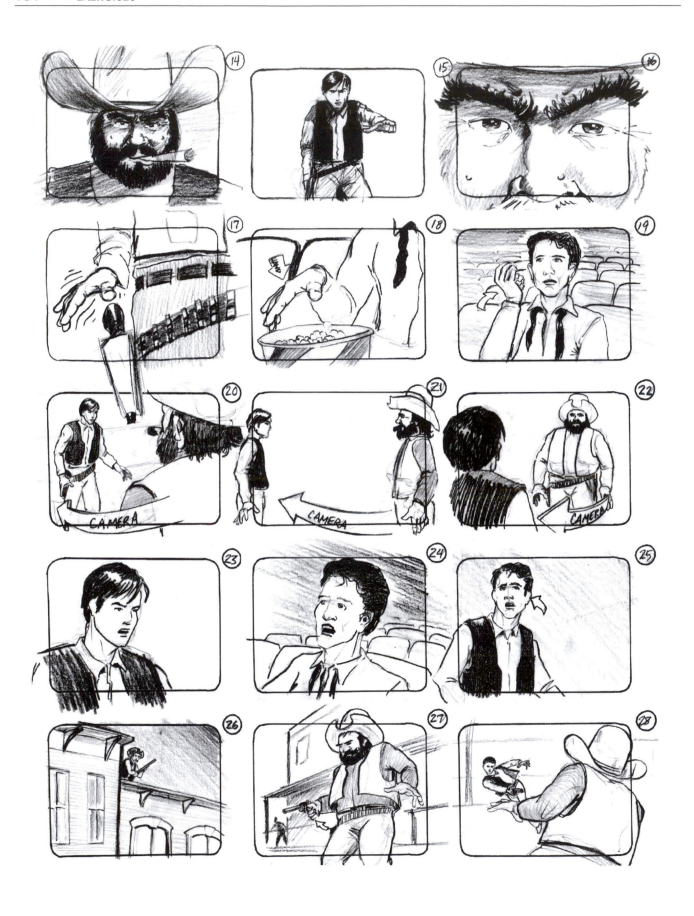

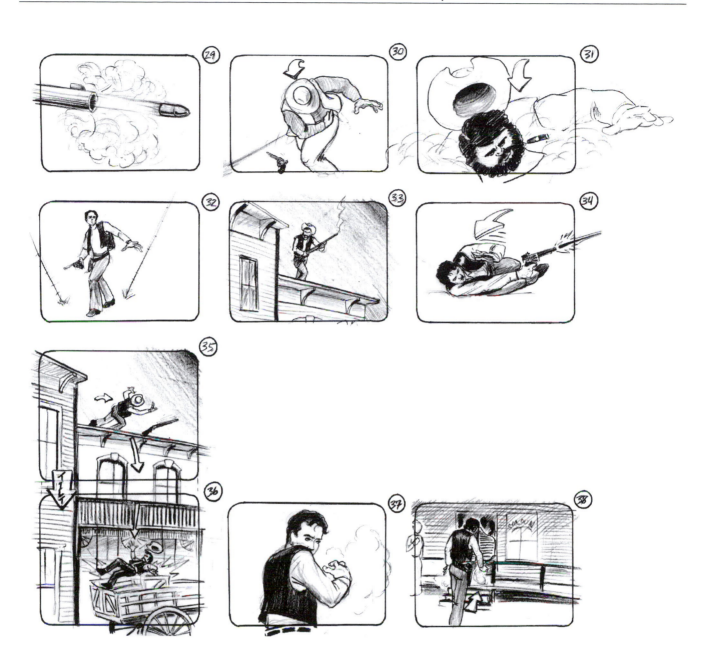

CHAPTER 46

EXERCISE 3: COMMERCIAL

This will be a :30 (thirty-second) commercial. We are going to break this exercise into two parts. Each part of this exercise will use the same commercial. This will give you an idea of what it's like to work with advertising agencies.

In the first part, you will illustrate the commercial as a set of full-color presentation boards. Presentation boards are generally beautifully rendered boards used by advertising agencies to pitch their ideas to a client. You usually only need a few presentation boards per spot (commercial spot), just enough to get the idea across to the client.

In part two, you will illustrate a set of black and white production boards. Production boards usually do not need to be in color and portray the commercial spot shot-by-shot the way the director sees it. There will be many more panels in a production board than a presentation board, as every shot and edit in the finished commercial need to be portrayed.

PART ONE: PRESENTATION BOARDS

The first thing you need to do is to figure out how many panels are needed for this spot so that a client can understand it—keep it as short as possible. There are two main reasons why there are fewer panels for presentation boards than for production boards. Presentation boards are more expensive than production boards, and most clients only need (and want) to see a visual outline of the commercial concept.

You can get away with seven to nine panels for these presentation boards. Design them yourself.

ANIMATICS & STORYBOARDS, INC.
LIVE-ACTION SPOT :30
ROYAL'S GYM
WRITER: JEANNE PAPPAS SIMON

VIDEO:	AUDIO:
Medium shot of workout woman.	JEANNE: I don't wear lace. And bows? Definitely not me.
Wide shot of group aerobics.	I do work out though. I like a no-nonsense, breath-pounding, sweat-dripping workout, and I can get that at Royal's Gym.
Quick shots of weights, stationary bikes and people running on an indoor track.	They've got free weights, the hot new bikes, and an awesome indoor padded track.
O.T.S. (Over the shoulder) shot past woman of monitors on wall.	Plus, Royal's has walls and walls of monitors playing the hottest videos from MTV that keep the place jammin'.
Racquetball court.	Oh yeah, I almost forgot . . . they have four racquetball courts.
Close-up of woman.	And mom . . . I never let the boys win.
Logo.	Royal's—the place for a serious workout.

PART TWO: PRODUCTION BOARDS

When drawing the production boards, you need to work with the director. The director's ideas will always be a bit different from the agency's—it's called creative freedom and job justification. Since the publishers of this book couldn't afford to send a director to your house, we'll give you her notes below as if she were actually talking to you. This is exactly like a number of the commercials I've worked on.

Take the director's notes, make quick sketches, and then draw the final boards. If this were a real job, you'd get approvals on your rough pencil drawings before you finished the art. You may want to have someone do this for you and give you notes. It's good practice to

take creative notes. Don't take the criticism personally; use it to make your work better. To make this a realistic test, complete the production boards in one to two days. That's about all you'll get in production.

DIRECTOR'S NOTES

"To start with, you'll see a couple of photos here that can serve as good reference. The one of the woman's backside gives you an idea of what she'll be wearing in the close-ups when she's talking to camera. Whenever we see her working out, she'll be wearing a sexy half-shirt over it, as in the other photo.

"The photos of the equipment gives you an idea of what some of the products look like at Royal's Gym.

FIGURE 46.1 Costume reference for the sexy workout woman.

FIGURE 46.2 Exercise equipment reference.

We don't have reference of what the bikes look like or the indoor track. Do you have reference of workout bikes?" (Say "yes" and find photo references after the meeting.) "We're going to have a lot of fast edits of different parts of her body cut in with wider shots of the facility. Think of the Bally commercials and you'll get the idea. The camera will be moving on every shot, either as a handheld swish-around or as fast-tracking moves using a dolly.

"On the first shot I want to start close on the back of her legs, panning up. Then I want to do the same move on her right arm. I want that shot so we're seeing the profile of her breast beside her arm. Then when she says, 'Definitely not me,' I want to cut to a headshot, including her shoulders. She should look sexy, but tough. Have her wearing a headband like she's been working out a little bit already. This is the only static shot in the spot.

"Now I want a fast move in front of an aerobics class with our talent centered in the front. Have about fifteen women in the class, mirrors all around. Intercut shots of extreme close-ups, like feet hitting the floor in rhythm, a head moving up into frame, quick pan past sexy sweating heads.

"I want to see a pan down across a stack of chrome handweights on their stand. I want to follow a barbell on its upward curve to reveal our woman's half shirt. I want to see feet spinning rapidly on a stationary bike's pedals, then cut to a quick shot of the camera running up a row of women on the bikes, to make it look like they're pedaling past the camera. Have you ever seen spinning? That's the look I'm shooting for. Cut to a hand pumping in and out of frame, with a sweatband on the wrist—this should be a jerky shot. Go to a close shot of a sweaty forehead and move down the woman's face to see her breathing hard. Then let's go to a shot down low and have our woman run past the camera and make it look like she's speeding past us on the indoor track.

"Quick pan from left to right across a bank of monitors with music videos on them. Then cut to a quick pan right to left across woman working out. Then another cut to a quick move behind the women as they're moving in rhythm to the music and we see the monitors beyond. Go to a quick shot of our woman's eyes for the 'Oh yeah.' Then let's go to a low shot where a racquetball racket hits a ball up close right into the lens. The racket needs to fill the frame on this shot. Give me a variety of fast shots in a court of a ball hitting the line, a person flying past camera leaping for a shot, two other shots you can make up, and a high shot seeing down in more than one court.

"When we get to 'I never let . . . ,' I want to start on a medium shot 3/4 back view of our woman. She should turn to the camera, and we need to do an extremely fast push into her face, with a very serious look on it. Cut to their logo with a towel thrown into the background. I want to see the towel land on the floor and against the corner, and take up part of the camera left background of the frame. We don't have their logo yet, so just come up with something nice and generic to use in the boards."

Now, remember, all this will show up in 30 seconds—Whew! You should end up with around thirty-one to thirty-four panels for your production boards.

CHAPTER 47

EXERCISE 4: ANIMATION/ CARTOON

When you storyboard an animated TV episode, you may not get much guidance from the director. The script is written with much more detail regarding shots and camera angles than live action, but you probably won't be going over a shot list with a director. You will, most likely, get notes from the storyboard supervisor and/ or director. Remember to illustrate every little nuance of action or character reaction. Your drawings will probably be sent overseas to be animated. If you don't have an action in your storyboards, it won't show up on the screen.

This script is from an animated pilot I produced called *The Winkles*. Work with the character designs I've given you to draw them accurately ("on character") and try to match the style of the art in your boards. This is very important in animation. One thing you need to know is that Winkles don't walk, they bounce—kind of like kangaroos. I've also given you some backgrounds. You can use the entire background, or just a portion of one for close shots.

All you get here is the script. You do all the breakdowns yourself, but you may want to have someone give you creative notes before you do your clean-ups.

THE WINKLES — "MATERIAL GIRL"
COPYRIGHT 1996, ANIMATICS & STORYBOARDS, INC.
WRITTEN BY JEANNE PAPPAS SIMON

```
Fade in:

SEGMENT 1 - EXT YARD

As we open, we are flying behind two Gorks, delusional
ducks who think they're World War II fighter pilots.
They are flying, gliding actually, holding their arms
out from their sides like a kid does when she pretends
to fly. We see below them the fantastic rolling land-
scape of their planet Mirth.

We cut to a low angle looking up at Gork 1.
```

 GORK 1
 Pilot to bombardier, pilot to bombar-
 dier! We have the targets in sight!

Gork 2 is looking down past the camera and is holding a blueberry
pie out in one hand.

 GORK 2
 Roger that, Gorkmeister, blueberry bombs
 loaded and ready to fly.

Down on the ground Walter and Winnie Winkle, no relation, are play-
ing Nurfletee, a nonsensical game where there are sticks placed in
a circle and you roll an eight-sided die. If you lose a point you
put a stick in your hair. Walter and Winnie each have two sticks in
their hair.

Walter has one eye closed as he concentrates on rolling the die.
Winnie is impatiently waiting for him to do so.

 WINNIE
 Come on Walter, roll your Bink.

Back up in the sky, we are close on Gork 1. Gork 1 yells excitedly
and pumps his left arm as he says it.

 GORK 1
 Targets are in positionnnnn . . . Now!
 Go! Go! Go!

Gork 2 holds the pie up behind his head with both hands. His pos-
ture is bent backward to get the hardest possible throw. As he
throws the pie, his feet fly up and his hands go down between and
beneath his legs.

 GORK 2
 WAHOO!

Walter has wound up . . . hesitates . . . and throws the die. As he
throws it he leans forward with the force of the throw. The pie
from above barely misses him and hits the screen, totally covering
it with blue.

As the blue drips off the screen, we reveal a close-up of Walter,
angry, pumping his fist up in the air, yelling at the Gorks.

 WALTER
 You stupid Gorks.

Cut to close shot of Gork 1 with his head stretched down looking at
Walter. He lifts his head and looks back at Gork 2.

 GORK 1
 Pilot to bombardier. The enemy has
 turned aggressive. Take evasive mea-
 sures.

Medium shot, both Gorks fly in formation and bank off into the
clouds as they glide away.

Winnie shrugs off the attack. Then she turns and hops off towards the fence to fetch the Bink, an eight-sided die.

 WINNIE
 Forget those Gorks, they always miss.
 Come on, let's keep playing. I'll get
 the Bink.

Winne hops into frame by the fence. She looks down and spots a shiny rock, which looks like a colorful quartz crystal sticking out of a hardened mass of mud. She picks it up holding it up high, right in front of her face, and looks at it carefully and with a lot of pleasure. As she calls out to Walter behind her, she never stops looking at the rock.

 WINNIE
 Oh, Walter, look at what I've found!
 Isn't it pretty?

Walter comes up behind her. He tries to look over both of her shoulders, popping up over her left, then her right, then her left, and so on, to see the sparkly rock.

 WALTER
 Winnie, lemme see.

Winnie shrugs up her shoulder and tries to keep Walter from getting too close. She now holds the sparkly rock close to her chest with excessive pride.

 WINNIE
 Finders keepers Walter. You can look,
 but you can't touch.

Walter backs away hurt. He then gets mad, puts his hands on his hips, and lets Winnie have it. As he talks he wags his head from side to side for emphasis.

 WALTER
 Hmph . . . I don't like you very much. I
 don't wanna hold it. I don't wanna see
 it. I don't wanna play with YOU . . .

Walter's finger points right at camera, getting very close.

 WALTER
 (cont.) . . . anymore.

Walter then turns away from us and Winnie, hangs his head low, and slowly walks (not bounces) away. We slowly pull out to reveal Winnie in the foreground looking at her rock, oblivious to Walter or what he just said.

SEGMENT 2 - EXT. STREET

We see an adult Winkle sitting on a park bench, reading his paper. Winnie comes bouncing into frame, stops at his feet, and proudly presents her sparkly rock to him.

 WINNIE
 Look at my very special rock. It's my
 treasure beyond measure.

The adult Winkle smiles and pats Winnie on her head dismissively.

In the background we see the gorks approach, unaware that they're
about to walk up on Winnie.

Close on gorks as they saunter through the frame. Gork 2 stops on
the edge of frame, does a double take, and his head and neck
stretch back to the center of the frame as he excitedly yells . . .

 GORK 2
 Code red! Code red! Enemy at twelve
 o'clock.

Gork 1's head stretches into frame to look, his eyes bug out, and
his mouth hangs open in surprise.

 GORK 1
 Wha??

Medium shot as Winnie bounces up to the gorks. She stops in front
of them smiling.

 WINNIE
 Hi!

Close on the two gorks. Gork 1 has his hands tightly around Gork
2's neck and is vigorously shaking Gork 2's head back and forth.

 GORK 1
 We've been spotted!

Gork 2's eyes are bugging out and his tongue is swinging around and
turning blue.

 GORK 2
 Urp!

Shot of the park. Gork 1 slides his head in from Camera Right; he's
holding a microphone and is talking to the camera.

 GORK 1
 Houston, we have a problem.

Gork 1 pulls his head back out of frame.

Cut to a 3 shot.

 GORK 1
 Activate Operation Camouflage.

The gorks quickly duck their heads down into their jackets. Gork 1
remains standing and Gork 2 ends up sitting in the middle.

Winnie is presenting her sparkly rock in her presentation pose with
her eyes closed. She's more interested in voguing than in their
reaction, so she's not paying any attention to what they're doing.

Gork 1's eyes pop up out of his jacket, he looks around, and then slowly brings his entire head up. Winnie is not moving. He leans forward and looks at the rock. He then pulls out a blueberry pie and proudly presents it to Winnie with a mischievous grin. Gork 1 turns to the audience in a close up . . .

<div align="center">

GORK 1
(to camera)
This is too easy.

</div>

Once Winnie's sure they're adequately impressed she turns and bounces away.

<div align="center">

WINNIE
Okay . . . Bye bye.

</div>

Gork 1 winds up with his pie, ready to throw it at Winnie . . .

Gork 2 suddenly pops his head up in between them . . .

Gork 1 lets the pie fly and it hits Gork 2 in the back of the head.

We see Winnie bouncing away into the distance, happy and pie-free.

WINNIE **WALTER**

FIGURE 47.1 Winnie and Walter Winkle (no relation). If you decide to do these in color, Winnie is green and Walter is yellow. They both have pink hearts. (Designs by Mark Simon. © 1997 Animatics & Storyboards, Inc.)

PILOT GORK

BOMBARDIER GORK

FIGURE 47.2 Gork 1, pilot, and Gork 2, bombardier. They fly by holding their arms straight to their sides. They are purple with brown bomber jackets. (Designs by Mark Simon. © 1997 Animatics & Storyboards, Inc.)

ADULT WINKLE

FIGURE 47.3 Adult Winkle (no relation). He can be any color and just sits on the park bench. (Designs by Mark Simon. © 1997 Animatics & Storyboards, Inc.)

FIGURE 47.4 Winnie's colorful rock.

FIGURE 47.5 Backgrounds. The first background is where Winnie and Walter play. The second is where Winnie finds her rock. The third background is where the adult Winkle is sitting. (Art by Mark Simon. © 1997 Animatics & Storyboards, Inc.)

EXERCISE 5: ANIMATION/ SUPERHERO

For the following scenes, the style of animation should look more like the SUPER-MAN series or JOHNNY QUEST and be more "realistic" in comparison to the cartoony style used in Exercise 4 in Chapter 47. The bulk of the direction you'll get as a storyboard artist for this animation is from the script, as was the case in Exercise 4. Be creative in your action and camera angles. The character design and layouts are up to you in this sequence—it's time to shine.

WRITTEN BY TROY SCHMIDT
COPYRIGHT 1998

> The following is a scene that takes place way back when. Volcanus is the lair of the Cyclops who is the keeper of the trident that, when it strikes the ground, causes the earth to rumble. Bradus seems to be a hero, but is soon enough shown to be selfish in his quest. Nick and Lisa are present-day people wandering through the past trying to find their way home with their dog Zeus.
>
> INT. VOLCANUS - WIDE ON CAVE
>
> A large open space, taking up one half of the volcano. The lava flows upwards past a hole in the wall (the Cyclops' forge). For now the volcano is silent.
>
> WIDE ON CYCLOPS
>
> The thirty-foot giant sleeps on the ground, his back to us.
>
> MEDIUM SHOT ON BRADUS

Bradus tiptoes up to the trident and helmet. He carefully takes them into his hand then walks away.

WIDE ON CYCLOPS

Still sleeping.

MEDIUM ON NICK, LISA, ZEUS

Lisa cheers Bradus on.

> LISA
> He's got them.

MEDIUM SHOT ON BRADUS

Bradus is relieved that he has them until—

CLOSE ON TRIDENT

The pronged end of the trident hits a rock. This triggers a RUMBLING.

WIDE OF CAVE

An earthquake shakes the cave. Rocks fall.

MEDIUM SHOT ON BRADUS

Bradus is thrown about. He drops the helmet.

CLOSE ON HELMET

The helmet falls to the ground.

CLOSE ON CYCLOPS

The Cyclops awakens and turns his head. A hideously grotesque man with one eye squarely in the center of his head and a few fang-like teeth in his mouth (obviously hasn't brushed after eating every human).

WIDE ON CYCLOPS

He stands, SNARLING, rocks falling all around him.

MEDIUM WIDE ON NICK, LISA, ZEUS

The trio stands, preparing to exit.

> NICK
> This place is rockin'. Let's skeedaddle!

But a falling rock whacks Lisa in the head. She loses her balance.

LOW ANGLE OF LISA

Angle from the ground, looking up as Lisa falls.

HIGH ANGLE, LOOKING DOWN

At Lisa on the ground.

CLOSE ON NICK, LOOKING DOWN

 NICK
 Lisa!

CLOSE ON CYCLOPS

The Cyclops hears the cry and turns in that direction.

WIDE ON CYCLOPS

Walking towards Nick and Zeus. The earthquake stops.

CLOSE ON NICK

 NICK
 (terrified)
 Look out!

Nick runs for cover.

WIDE ON CYCLOPS

He stops at the ledge, looking for the intruders, then looks down.

HIGH ANGLE, LOOKING DOWN

At Lisa on the ground. The Cyclops' hand reaches in.

MEDIUM ANGLE ON CYCLOPS

As he raises an unconscious Lisa to his face.

CYCLOPS POV OF LISA

The Cyclops examines this fascinating intruder.

CLOSE-UP OF CYCLOPS

Something about his countenance changes. You can see it in his eye.
He doesn't want to hurt this one. He takes her away.

MEDIUM ANGLE ON ZEUS, NICK, AND BRADUS

Bradus joins Nick and Zeus in a rock alcove.

 BRADUS
 I have the trident.

 NICK
 And the Cyclops has Lisa. How are we
 going to get her back?

 BRADUS
 I do not know, but I cannot help you at
 this time. I must get this trident to my
 city.

 NICK
 But Lisa's going to get eaten by the
 thing.

 BRADUS
 And 40,000 of my people will die if I do
 not bring help. The needs of the many
 outweigh the needs of the few. I'm
 sorry.

Bradus walks off. Nick shakes his head. Now what?

FADE OUT:

PART FIVE

STORYBOARD EXPERIMENT

CHAPTER 49

EXPERIMENT

All storyboard artists brings their own vision and talent to a production. Even with the same script and notes, artists are bound to illustrate scenes differently.

In the first test of its kind (and an extremely cool one, I think), I asked a few storyboard artists to board out the same scene, using the same references and director's notes. You will be amazed at the differences. Below is the exact script and information we gave each artist.

DESCRIPTION FOR THE ARTISTS

Each of you is being given the same short scene. Along with this scene you will find common references to work from as well as director's notes. The parameters for this experiment are:

Black and white boards. Pencil or pen is up to you. You determine tone or line illustration.

Panel format should be 16:9, or feature film ratio.

Panel count. The total number of frames will be up to your discretion.

Do your best to work within the directors' notes. If you have a great idea to make the scene better, go ahead.

SCENE

The following scene is excerpted from the script "Couples" by Alfred Wayne Carter.

COUPLES
WRITTEN BY ALFRED WAYNE CARTER

```
INT. KITCHEN - MORNING

The kitchen is a bit of a mess. Plates are pilled high
on the counter and on the sink. Pots are stacked on the
stove.
```

BILL, in his robe and still not quite awake, sits at the table where his "STAR TREK" MUG is waiting for him filled with tea. He delicately handles it like it was the Holy Ark of the Covenant. He looks at the window and listens to the sound of birds CHIRPING.

A pile of DISHES towering out of the sink suddenly CRASHES down and explodes across the kitchen floor with hell-born fury.

BILL leaps from his chair in surprise, lifting the table up with him and sending his beloved "STAR TREK" MUG into orbit. He throws his body across the table in a futile effort to catch its fall, but it drops past his outstretched fingertips and SHATTERS into the wreckage below.

FADE OUT

DIRECTOR'S NOTES

CHARACTER

Bill is in his mid-thirties. In this scene his hair is disheveled and his robe is the kind his wife has wanted to throw away for years. It's plaid, heavy, and slightly ragged. He's not fully awake.

LOCATION

The kitchen is fairly upscale. The kitchen table is round and about five feet in diameter. The newspaper and salt and pepper shakers are on the table. The layout of the kitchen is shown below.

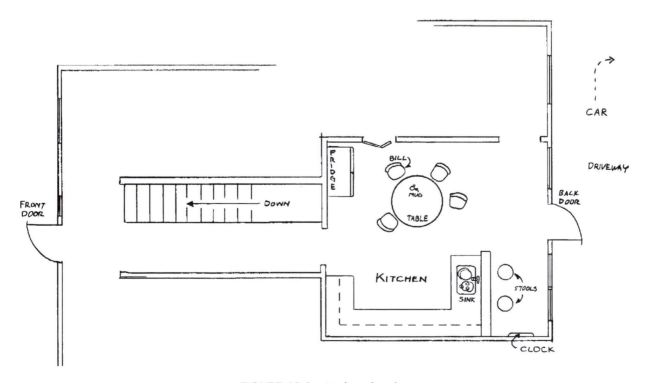

FIGURE 49.1 Kitchen plot plan.

ACTION

Bill is still not fully awake as he sits at the table. His hair is a mess and he's somewhat slumped over—obviously not a morning person.

Bill picks up his mug affectionately with both hands and holds it up by his face. While his eyes don't open much, he smiles in appreciation for his mug and for how this tea will make him feel in a moment.

Bill looks at the window toward where the birds are singing outside with a look of "where has the joy in my life gone?" When the dishes fall, his eyes snap wide open and he leaps into action. When he quickly stands up, his lap knocks the table up hard, throwing his mug forward in the air.

In slow motion, we see Bill from the opposite side of the table leaping towards us with a look of fear on his face as he reaches for his beloved mug. We see the mug barely miss his fingers in a close-up. From a high angle, looking straight down, the mug shatters on the floor spewing tea in every direction.

The last shot we see is from just above the table surface of Bill lying dejectedly across the table towards the camera.

Gentlemen and gentlewomen, start your pencils and let the games begin.

EXPERIMENT STORYBOARDS

EXPERIMENT BY STEVE SHORTRIDGE

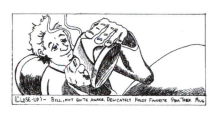

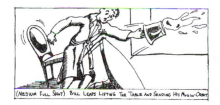

EXPERIMENT BY CHRIS ALLARD

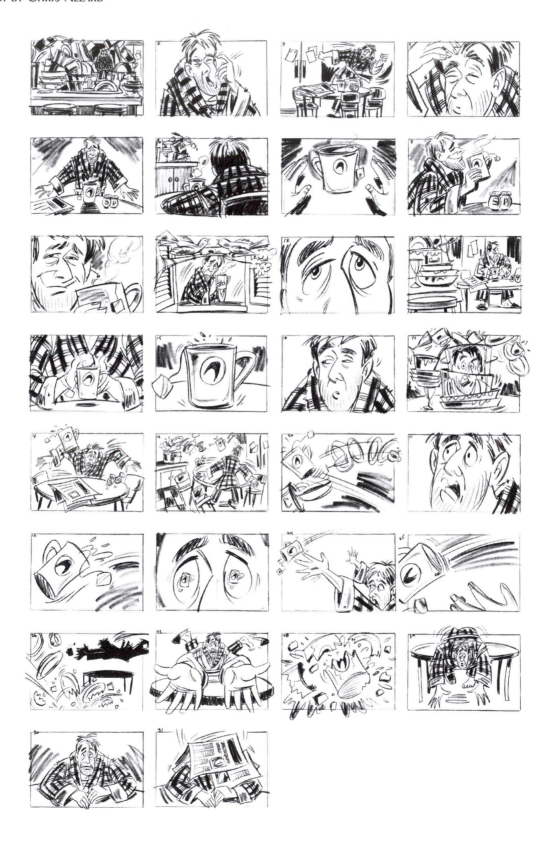

EXPERIMENT BY KEITH SINTAY

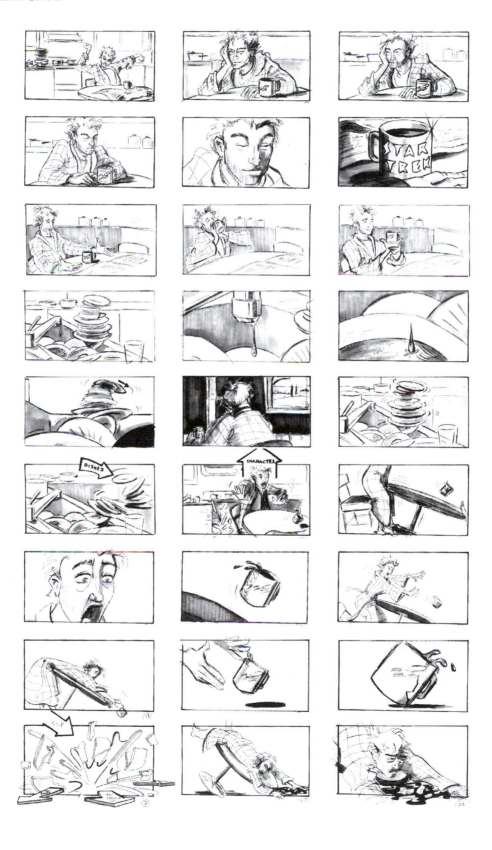

EXPERIMENT BY MARK SIMON

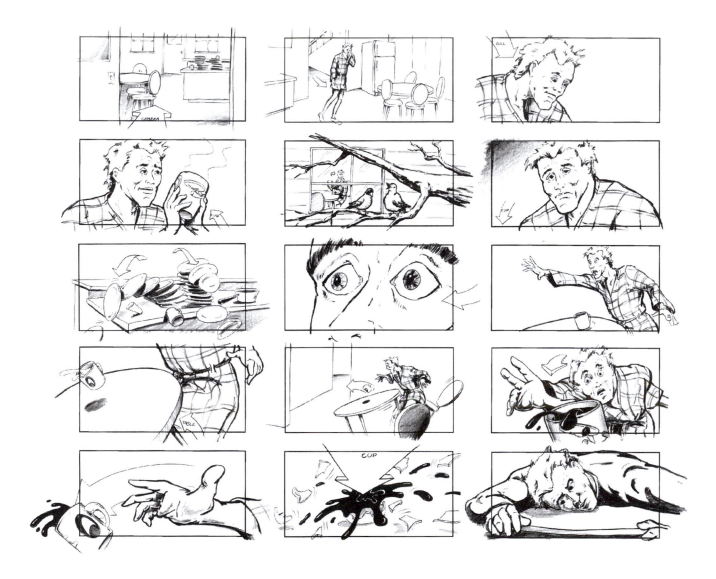

EXPERIMENT BY DAN ANTKOWIAK

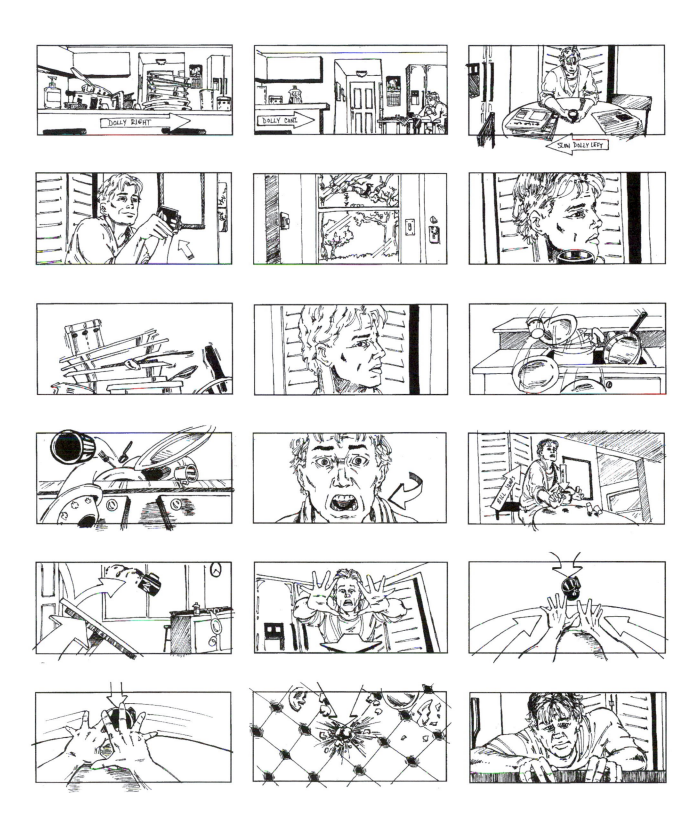

PART SIX

APPENDICES

CHAPTER 50

RESOURCES

RECOMMENDED BOOKS

These books will help you in storyboarding in many ways. They will serve as visual references, inspiration, and help with knowledge of the entertainment industry and storytelling. This is by no means a complete list, but it is a great start.

ENCYCLOPEDIAS

Any set, printed or digital.
Great reference for any image.

"MAKING OF" BOOKS

The Making of Congo: The Movie
By Jody Duncan and Janine Pourroy
Publisher: Ballantine Books
1995
$18.95
181 pages
Great examples of conceptual art for the movie.

The Making of Judge Dredd
By Jane Killick, David Chute, and Charles M. Lippincott
Publisher: Hyperion
1995
$15.95
192 pages
Conceptual art and costume design. Large section of storyboards in the back.

The Making of Jurassic Park
By Don Shay and Jody Duncan
Publisher: Ballantine Books
1993

$18.00

195 pages

Written by the publisher and editors of *Cinefex*, the finest magazine on the effects industry. The best book of its kind I've found. Great photos and renderings of the concepts, sets, dinosaurs, robots, and more. Also includes the greatest gallery of storyboards (41 pages worth) I have ever seen in a "making of" book. A must.

The Making of The Lost World: Jurassic Park
By Jody Duncan
Publisher: Ballantine Books
1997
$18.00
165 pages
Tons of great conceptual art and storyboards. Has a great sequence of digital storyboards combining the actual footage and hand-drawn dinosaurs.

The Making of Starship Troopers
By Paul M. Sammon
Publisher: Boulevard Books
1997
$15.00
152 pages
Examples of the director's sketches and real storyboards.

The Making of Waterworld
By Janine Pourroy
Publisher: Boulevard Books
1995
$15.00
147 pages

T2: The Making of Terminator 2: Judgment Day
By Don Shay and Jody Duncan
Publisher: Bantam Books
1991
$9.99
127 pages
Storyboards, photos, and explanations of the effects.

Toy Story: *The Art and Making of the Animated Film*
By John Lasseter and Steve Daly
Publisher: Hyperion
1995
$39.95
128 pages
Lots of conceptual art and storyboards.

"ART OF" BOOKS

Tim Burton's Nightmare Before Christmas: *The Film, The Art, The Vision*
By Frank Thompson
Publisher: Hyperion
1993
$15.95
192 pages

The Art of Anastasia
By Harvey Deneroff
Publisher: HarperCollins
1997
$50.00
192 pages

Disney's Art of Animation
By Bob Thomas
Publisher: Hyperion
1991
$19.95
208 pages

The Art of The Lion King
By Christopher Finch
Publisher: Hyperion
1994
$50.00
189 pages

The Art of Pocahontas
By Stephen Rebello
Publisher: Hyperion
1995
$50.00
197 pages

The Art of The Hunchback of Notre Dame
By Stephen Rebello
Publisher: Hyperion
1996
$50.00
199 pages

The Art of Star Trek
By Judith and Garfield Reeves-Stevens
Publisher: Pocket Books
1995
$50.00
291 pages

Filled with art, designs, and photos from the original and contemporary series and films.

The Art of Star Wars
By Carol Titelman
Publisher: Ballantine Books
1979
$14.95
175 pages
Production paintings, storyboards, sets, costumes, and creature sketches. The best of its kind.

The Art of The Empire Strikes Back
By Deborah Call
Publisher: Ballantine Books
1980
$15.95
176 pages
Production paintings, storyboards, sketches, and more of the sets, creatures, and wardrobe. Awesome.

The Art of Return of the Jedi
Publisher: Ballantine Books
1983
$17.95
151 pages
Production paintings, sketches, and storyboards of the sets, creatures, and costumes. Incredible.

Indiana Jones and the Temple of Doom: *The Illustrated Screenplay*
Introduction by Steven Spielberg
By Willard Huyck and Gloria Katz
Publisher: Ballantine Books
1984
$17.95
122 pages

Men in Black: *The Script and the Story Behind the Film*
By Barry Sonnenfeld, Ed Solomon, Walter F. Parkes, and Laurie MacDonald
Publisher: Newmarket Press
1997
$16.95
158 pages
Great drawings of futuristic weapons.

Space Jammin': *Michael and Bugs Hit the Big Screen*
By Charles Carney and Gina Misiroglu
Publisher: Rutledge Hill Press
1996

$19.95
173 pages
Great art and good simple descriptions of how the animation and live action were produced.

The Prince of Egypt: *A New Vision in Animation*
By Charles Solomon
Publisher: Harry N. Abrams 1998
$45.00
192 pages

Dune: *Official Collector's Edition*
Publisher: Paradise Press
1984
$3.50
61 pages
Photos of sets, props, and characters.

Dracula: *The Film and the Legend*
Publisher: New Market Press
1992
$14.95
172 pages
Wonderful photos and sketches of the immense sets used in this Academy Award winning movie. Storyboards and design ideas explained.

Oblagon: *Concepts of Syd Mead*
By Syd Mead
Publisher: Oblagon
213-850-5225
1985
$35.00
167 pages
Art of this incredible futurist designer. Included are designs for movies such as *Blade Runner* and *2010*. Other books by Syd Mead are available as well.

Batman: *The Official Book of the Movie*
By John Marriott
Publisher: Bantam Books
1989
$7.95
96 pages
Photos and sketches of the sets, props, and costumes.

Batman Returns: *The Official Movie Book*
By Michael Singer
Publisher: Bantam Books
1992
$9.99

80 pages
Photos and sketches of the sets, props, and costumes.

Batman Animated
By Paul Dini and Chip Kidd
Publisher: Harper Entertainment
1998
$25.00
Great art, storyboards, character design, and behind-the-scenes stories. One of the best.

SPECIAL EFFECTS

Industrial Light and Magic: The Art of Special Effects
By Thomas G. Smith
Publisher: Ballantine Books
1986
$75.00
279 pages
The bible of special effects. Photos, sketches, and storyboards from some of the best FX movies ever made. Possibly the finest FX book ever published. A must for your collection.

Creating Special Effects for TV and Films
By Wilke
From Tri-Ess Sciences, Catalogue # BK903
$22.95
158 pages
A basic, simplified, page-by-page procedure for special effects such as wilting flowers, fires, cobwebs, quicksand, explosions, break-aways, etc. Helpful information for a storyboard artist to know.

Secrets of Hollywood Special Effects
By Robert McCarthy
From Tri-Ess Sciences, Catalogue # BK892
$38.00
192 pages
All types of effects are covered. This is highly recommended by Tri-Ess Sciences.

How Did They Do It? Computer Illusion in Film and TV
By Christopher W. Baker
Publisher: Marie Butler-Knight
1994
$20.00
182 pages
If you're going to draw how to do it, you need to know how to do it.

THE SCREENPLAY

The Screenplay: A Blend of Film, Form, and Content
By Margaret Mehring
Focal Press
Recommended text at Ringling School of Art and Design.

The Writer's Journey: Mythic Structure for Storytellers and Screenwriters
By Christopher Vogler
Michael Weise Productions
Recommended text at Ringling School of Art and Design.

ANIMATION

How to Draw Animation
By Christopher Hart
Publisher: Watson-Guptill Publications
1997
$18.95
144 pages
These animation illustration principals are essential for animation storyboard artists.

How to Draw Comics the Marvel Way
By Stan Lee and John Buscema
Publisher: Simon and Schuster
1978
160 pages
Quite simply, the book that taught me how to draw the human figure in action.

How to Draw Cartoon Animals
By Christopher Hart
Publisher: Watson-Guptill Publications
1995
$16.95
144 pages

How to Draw Comic Book Heroes and Villains
By Christopher Hart
Publisher: Watson-Guptill Publications
1995
$18.95
144 pages
Great simple drawing strategies.

Too Funny for Words: Disney's Greatest Sight Gags
By Frank Thomas and Ollie Johnston
Publisher: Abbeville Press
1987
23 pages

Disney Animation: The Illusion of Life
By Frank Thomas and Ollie Johnston
Publisher: Abbeville Press, Inc.
1984
382 pages
One of the animation bibles.

Disney's Animation Magic
By Don Hahn
Publisher: Disney Press
1996
$16.95
96 pages

Cartoon Animation
By Preston Blair
Publisher: Walter Foster Publishing
1994
224 pages

The Animation Book
By Kit Laybourne
Publisher: Crown
1998
$24.95
426 pages
Newly revised and expanded version of this bible of the industry.

Reference Books

Animals in Motion
By Eadweard Muybridge
Publisher: Dover
1957
$29.95
183 pages
Great reference for thirty-four animals walking, jumping, and running. Over 4,000 photos.

The Human Figure in Motion
By Eadweard Muybridge
Publisher: Dover
1955

$24.95
195 pages
Great reference of nudes walking, running, jumping, lifting, etc. Over 4,700 photos.

Couples, Vols. 1 (*Basic Pose*) and 2 (*Daily Pose*)
By Hisashi Eguchi
Publisher: Bijutsu Shuppan-Sha
$35.95 each
Black and white photo images of couples in various poses, taken from multiple angles. Clothed and nude. Around 900 images apiece.

Illustrator's Reference Manual: Nudes
Publisher: Chartwell Books
1989
Posed photos taken from multiple angles.

Perspective: A Step-By-Step for Mastering Perspective by Using the Grid System
Publisher: DAG Design
$19.95
80 pages
Includes grids to work with.

Storyboarding

Film Directing Shot by Shot: Visualizing from Concept to Screen
By Steven D. Katz
Publisher: Michael Wiese Productions/Focal Press
1991
$24.95
366 pages
Great examples of storyboards and how to visually tell a story.

Marker Magic: The Rendering Problem Solver for Designers
By Richard McGarry and Greg Madsen
Publisher: International Thompson Publishing
1993
146 pages
Great marker art samples for those who color storyboards with markers.

Creative Marker Techniques in Combination with Mixed Media
By Yoshiharu Shimizu
Publisher: Graphic-sha Publishing
1990

$50.00
131 pages
Great examples of conceptual art with markers.

MARKETING

Selling Your Graphic Design and Illustration: The Complete Marketing, Business and Legal Guide
By Tad Crawford and Arie Kopelman
Publisher: St. Martins Press
1981
236 pages
$13.95
Everything you should know about selling rights and licenses for artwork, including example contracts and pricing guidelines. A must if you sell artwork.

Artist's and Graphic Designer's Market
By Mary Cox
Publisher: F&W Publications
Updated every year.
$24.99
700+ pages
Interviews artists along with thousands of listings of where to sell your art and for how much. Yours truly was interviewed in the 1997 edition.

Graphic Artists Guild Handbook: Pricing and Ethical Guidelines
1997
$22.95
313 pages
Graphic Artists Guild
90 John St., Suite 403
New York, NY 10038
800-878-2753
The best pricing and business information book for artists I have ever read. Copyright and tax laws, ethical issues, business forms, liability, new technology, and more.

ARCHITECTURE AND INTERIORS

Entourage: A Tracing File for Architecture and Interior Design Drawing
By Ernest Burden
Publisher: McGraw-Hill
1991
280 pages

Photos and drawings of people, buildings, cars, animals, and plants for reference and tracing. The only drawback is that many of the clothing styles are out of date.

Interior Space Designing
By Yasuo Kondo
Publisher: Graphic-Sha Publishing
1989
1160 pages
Mostly commercial building interiors; great for conceptual reference.

Restaurant Design 2
By Judi Radice
Publisher: Rizzolli International Publishers
1990
Restaurant interiors for conceptual reference.

Exhibit Design 4
By Robert B. Konikow
Publisher: PBC International
1990
Designs of outrageous and large industrial and exhibition hall exhibits. There are six books in this series.

Retail Design
By Rodney Fitch and Lance Knobel
Publisher: Whitney Library of Design
1990
Commercial retail design interiors.

Display and Commercial Space Designs
(All Volumes)
Publisher: Rikuyo-Sha Publishing
Commercial retail and point-of-purchase display designs.

Any book by Nippon Books
All architectural designs from Japan.
213-604-9701

International Contract Design
By Lewis Blackwell
Publisher: Abbeville Press
488 Madison Ave.
New York, NY 10022
1990
256 pages
Some of the most exciting public interiors for offices, stores, restaurants, bars, hotels, museums, and health centers.

The Complete book of Home Design (Revised Edition)
By Mary Gilliatt
Publisher: Little, Brown and Company
1989
$29.95
384 pages
Ideas for studies, children's rooms, and all household rooms. Information on changing technology. Space, color, and fabric design.

Rooms by Design
By Gerd Hatje and Herbert Weisskamp
Publisher: Harry N. Abrams
1989
Very different types of interior design. Many are very eclectic.

An Illustrated History of Interior Decoration: From Pompeii to Art Nouveau
By Mario Praz
Publisher: Thames and Hudson
1964, 1982
$75.00
Illustrations and paintings through the ages, mostly from 1770 to 1860, from Europe, Russia, and America. Many well-known artists represented. Good source for period props and architecture design.

Homes and Interiors of the 1920s
By Lee Valley
Publisher: Sterling Publishing
1987
$19.95
439 pages
Interior and exterior designs of the 20s. Illustrations show everything from floor plans to casework and balusters.

American Vernacular Interior Design: 1870–1940
By Jan Jennings and Herbert Gottfried
Publisher: Van Nostrand Reinhold Company
1988
$39.95
438 pages
Historic design concepts and sketches of all construction pieces and fixtures. Interior and exterior designs and vernacular illustrated. Great for period pieces.

Architectural Detailing in Residential Interiors
By Wendy W. Staebler

Publisher: Whitney Library of Design
1990
$49.95
High-quality photos and designs of different residential interiors.

Castles: Their Construction and History
By Sidney Toy
Publisher: Dover
1985
$6.95
241 pages
Sketches, designs, photos, and vernacular of castles.

Industrial Landscape
By David Plowden
Publisher: W.W. Norton
1985
$39.95
148 pages

Photos of industrial complexes, interior and exterior, and the surrounding living areas. One of the references to this type of design.

OTHER RESOURCES

Weapons through the Ages
By William Reid
Publisher: Crescent Books
1976
Illustrations and designs of armor and weapons from Neolithic archery to modern tanks.

Ships and the Sea: A Chronological Review
By Duncan Haws
Publisher: Crescent Books
1975
$24.95
240 pages

Illustrated ships and sailing vessels from the dawn of time to the present day. Every aspect of sailing is explored. Styles, vernacular, and design specs on each ship.

The Internet
The Internet is also a great source for any visuals you can't find in these books.

PERIODICALS

Dramalogue
1456 N. Gordon
Hollywood, CA 90028
213-464-5079
Los Angeles-based industry newspaper. Has employment listings for crew members one day a week. Usually this is for low-budget (or no-budget) productions, but work begets work. I got my first industry job here.

Daily Variety
5700 Wilshire Blvd.
Los Angeles, CA 90036
800-552-3632
310-782-7012
$129 per year
Biggest industry newspaper. Listings of features in pre-production and in production around the world in every Friday edition. Good for trade information.

Hollywood Reporter
5055 Wilshire Blvd.
Los Angeles, CA 90036-4396
213-525-2000
$149 per year
Daily industry trade paper. Very good listings of features in production and preproduction and the top crew people. Good for trade information.

Backstage
1515 Broadway, 14th Floor
New York, NY 10036
212-764-7300
Fax 212-536-5318
$65 per year
Published every Friday. Deals mainly with New York production in TV, film, and theater. Casting information for crew and talent. Good for trade information.

Art Direction
10 E. 39th Street
New York, NY 10016
212-889-6500
$29.97 per year
Monthly magazine dealing with design for the visual arts. Mostly for print, with some commercial Storyboards. Information on new design software and more. Great for keeping up with the latest looks and designs.

Interior Design
44 Cook Street
Denver, CO 80206-5800
800-542-8138
$34.95 per year
Monthly magazine with great photos of residential and commercial design. Awesome reference material each month.

Cinefex
P.O. Box 20027
Riverside, CA 92516
Published quarterly
4 issues for $22
Simply the finest magazine published for designs and special effects. Photos and descriptions of FX for the latest movies and commercials. The advertisers are the best sources for whom to call or where to get special supplies. A definite must. They supply a list in the back of each issue for ordering back issues.

Post
25 Willowdale Avenue
Port Washington, NY 11050-9866
516-767-2500
Fax 516-767-9335
$40 per year
Monthly magazine dealing with all aspects of postproduction. A lot of information on computer graphics is included in each issue as well as some FX information.

millimeter
Penton Publishing
Subscription Lockbox
P.O. Box 96732
Chicago, IL 60693
$60 per year
Monthly magazine dealing with new production and postproduction techniques.

American Cinematographer
ASC Holding Corp.
1782 N. Orange Dr.
Hollywood, CA 90028
213-876-5080
$24 per year
Monthly magazine with articles on every aspect of the industry. Some articles touch on the art fields. All the photos are great references from the top movies.

RESOURCE GUIDES

LA 411
P.O. Box 480495
Los Angeles, CA 90048
213-460-6304
Fax 213-934-0226
$55 for 13th edition
The best film and video guide for crew and services in Southern California. Includes production companies and union rules. If you live and work around L.A., get in this book.

SF 411
P.O. Box 77146
San Francisco, CA 94107
415-285-5556
$45 for 1988 edition
Film and video guide for crew and services in northern California.

Chicago Prop Finders Handbook
The Print Group
Broadway Press
12 W. Thomas St.
Box 1037
Shelter Island, NY 11964-1037
800-869-6372
$55
For the Chicago area, 482 pages of supplies and crews.

CHAPTER 51

FORMS

Project:

form: a-s-tv.599

FIGURE 51.1 TV Storyboard Form

FIGURE 51.2 ANIMATION STORYBOARD FORM

Project:

form: a-s-film.599

FIGURE 51.3 Feature Film Storyboard Form

STORYBOARD INVOICE

Please make checks out to:

Invoice #

TO:

Date:
Commissioned By:

Assignment Description:

Boards for

Number		
Panels		
Subtotal		
Number		
Subtotal		
Number		
Subtotal		
Total Fees		

Expenses:
The Client shall reimburse the designer/artist for all expenses.

Photography, location reference	Zip & Jazz disks
Models & Props	Client's Alterations
Materials & Supplies	Toll Telephone
Digital Blurring	Transportation & Travel
Stats, Proofing & Copies	Messengers
Mechanicals	Shipping & Insurance
LD Fax/page	Other Expenses
Scans on disk	**Subtotal Expenses**

Fee	
Expenses	
Payments on Account	
Balance Due	

1.5% monthly interest due after 30 days. Client responsible for all collection fees.

Rights Transferred:
The designer/artist transfers to the client the following exclusive rights of usage.

Title or Product:
Category of Use:
Medium of Use:
Edition (if book):
Geographic Area:
Time Period:

Any usage rights not exclusively transferred are reserved to the designer. Usage beyond that granted the client herein shall require payment of a mutually agreed upon additional fee subject to all terms

Receiving Party Signature:

Date:

Please Print Name:

FIGURE 51.4 SAMPLE STORYBOARD INVOICE, PAGE 1

Terms:

1: Time for Payment
All invoices are payable within thirty (30) days of receipt. A 1 1/2% monthly service charge is payable on all overdue balances. The grant of any license or right of copyright is conditioned on receipt of full payment.

2: Default in Payment
The client shall assume responsibility for all collection of legal fees necessitated by default in payment.

3: Expenses
The client shall reimburse the designer/artist for all expenses arising from this assignment, including the payment of any sales taxes due on this assignment.

4: Changes
The client shall be responsible for making additional payments for changes requested by the client in original assignment. However, no additional payment shall be made for changes required to conform to the original assignment description. The client shall offer the designer/artist the first opportunity to make any changes.

5: Cancellation
In the event of cancellation of this assignment, ownership of all copyrights and the original artwork shall be retained by the artist, and a cancellation fee for work completed, based on the contract price and expenses already incurred, shall be paid by the client.

6: Ownership and Return of Artwork
The designer/artist retains ownership of all original artwork, whether preliminary or final, and the client shall return such artwork within thirty (30) days of use unless otherwise indicated below.

7: Credit Lines
The designer/artist and any other creators shall receive a credit line with any editorial usage. If similar credit lines are to be given with other types of usage, it must be so indicated here:

8: Releases
The client shall indemnify the designer/artist against all claims and expenses, including reasonable attorney's fees, due to uses for which no release was requested in writing or for uses which exceed authority granted by a release.

9: Modifications
Modifications of the Agreement must be written, except that the invoice may include, and the client shall pay, fees or expenses that were orally authorized in order to progress promptly with the work.

10: Uniform Commercial Code
The above terms incorporate Article 2 of the Uniform Commercial Code.

11: Code of Fair Practice
The client and the designer/artist agree to comply with the provisions of the Code of Fair Practice, a copy of which may be obtained from the Joint Ethics Committee, P.O. Box 179, Grand Central Station, New York, NY, 10017.

12: Arbitration
Any dispute in excess of $2,500 (maximum limit for small claims court) arising out of this Agreement shall be submitted to binding arbitration before the Joint Ethics Committee or a mutually agreed upon Arbitrator pursuant to the rules of the American Arbitration Association. The Arbitrator's award shall be final, and judgement may be entered in any court having jurisdiction thereof. The client shall pay all arbitration and court costs, reasonable attorney's fees and legal interest on any award or judgement in favor of the designer/artist.

form: a-s.brd-inv$.wp1

FIGURE 51.5 SAMPLE STORYBOARD INVOICE, PAGE 2

CHAPTER 52

SCHOOLS OFFERING STORYBOARDING

There are many schools around the world that teach both film and animation production. Over the years only a few film schools have taught the value of storyboarding, but more seem to be doing so every year. Most animation schools teach storyboarding either as its own course or as part of the overall curriculum since it's so integral to the production of animation.

While this is by no means a complete list of schools that have storyboarding in their curriculums, it is the most comprehensive list you will find. Some schools and associations offer extension courses on storyboarding and won't be listed here. If you have any questions about a school that you're interested in call the school and talk to the heads of the film, production, and animation departments directly. The more people ask for classes on storyboards, the more such classes will be offered.

Adelphi University
516-817-4908
Garden City, NY
Storyboarding for live action is included in five production classes.

Academy of Media
49-22-12-01-89-0
Peter-Welter-Platz 2
D-50676 Koln
Germany
www.khm.de
Storyboards are taught in TV/Film and Media Design courses.

American Film Institute
323-856-7600
2021 N. Western Avenue
Los Angeles, CA 90027
www.afionline.org

Courses: The Center for Advanced Film and Television Studies offers an MFA in Film Production and also offers seminars and workshops on many film subjects, including storyboards, to the public.

Animation Workshops
213-655-2664
437 1/2 No. Genessee Avenue
Los Angeles, CA 90036-2282
Storyboarding for 2D animation. Storyboards are taught in the early stages of their sessions.

Animationsvaerkstdedt
45-8-667-2007
Skaldehojvey 2
8800 Vilborg
Denmark
www.animwork.dk
In the "Character Animation" course, there is a two-week class on storyboarding.

Art Center College of Design
626-396-2373
Pasadena, CA 91103
The gamut is covered, from concept to execution: storyboards, shooting boards, animatics, and more.

Art Institute of Fort Lauderdale
954-463-3000
1799 SE 17th Street
Fort Lauderdale, FL 33316
www.aii.edu
An intensive class in storyboarding for animation is offered.

Art Institute of Houston
713-623-2040
1900 Yorktown
Houston, TX 77056-4197
Course: "Storyboarding for Animation." Storyboarding is also integrated into some of the other curriculums.

Associates in Art
818-986-1050
5211 Kester Avenue
Sherman Oaks, CA 91411
Courses: "Storyboarding for Animation" and "Storyboard for Live Action Film and Advertising."

Atelier Ecole de Realisation de Films
33-4-75-43-34-05
6 rue Jean Bertin

26000 Valence
France

Austin Community College
512-223-4830
11928 Stonehollow Drive
Austin, TX 78758
The basics of storyboarding are taught for the final project.

Brooklyn College
718-951-5664
2900 Bedford Avenue
Brooklyn, NY 11210-2889
http://depthome.brooklyn.cuny.edu/film
Storyboarding is incorporated into most of the production courses. Courses: "Super 8 Production" and "16mm Intro"; "Advanced Production" and "Directing Workshop" courses.

Cal State Chico
530-898-4421
1st and Normal
Chico, CA 95929-0005
www.ecst.csuchico.edu/vertolli
Storyboards taught in course numbers CSCI 240 ("Computer Animation") and CSCI 298C ("Special Projects").

Capilano College
604-983-7516
2055 Purcell Way
North Vancouver, BC V7J 3H5
Canada
Part-time courses are offered in "Storyboarding for Animation." The Commercial Animation Program includes a "Storyboard Design" course.

Centre national de la bande dessinee et de l'image
(National Center for Comic Art and the Image)
33-5-45-38-65-75
121 rue de Bordeaux
16000 Angouleme
France
Storyboarding is included in their curriculum.

CDIS – Center for Digital Imaging and Sound
604-298-5400
3264 Beta Avenue
Burnaby, BC V5G 4K4
Canada
www.artschool.com

Storyboard training; course number STB 200. Other classes integrate storyboarding into the curriculum.

CityVarsity
+27 21 423 3366
32 Kloof Street
Cape Town 8001
South Africa
www.cvarsity.co.za
Storyboarding is part of four courses: Multimedia design and production; Film and TV production techniques; Art Department, specializing in Special Effects, Decor Painting and Make Up; Animation for Film and TV.

College Boreal
705-848-6673
20 Chemin Lisborn
Elliot Lake, ON P5A 3N9
Canada
Course: Number Scenarios 12019. Course covers TV and animated film storyboarding. All courses are offered in French.

Cyclone Arts and Technologies
514-288-3731
465 rue Saint-Jean
Bureau 120
Montreal, QC H2V 2R6
Canada
Students learn how to make both a script and a storyboard to produce a short animated film.

DH Institute of Media Arts
320-899-9377
1315 3rd Street Promenade
Suite 300
Santa Monica, CA 90401
Course: "Storyboarding."

Edinboro University of Pennsylvania
814-732-2406
Art Department
Edinboro, PA 16444
www.edinboro.edu/cwis/art/geninfo.html
Storyboard work is required in all of the animation production courses and optional in the film and video production courses.

Escola das Artes Universidade Catolica
35-126169185
Rua Diogo Botelho 1327-4169-005

Porto
Portugal
www.artes.ucp.pt
Courses: "Video Production" and "Media Production."

Florida Center for Electronic Communication (CEC) at Florida Atlantic University
954-762-5618
3264 Beta Avenue
Fort Lauderdale, FL 33301
Storyboards are included as a fundamental part of their computer arts animation program.

Full Sail Real World Education
800-226-7625
3300 University Blvd.
Winter Park, FL 32792
Basic storyboarding is used in three courses: "Video Production," "Design and Art Theory," and "Computer Animation 2."

Gnomon Inc.
323-466-6663
1015 No. Cahuenga Blvd.
Hollywood, CA 90038
www.gnomon3d.com
Storyboarding for animation.

Grand Valley State University
616-895-3486
1 Campus Drive
Allendale, MI 49401-9403
www.gvsu.edu
Pre-admission course: "Image and Sound."

Hollywood Film Institute
800-366-3456
P.O. Box 481252
Los Angeles, CA 90048
Courses: "The Film School Crash Course," "The Directing Crash Course," and "The Weekend 35mm Shoot."

INA Formation
33-1-40-83-24-24
4 Avenue de l'Europe
94360 Bry sur Marne
France
www.ina.fr/formation
Storyboarding is included in the course.

Joe Kubert School of Cartoon and Graphic Art
201-361-1327
37 Myrtle Avenue
Dover, NJ 07801
Storyboards are taught in the "Cinematic Animation II" course, class 202 B. Storyboards.

FIGURE 52.1 The Joe Kubert School of Cartoon and Graphic Art

London Animation Studio
44-171-514-7373
2-6 Catton St
London WC1 4AA
www.las.linst.ac.uk
A twenty-four-week course in animation is offered with two major projects that must be fully storyboarded.

Mesmer Animation
800-237-7311
2021 N. Western Avenue
Los Angeles, CA 90027
Storyboards for animation are used at a fundamental level.

Mesmer Animation
800-237-7311
1116 NW 54th
Seattle, WA 98107
Storyboards for animation are used at a fundamental level.

Mercer County Community College
609-586-4800
1200 Old Trenton Road
Trenton, NJ 08690
Storyboarding is part of the "Production Design" course.

Quickdraw Animation Society
403-261-5767
201,351-11 Avenue SW
Calgary, Alberta, Canada T2R 0C7
Storyboard workshop (approximately three hours); some drawing ability required. You'll learn to tailor your storyboards to their intended audience, including full-color artwork to include in grant applications.

Ringling School of Art and Design
941-351-5100
2700 N. Tamiami Trail
Sarasota, FL 34234-5895
Two courses: "Story Development" (classes EL332 and CG332). Develop storytelling with script, storyboards, and visual media.

Rochester Institute of Technology
716-475-2754
70 Lomb Memorial Drive
Rochester, NY 14623-5604
Courses: "Freshman Production," "Intro to Animation," "Advanced Animation Tools," "Animation Preproduction," "Graduate Seminar I and II," and "Research Seminar I."

Royal College of Art
44-171-590-4512
Kensington Gore
SW7 2EU London
United Kingdom
www.rca.ac.uk
Offers workshops on storyboarding for live action.

San Francisco State University
415-338-1629
1600 Holloway Ave
San Francisco, CA 94132
www.cinema.sfsu.edu

Storyboarding is specifically covered in courses CINE 354 ("Short Format Screenwriting") and CINE 701 ("Creative Process").

Savannah College of Art and Design
800-869-SCAD
548 E. Broungton St.
Savannah, GA 31401
www.scad.edu
Sequential art for animation, comic books, and comic strips, with an emphasis on storytelling. Other 2D and 3D animation classes include storyboarding.

FIGURE 52.2 Savanah College of Art and Design

School of Visual Arts
212-592-2100
209 East 23rd Street
New York, NY 10010
This school offers storyboards for animation, television, and cartoon shorts.

Sheridan College
905-849-2800
P.O. Box 2500
Station Main
Oakville, Ontario
Canada L6J 7T7

Storyboarding is offered in many of their animation courses. Courses with more storyboarding are "Layout and Design" and "Visual Language."

Studio M
416-703-6877
96 Spading Avenue
Suite 902
Toronto, Ontario M5V 2J6
Storyboarding for animation. Courses: "Introduction to Storyboarding," "Storyboarding Part 1 and 2," "Advanced Storyboarding."

Texas A and M
409-845-3465
A216 Langford Center
College Station, TX 77843-3137
www.viz.tamu.edu
Storyboards and animatics
Courses: Viza613; Viza615; Viza617.

The Art Institute of Philadelphia
800-275-2474
1622 Chestnut St
Philadelphia, PA 19103
Teaches storyboards as a part of the animation curriculum.

The Lab 3D Animation Training Center
619-715-5858
5125 Convoy
Suite 212
San Diego, CA 92111
www.thelab3d.co
Storyboards are a big part of the 3D animation and digital effects training course.

UCLA Animation Workshop
310-825-5829
102 East Melnitz
405 Hilgard Avenue
Los Angeles, CA 90095-1622
Course: "Storyboarding for Animation" (209D).

University of Vales College, Newport
44-163-343-2182
NP6 1Y6 Newport, Gwent Wales
United Kingdom
The course includes storyboarding for animation.

University of Southern California (USC) School of Cinema-Television
213-740-3986
850 West 34th Street
Los Angeles, CA 90089-2211
Storyboarding is offered as a part of the animation program. Course: "Writing for Animation." The live-action courses also include storyboarding within their curriculum.

Vancouver Film School
604-685-5808
420 Homer St.
Vancouver, BC V6b 2V5
Canada
Storyboarding for animation. Course: "Storyboarding."

Victorian College of Arts
61-3-9685-9020
234 St. Kilda Road

3006 Southgate Victoria
Australia
www.vca.unimelb.edu.au/ftv
The animation course includes storyboarding.

Video Symphony Entertainment, Inc.
818-557-7200
731 N. Hollywood Way
Burbank, CA 91505
Storyboards for Animation.

Woodbury University
818-767-0888
7500 Glenoak Blvd.
P.O. Box 7846
Burbank, CA 91510-7846
www.woodburyu.edu
Storyboards are taught in the Animation Arts Major.

PART SEVEN

Storyboard Samples

CHAPTER 53

STORYBOARD SAMPLES

While storyboards are important to a well-run production, they also make great eye candy. Storyboards are meant to be viewed together to visually tell a story. When you look at a good set of boards, they should tell a story without any text. The following pages are a portfolio of some of the work of the best storyboard artists around. Enjoy.

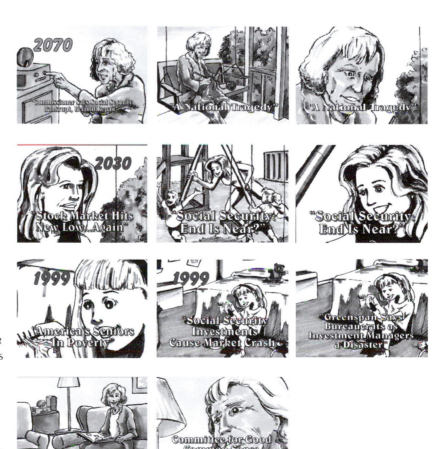

FIGURE 53.1 STORYBOARDS FOR DONER PUBLIC AFFAIRS. THESE BOARDS WERE PRODUCED AS A QUICK PAN-AND-SCAN ANIMATIC FOR TESTING. THREE DAYS AFTER THE TESTING, THE ACTUAL COMMERCIAL WAS SHOT. STORYBOARDS AND ANIMATIC PRODUCED BY MARK SIMON AT ANIMATICS & STORYBOARDS, INC.

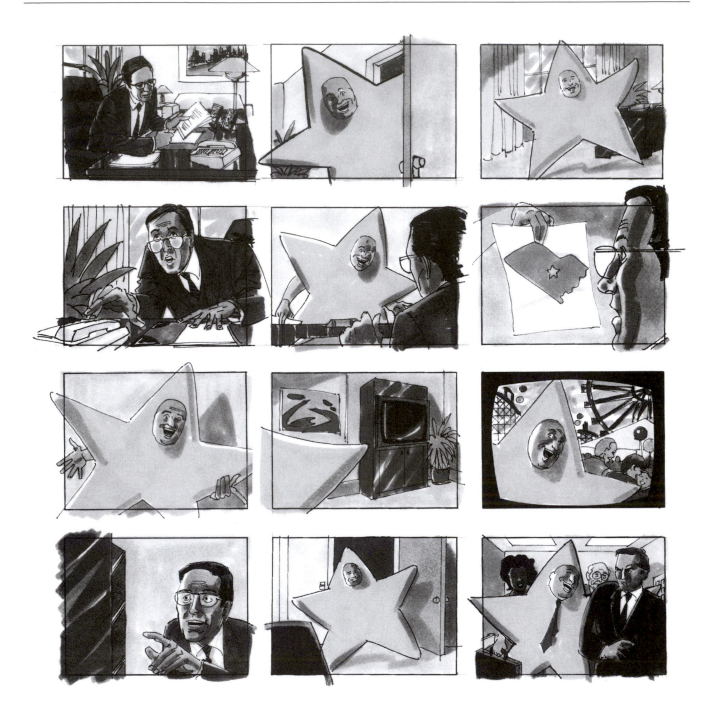

FIGURE 53.2 Storyboards for Chernoff/ Silver & Assoc. These were presentation boards for the mayoral race of Charleston, SC. The concept was based on one character being a star. The day after we delivered the boards to the client, and the day before they were to be presented, Arby's Restaurant released a campaign with a star character, killing this concept. Boards by Alex Saviuk and Mark Simon of Animatics & Storyboards, Inc.

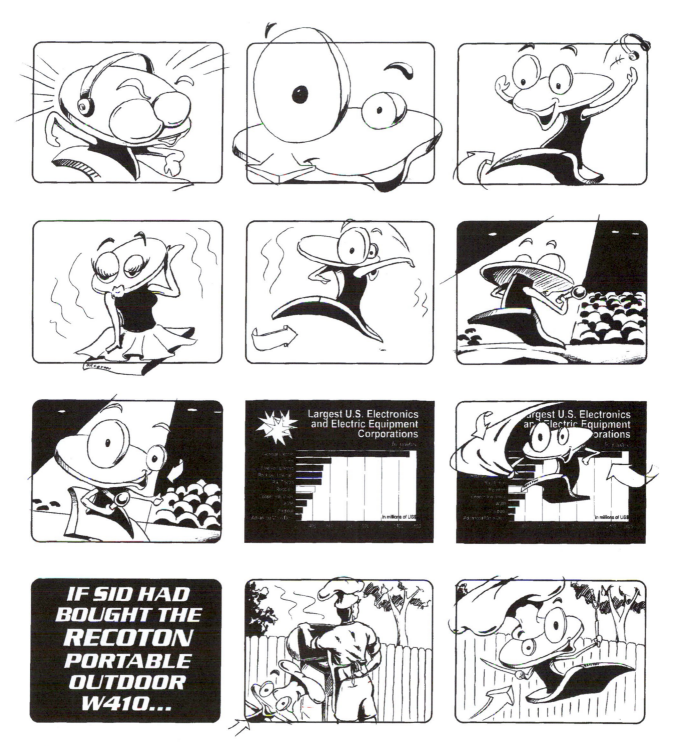

FIGURE 53.3 Storyboards for Digitec and Recoton. We were approached to design a cartoon character based on a wireless speaker transmitter that would be animated in 3D. These boards were really fun to do but I never got to see the final product. Boards by Mark Simon of Animatics & Storyboards, Inc.

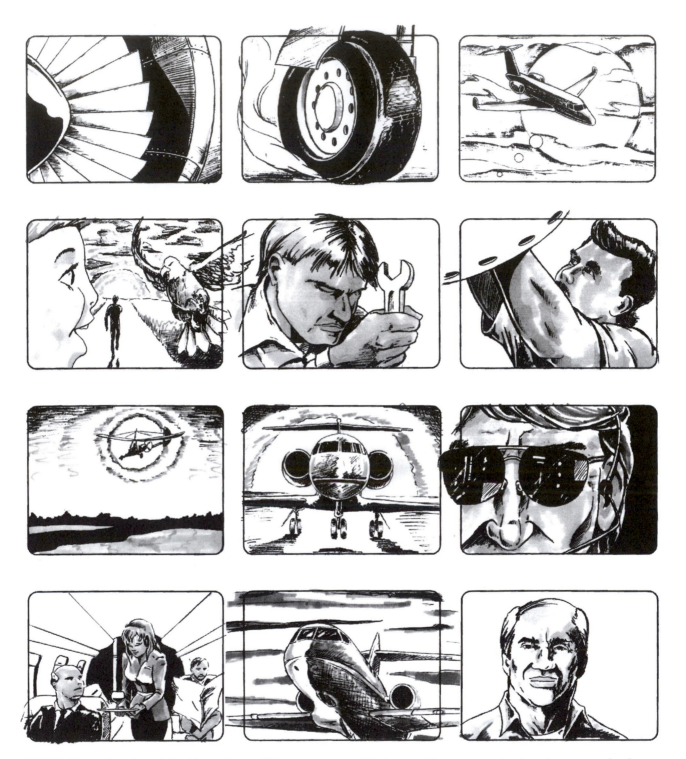

FIGURE 53.4 Storyboards for Florida Film and Tape to present to KC Aviation. These presentation boards were completed in color and just hit the highlights of the script. Boards by Mark Simon of Animatics & Storyboards, Inc.

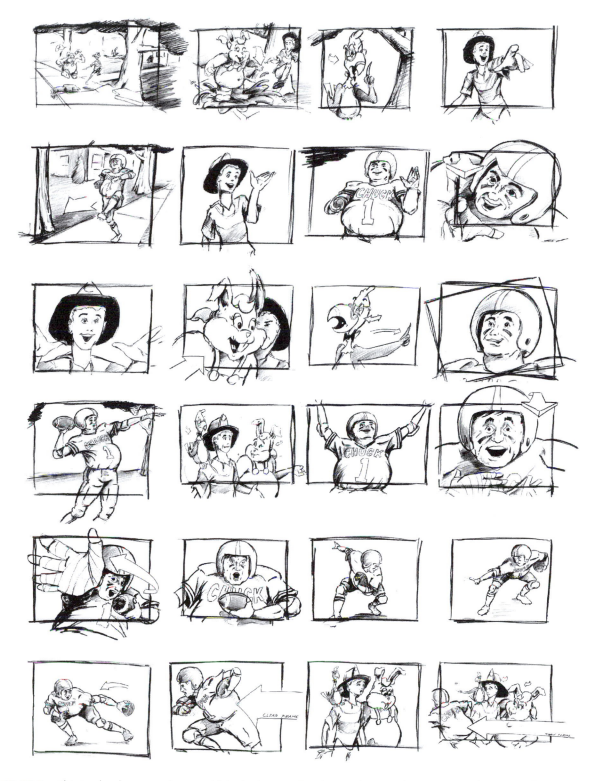

FIGURE 53.5 This is what happens when good friends sit around and create bizarre characters together. My wife, Jeanne, a creative partner of ours, Bill Suchy, and his wife, Joyce, sat around and created this show "Jonathan's Town." The storyboards on this children's show were incredibly fun and were used to pitch the show to the networks. Boards by Mark Simon of Animatics & Storyboards, Inc. (© 4friends Prod., Inc.)

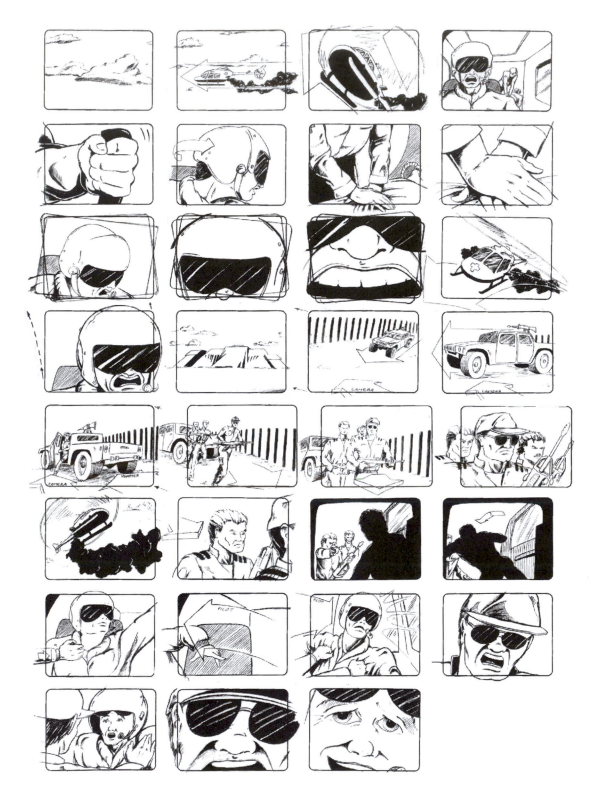

FIGURE 53.6 *seaQuest DSV* was probably the most fun I've ever had on a show. Nine months of storyboarding science fiction on a Steven Spielberg project. Producer Oscar Costo also directed this episode, "Dagger Redux." Boards by Mark Simon. (© by Universal City Studios, Inc. Courtesy of MCA Publishing Rights, a Division of MCA, Inc.)

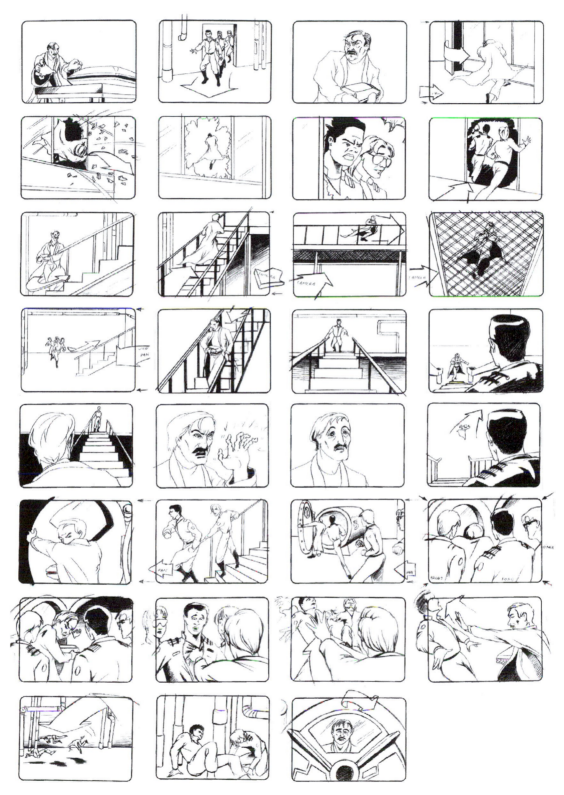

FIGURE 53.7 *seaQuest DSV* episode "SOMETHING IN THE AIR." DIRECTOR: STEVE ROBMAN. WE SHOT THIS EPISODE IN AN OLD POWER PLANT OUTSIDE OF ORLANDO. I'VE NEVER HAD TO DRAW SO MANY PIPES. BOARDS BY MARK SIMON. (© BY UNIVERSAL CITY STUDIOS, INC. COURTESY OF MCA PUBLISHING RIGHTS, A DIVISION OF MCA, INC.)

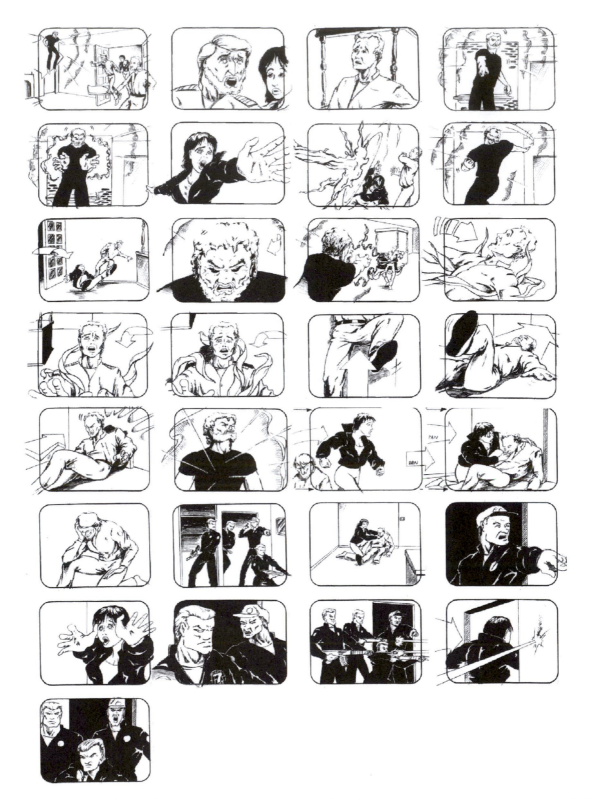

FIGURE 53.8 *seaQuest DSV* episode "Alone." Executive producer David Burke directed this episode. The man in black called himself the Avatar, and he had psychic powers. Drawing the effects in these boards was about the closest I've come to drawing comic books. Boards by Mark Simon. (© by Universal City Studios, Inc. Courtesy of MCA Publishing Rights, a Division of MCA, Inc.)

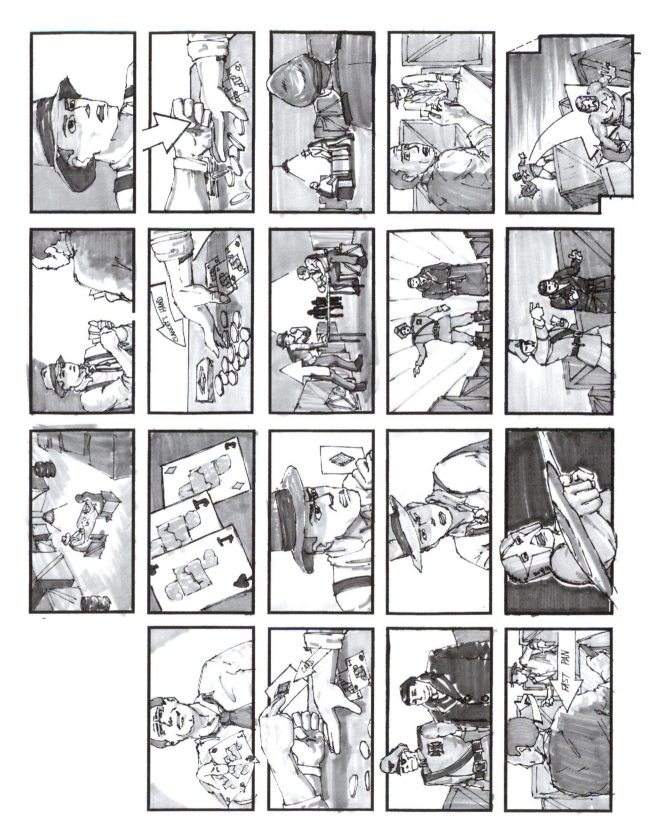

FIGURE 53.9 *Crusaders* storyboards by Dan Antkowiak. Preproduction boards for a feature that was never made.

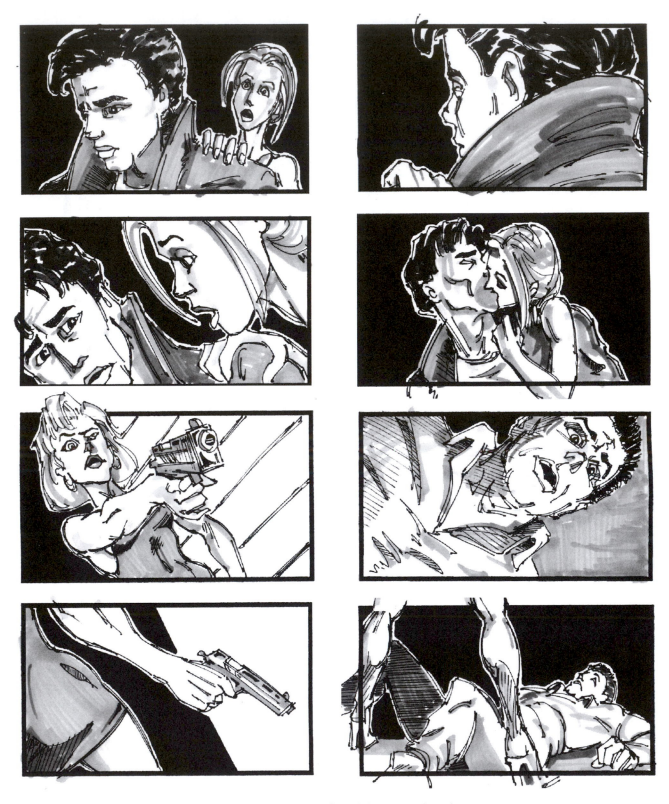

FIGURE 53.10 Storyboards by Dan Antkowiak.

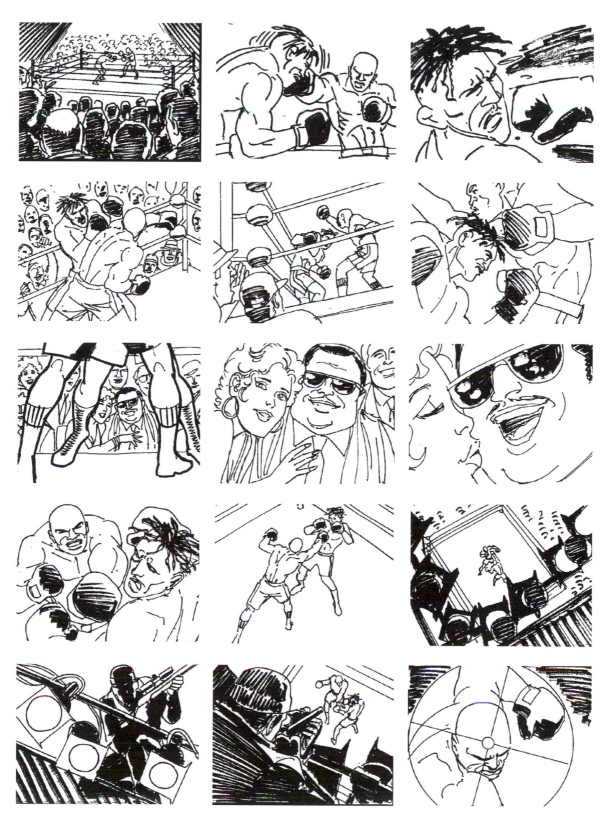

FIGURE 53.11 Storyboards by Alex Saviuk.

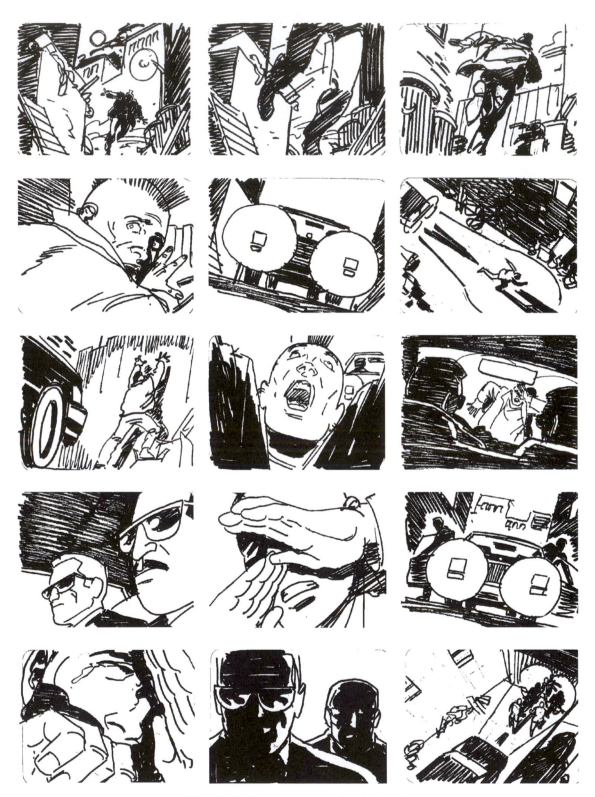

FIGURE 53.12 Storyboards by Alex Saviuk.

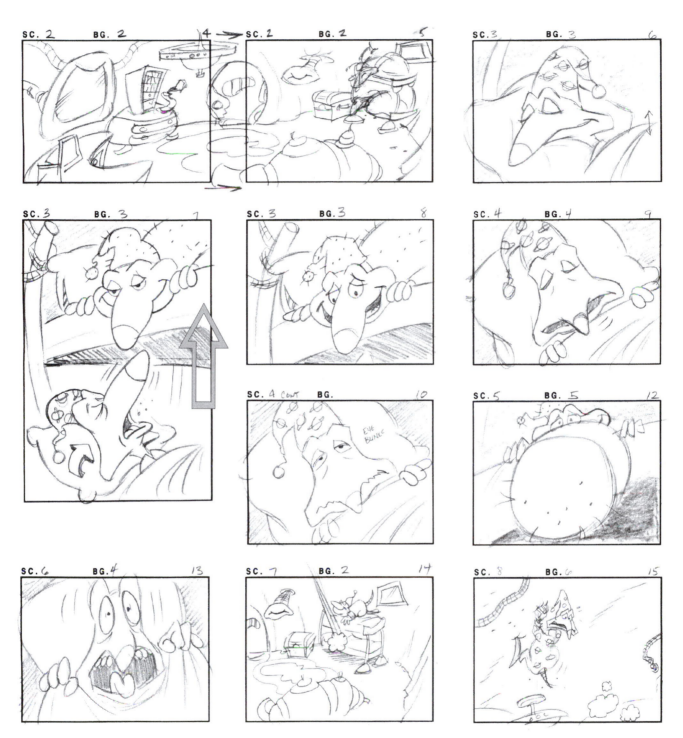

FIGURE 53.13 *The Brothers Flub*, episode "Guapos Galore," storyboards by Wolverton of Animatics & Storyboards, Inc. (© Sunbow Entertainment.)

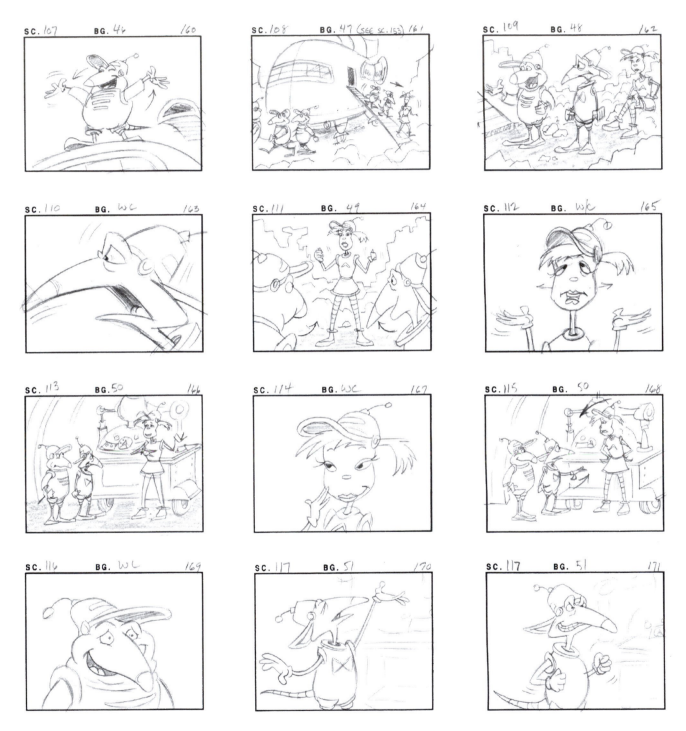

FIGURE 53.14 *The Brothers Flub*, episode "Guapos Galore," storyboards by Wolverton of Animatics & Storyboards, Inc. (© Sunbow Entertainment.)

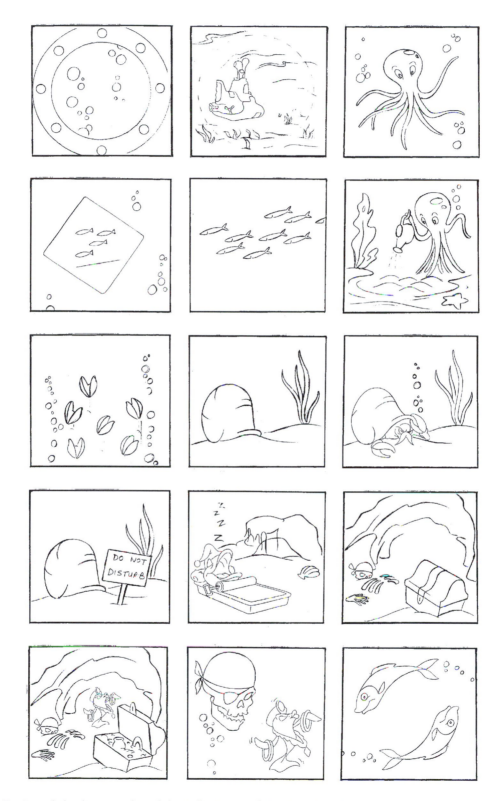

FIGURE 53.15 Laser light show storyboards by Willie Castro of AVI. Boards and show were based on the song "Yellow Submarine" by The Beatles. The simple line work is needed for the limitations of laser projection. (© AVI.)

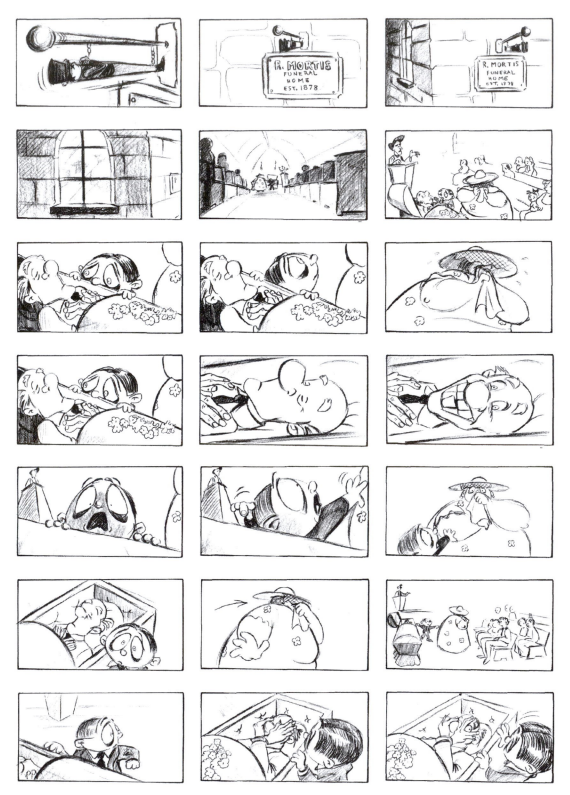

FIGURE 53.16 *Winslow* storyboards by KEITH SINTAY. THIS IS A SHORT FILM BEING PRODUCED IN 3D. CREATED BY KEITH SINTAY. (© by KEITH SINTAY.)

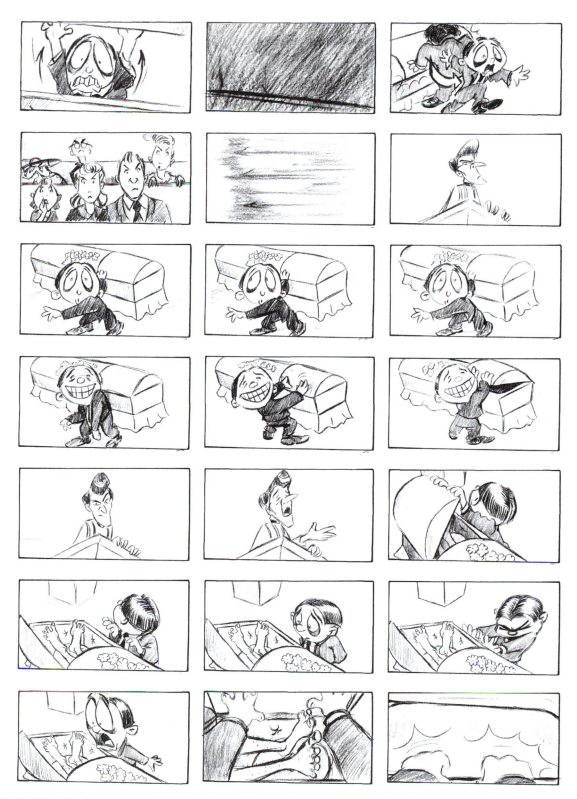

FIGURE 53.17 *Winslow* storyboards by Keith Sintay. This is a short film being produced in 3D. Created by Keith Sintay. (© by Keith Sintay.)

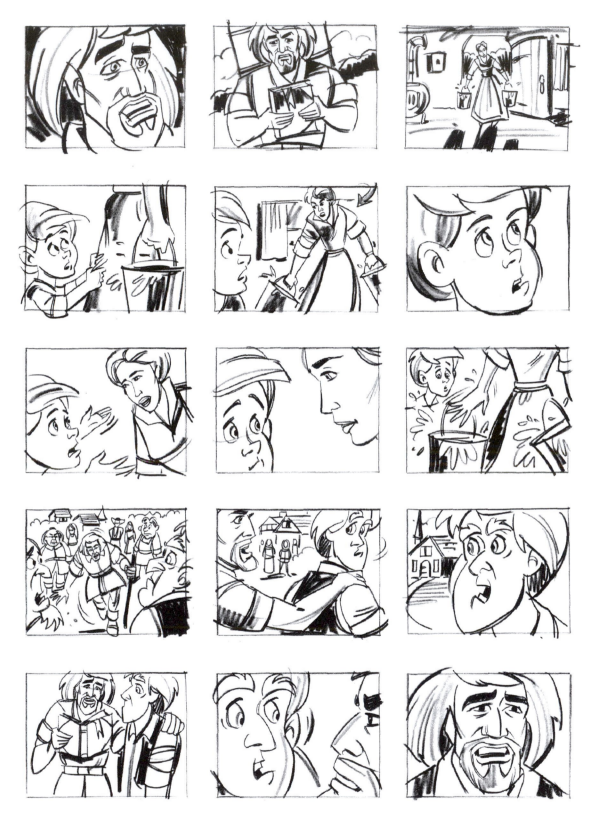

FIGURE 53.18 *The Pilgrim Program* feature film storyboards by Chris Allard.

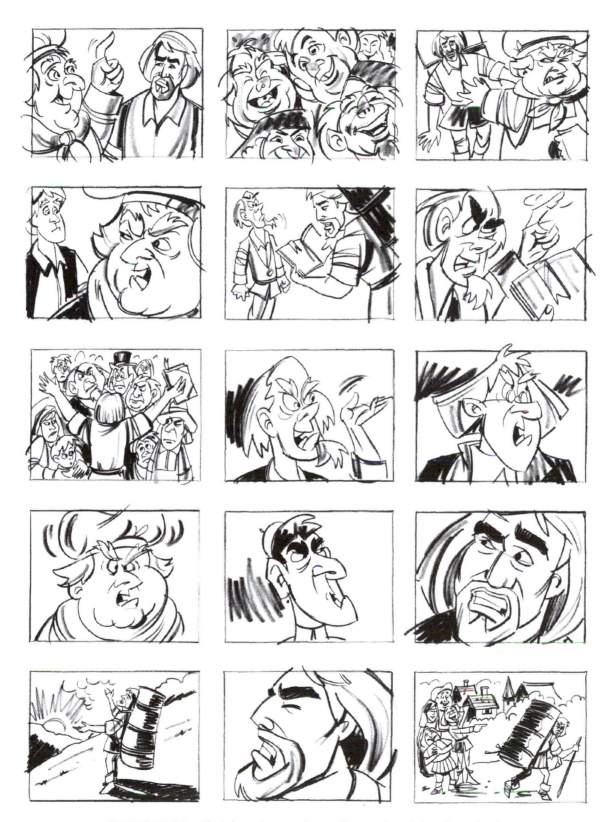

FIGURE 53.19 *The Pilgrim Program* feature film storyboards by Chris Allard.

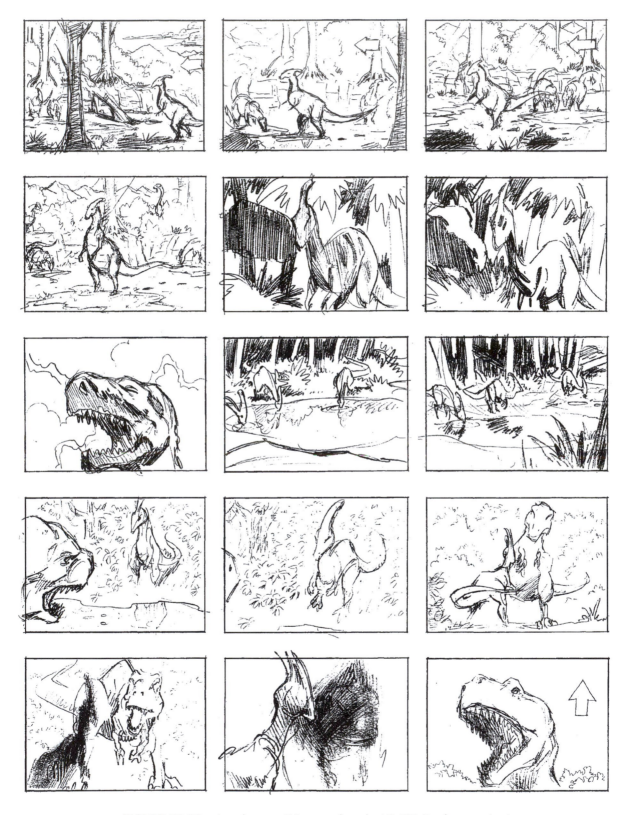

FIGURE 53.20 Arcade game, T-Rex storyboards. (© EPL Productions, Inc.)

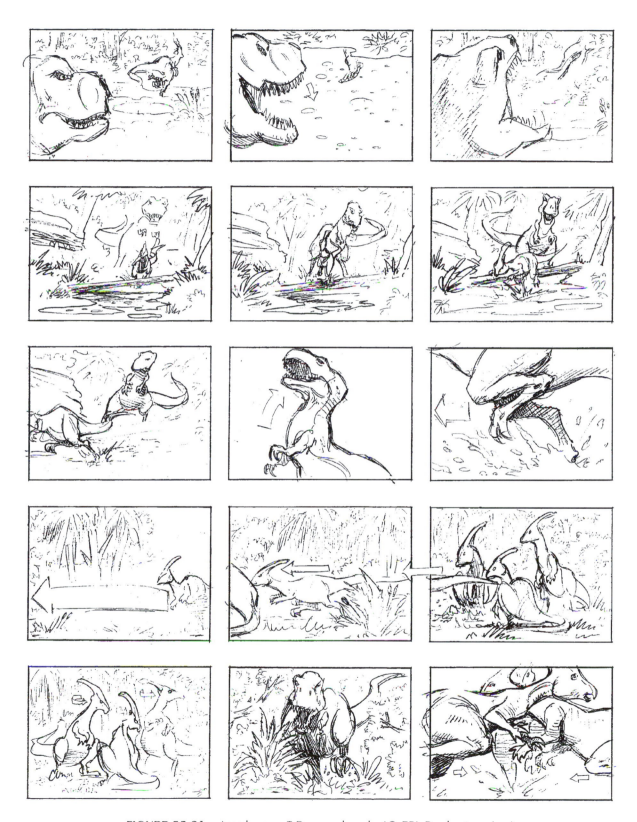

FIGURE 53.21 ARCADE GAME, T-REX STORYBOARDS. (© EPL PRODUCTIONS, INC.)

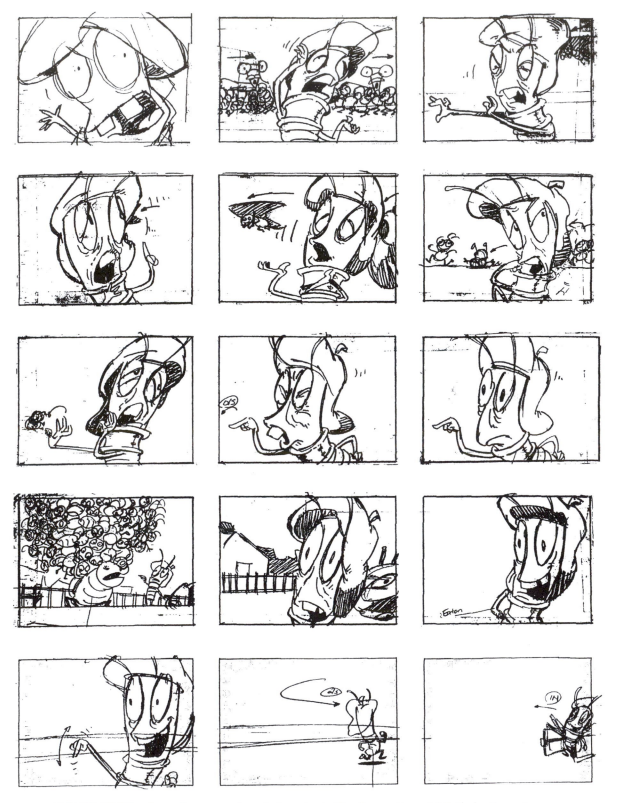

FIGURE 53.22 *Santo Bugito* storyboards for episode "The Carmen Tango." (© Klasky Csupo.)

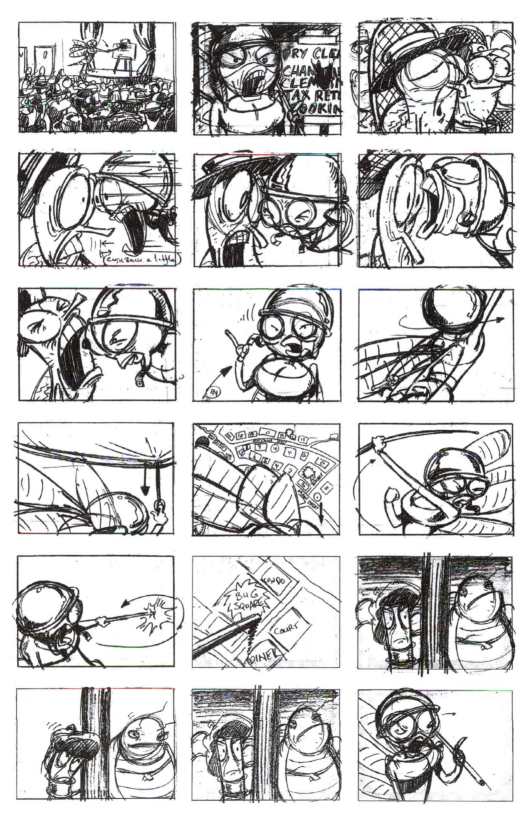

FIGURE 53.23 *Santo Bugito* storyboards for episode "The Carmen Tango." (© Klasky Csupo.)

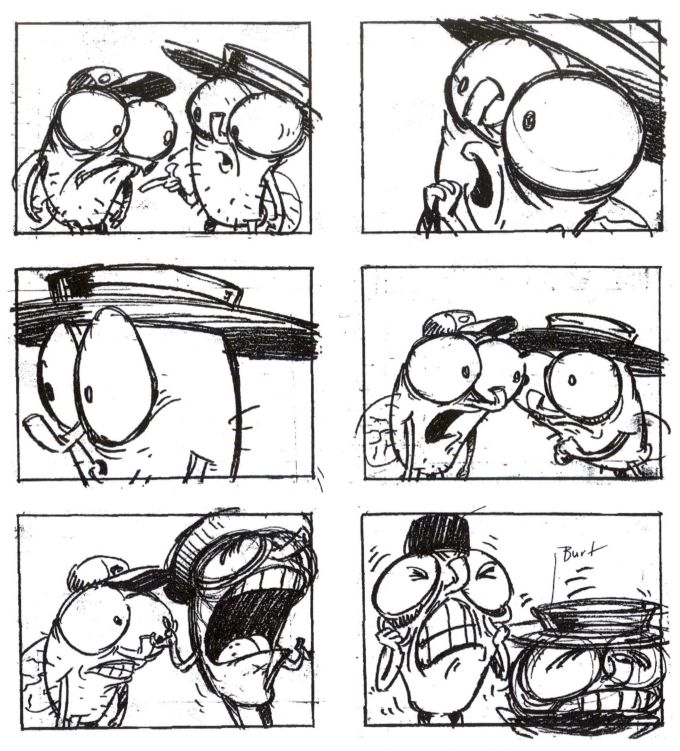

FIGURE 53.24 *Santo Bugito* storyboards for episode "The Carmen Tango." (© Klasky Csupo.)

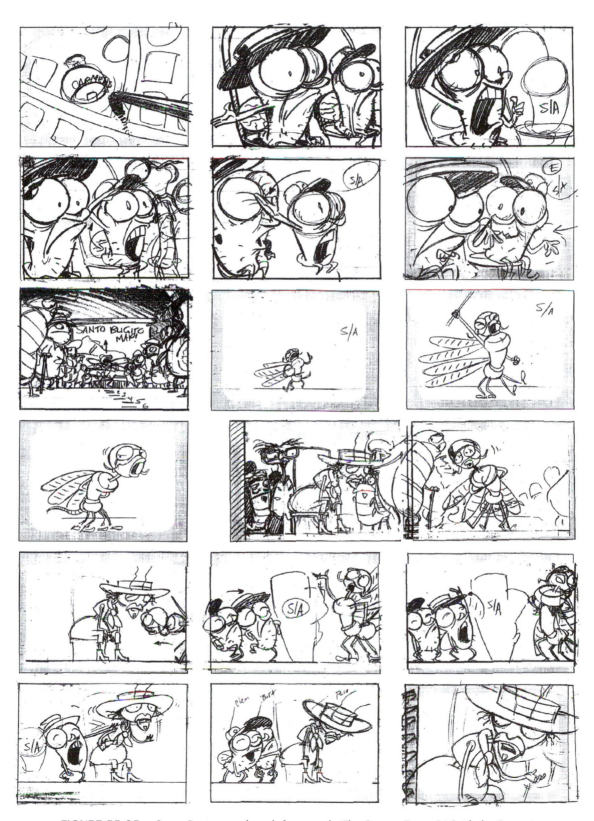

FIGURE 53.25 *Santo Bugito* storyboards for episode "The Carmen Tango." (© Klasky Csupo.)

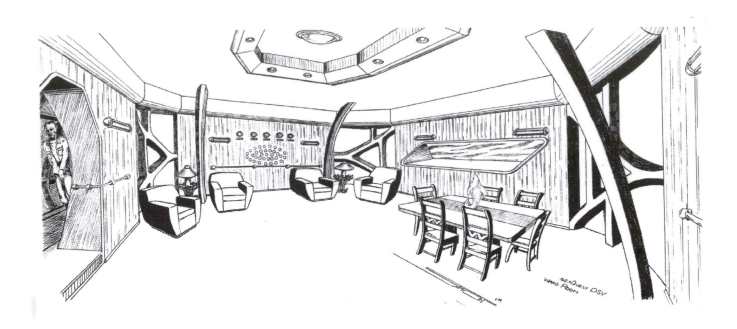

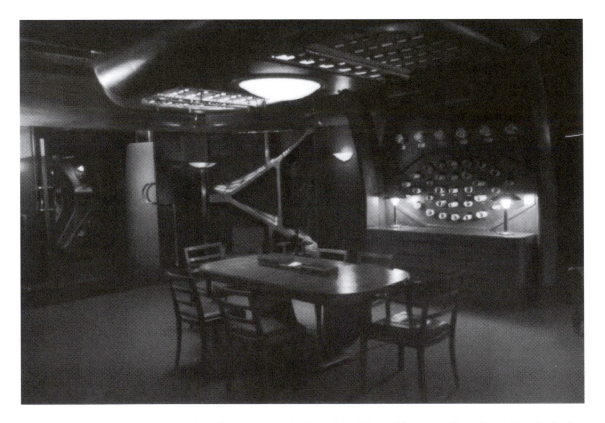

FIGURE 53.26 *seaQuest DSV* conceptual set illustration of the ship's Ward Room. The photo shows how close the final set was to the original drawing. Production Designer: Vaughan Edwards. Artist: Mark Simon. (© by Universal City Studios, Inc. Courtesy of MCA Publishing Rights, a Division of MCA, Inc.)

FIGURE 53.27 *seaQuest DSV* CONCEPTUAL SET illustration of the end of a ship corridor. The vent at the end was needed for a scene with Dagwood the Dagger. Throughout the series I would add humorous touches to different drawings. Take a look in the lower left corner of the drawing and you'll see a Band-Aid fixing a pipe. No one ever commented on any of these additions of mine. Production Designer: Vaughan Edwards. Artist: Mark Simon. (© by Universal City Studios, Inc. Courtesy of MCA Publishing Rights, a Division of MCA, Inc.)

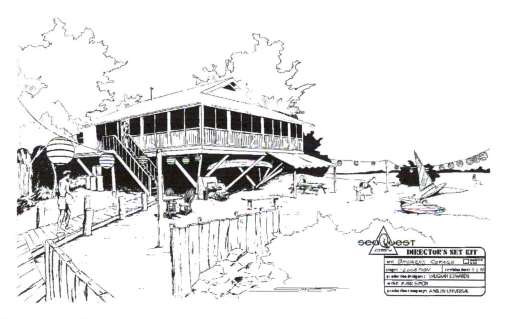

FIGURE 53.28 *seaQuest DSV* CONCEPTUAL location illustration of Bridger's cottage. There was a scene with a celebration at Bridger's place. We took a boy's club located on a small island off St. Petersburg, FL, and turned it into Bridger's summer place. We had to move all our equipment in on barges, since there were no roads leading to it. Production Designer: Vaughan Edwards. Artist: Mark Simon. (© by Universal City Studios, Inc. Courtesy of MCA Publishing Rights, a Division of MCA, Inc.)

GLOSSARY

There are a number of industry terms that you will be hearing as you work in storyboards and most any area of filmmaking. Here is a list of the most common terms as they relate to drawing storyboards.

Aerial. Extremely high-angle shot, usually taken from a plane or helicopter.

Aspect Ratio (Field Ratio). The relationship of the horizontal dimension to the vertical dimension for any given film or tape format. For example, the aspect ratio for TV is 4:3; that is, a TV screen is 4 units wide by 3 units high.

BG (bg): Background. Action or items behind the subject on which the camera is focusing.

Blocking. Action and positioning of the actors as determined by the director.

Boom Up or Down. This is where the camera moves vertically.

Breakdown (breakdown a script). Develop a script as a series of shots to tell the story. This could be a written shot list, thumbnail storyboards, or full storyboards.

Canted Frame (Twisted, Chinese, or Dutch Angles). The framing of the horizon is not parallel to horizontal. This is used to disorient the viewer or show that a character is out of sorts.

Cleanups. Finished pencil or ink over initial rough storyboards.

Cont. (Continued). Action or dialogue continues from one panel or scene to the next.

Countering. Camera moves in the opposite direction as the subject.

Cover shot. See Master Shot

Crosscutting. Show parallel action by alternating between shots of two or more scenes.

Crossing the Line. Crossing the line refers to the camera placement in relation to the action and an invisible line, which when crossed causes the action to look like its direction has reversed. Action has crossed the line when the subject appears to go in the opposite direction in successive cuts. This is caused by shot "A" showing the subject going from left to right on the screen, and shot "B" showing the subject going from right to left.

CU: Close-Up. This shot should include the tops of an actor's shoulders and head with a little headroom.

Cut. Hard edit from one shot to the next.

Cutaway. See Insert.

Deep Focus. Keeping the extreme foreground and the background in focus at the same time.

Depth of Field. The area in the camera lens that is in focus.

Dissolve. One scene on the screen dissolves or fades into the next as a soft transition used to slow the pace of a scene or show a transition in time.

Dolly (Truck or Travel). This is the movement of the camera along a horizontal line. If the camera is to be mounted on a dolly, then the term Dolly is most appropriate.

ECU: Extreme Close-Up. Any extremely close shot of an actor or an object.

Establishing Shot. A wide shot at the beginning of a scene to inform viewers of a new location and to ori-

ent them to the relative placement of characters and objects.

Fade In and Fade Out. Fade from black to a scene and from a scene to black, respectively. Used in scripts as "begin" (fade in) and "end" (fade out).

FG (fg): Foreground. Items or actors closer to the camera than other elements in the frame.

Flash Cut (Flash Frame). Extremely brief shot, sometimes only one frame. Used as an effect, such as a white frame, for a gunshot or lighting effect.

Focus Pull (Follow Focus). Refocusing the lens to follow a character or object.

Follow Shot. A truck pan or zoom that follows a moving subject.

Full Shot. Head-to-toe framing of a subject.

HA: High Angle (Bird's-Eye View). The camera is up high looking down.

Halftone. A digitized version of a photo or piece of art that breaks the image into very tiny dots that print and reproduce very well. Newspaper photos are halftones.

Insert (Cutaway). A close shot of some article or minute action that is edited into the scene and that supports the main action. For example: There is an alert at an army base and guards are trying desperately to maintain control. During all the commotion there may be cutaways of flashing lights or of a finger flipping a switch.

Jump Cut. Shots that appear to jump out of proper continuous time. For example, a single camera shot with a portion of that shot edited out, which makes the characters seem to jump to new positions without warning or reason.

LA: Low Angle (Worm's-Eye View). The camera is down low looking up.

Local (as in "a local"). A crew member who will work in a city where he or she doesn't live and charge a rate as if he or she does. In other words, they are not taking an extra fee for mileage, hotel, or per diem.

Locked-Off Camera. The camera is stabilized for a steady shot. Often used for effects shots where multiple images are to be combined.

Loose. A shot composition where there is plenty of space around the subject.

LS: Long Shot. The use of a long lens to show action far away.

Main Unit (First Unit). The production crew that shoots the bulk of a production, including most of the actors' dialogue, with the director overseeing each shot.

Master Shot (Cover Shot). A viewpoint wide enough to establish the physical relationships between the characters and close enough to understand all the action.

Match Cut. A transition between scenes. An element in one shot lines up and matches another element in the next shot.

MCU: Medium Close-Up. The proper definition is tight enough so that the top and bottom of the head is cut out of the frame, or tighter than a close-up. Some directors and producers use this term to mean a little WIDER than a close-up. Should an MCU come up in the storyboarding process, make sure you define it.

Montage. A short portion of a story where a number of short, related elements are edited together to show background or time passage.

Morph. The changing of an object from one form into another. For example, a lazy character could be shown to morph into an eggplant.

Motivated Shot. A shot dictated by the action of the previous shot. For example, a woman looks up in one shot and the motivated shot would be her POV of the moon.

MS: Medium Shot. Shows an actor from the waist up.

OL: Overlay. Animation term meaning a portion of a drawing that is on the uppermost level of animation, allowing action to happen behind it.

OS (OC): Off Stage or Off Camera. This is when dialogue, sound effect, or action takes place beyond the view of the camera shot.

OTS: Over the Shoulder. When the camera is looking from just behind and over the shoulder of an actor.

Pan. The camera is stationary and rotates in one direction, left or right, on an axis.

Per Diem. An amount of money paid to crew members for every day in a production they stay in a city other than where they live. This money is meant to cover the cost of food, primarily.

Photo Boards. A storyboard generated using stock or custom photos; usually made by agencies for presentations.

Plot Plan. Overhead view or blueprint of a location or set.

POV: Point Of View (Subjective Shot). The viewer sees what the actor would be seeing.

Principal Photography. The main photography of a film.

Pull Back. Zoom or dolly back to a wider shot.

Rack Focus. The camera starts its focus on one subject and changes focus to another subject.

Reaction Shot. One character listening or reacting to another character or event.

Reverse Angle. A shot that is 180 degrees opposite the preceding shot.

Roughs. Unfinished sketches of a storyboard used to lay out the scene and get approvals.

SA: Same Action. An animation term describing a portion of the frame that does not change or move over consecutive storyboards.

Second Unit. Secondary crew of a film shoot. Usually shoots effects, stunts, or cutaways.

Setup. Each choice or setup of a camera angle.

Sight Line. An imaginary line between an actor and where he or she is looking.

Single. One subject is in the frame.

Static. Camera shot is stationary.

Storyboard Supervisor. Staff person on an animation who gives notes and makes corrections on storyboards. This person makes sure that the storyboard is true to the characters and series.

TB (Truck Back). Camera moves backwards along a horizontal path.

Tight. A tight shot encompasses an object with very little space around it.

Tilt. The camera is stationary and looks or tilts up or down on an axis.

Truck. The camera moves along a horizontal path.

Two-Shot. A shot that frames two people.

TV Safe. The area within a television screen that is guaranteed not to be cut off by certain televisions. Titling and important action needs to happen within the TV safe area so it's not lost on some TVs.

VO: Voice Over. Narration over a scene.

Whip Pan (Swish, Zip, or Flash Pan). A very fast pan in one direction that causes the image on the screen to blur.

Wipe. A transition between shots where one moves over the other.

WS: Wide Shot (Establishing Shot). Shows the entire action.

Zoom (Push In or Out). A camera lens is manipulated so that the image seems to come closer or move farther away without the camera moving at all but by using a zoom lens.

INDEX